Collins

ramblers

Yorkshire Dales

guide to 30 of the best walking routes

Published by Collins
An imprint of HarperCollins Publishers
77-85 Fulham Palace Road, Hammersmith, London W6 8JB

www.harpercollins.co.uk

Series Editor Richard Sale
© in this edition HarperCollins Publishers
© in the text, photographs and geological diagrams David Leather
All photographs and geological diagrams by David Leather

Mapping generated from Collins Bartholomew
digital databases on the inner front cover

This product uses map data licensed from Ordnance Survey ® with
the permission of the Controller of Her Majesty's Stationery Office.
© Crown copyright. Licence number 399302

The contents of this publication are believed correct at the time of printing.
Nevertheless, the publisher can accept no responsibility for errors or omissions,
changes in the detail given, or for any expense or loss thereby caused.

The representation of a road, track or footpath is no evidence of a right of way.

Printed in China ISBN 978 0 00 735141 1 Imp 001 XJ12486 / CCD

e-mail: roadcheck@harpercollins.co.uk

Contents

Introduction

The magnificent scenery of the Yorkshire Dales brings to mind the limestone of Malham Cove and Gordale Scar, the waterfalls at Ingleton and Aysgarth, flowery meadows in Swaledale and Dentdale and the shadowy peaks of Penyghent, Whernside and Ingleborough. Between the peaks flow rivers that, aided by glaciers, have carved deep valleys, or 'Dales' as they are invariable known. What a precious, unspoilt and generally peaceful district it is, full of secret corners waiting to be discovered: ravines, scars, abbey ruins, castles, leadmines, ancient farmhouses, hamlets and pubs. And just as exciting for the walker who is prepared to look around are birds of prey, song birds, butterflies, dragonflies, the occasional wild animal, toadstools, orchids and all the flowering plants along the wayside – a real wealth of wildlife interest.

The area covered in this collection of walks takes in rather more than the Yorkshire Dales National Park, and includes Nidderdale to the east, Ilkley Moor to the south, Barbondale in the west and Smardale and part of the Howgills to the north. After 1974, Sedbergh and much of the Howgills went to Cumbria and that's why the National Park boundary ends at Carlin Gill, the furthest outpost of the old West Riding.

The landscape depends on the rocks beneath, a skeleton on which the scenery is draped, and it is limestone that gives us its must stunning appearance. The Carboniferous limestone (about 340 million years old) emerges wherever it happens to be, adding character to the scene. Above the thick layer of so-called Great Scar limestone are the Yoredale series of strata, named after the old name for Wensleydale and the River Ure. These repeated beds of limestone, shale and sandstone form a thick sandwich, and it is the limestones again that stand out in the landscape.

Beds of alternating hard and soft rocks are ideal for the formation of waterfalls and there are dozens of these especially in the northern Dales where Yoredale strata are most prominent. Hardraw Force in Wensleydale is the highest single drop in England, while the three groups of falls at Aysgarth have the most visitors in the Park. In Swaledale are Catrake Force and Kisdon Force, and there are many more delightful waterfalls in the side Dales.

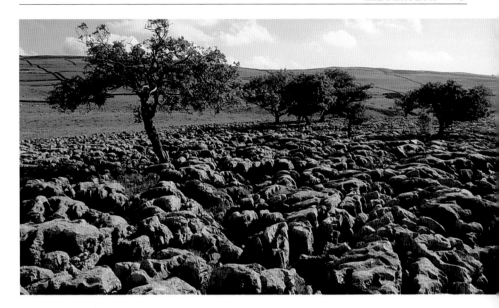

Most of the strata from Swaledale in the north to Ingleton and Malham in the south are remarkably horizontal – considering they are so old. Their flat-lying nature results not only in waterfalls, but also in long, level limestone scars that follow the valley sides and skirt the hills and, of course, the bare limestone pavements. Some of the best pavements occur around Sulber Nick, and others above Conistone and on the top of Malham Cove. The reason why these ancient rocks have not been folded or tilted is that they lie across a stable area, known as the Askrigg block and the reason why this block is so firm and resistant is that it is underlain by a large mass of granite. Below Wensleydale the granite lies only 1,640ft (500m) below the surface where it is a beautiful pale pink, flecked with green. A sample from the Raydale borehole is on display in the museum at Hawes. Man first saw it in the summer of 1973, until then geologists had only predicted it.

The granite is of Devonian age (about 400 million years old) and may have reheated about 300 million years ago, expanding at the same time, and cracking the rocks above it, making room for the metal ores. Hot brines containing lead and zinc entered the limestones leaving crystallised veins of galena (lead sulphide) and sphalerite (zinc sulphide), together with baryte, fluorite and calcite. Sometimes the lead ore occurs in 'flats' at the side of a vein where the limestone has been completely replaced by the metal ore. These are often the richest deposits.

Limestone Pavements like these near Conistone in Wharfedale shelter rare ferns

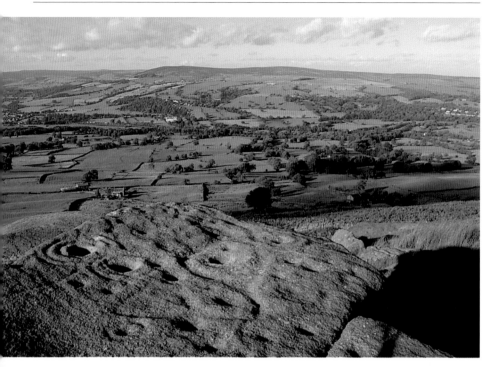

Neolithic man left cup and ring stone carvings, Piper's Stone, Ilkley Moor

Remains of former leadmines are to be seen all over the Dales. They can be picked out by the spoil heaps as seen on the walks to Trollers Gill, Gunnerside Gill and Swinner Gill. The miners only wanted the lead ore and the white 'sparry' minerals were thrown out leaving tip heaps full of interesting specimens. Sometimes miners came across old workings that may have dated back to Roman times and when they did so, they would speak knowingly of 't'owd man'. In the 12th Century, lead from Swaledale was used for the Tower of London and for the abbeys built in the Dales. During the height of the leadmining industry, in the 18th and 19th centuries, the landscape was devastated. Veins were dug deep across country, gashes in valley sides were made by repeated flooding (known as hushes), giant flues were constructed up hillsides, and poisonous fumes from smelters killed off surrounding vegetation. For the miner it was a hard life, but the industry came to an end in about 1882 when cheap ore was imported from abroad.

On top of the multiple sandwich of Yoredale rocks comes the millstone grit, a series of coarse sandstones with shales and occasional thin coal seams between them. The millstone grit forms the highest land in the Dales, capping the three peaks

and forming the moorland. As there is no lime, soils are acid and favour plants such as heather, cotton grass, sphagnum moss and coarse grasses. The formation of peat under the bogs together with the dark vegetation gives the landscape a sombre aspect, relieved here and there by big rocky outcrops like Brimham Rocks, Simon's Seat and Penhill Crags. On the slopes of Ilkley Moor there are still a few millstones, fashioned from the gritstone. The millstone grit also provides surrounding towns with good supplies of soft water – from reservoirs like those in Nidderdale, the Washburn valley and Wharfedale.

At the south-west corner of our rigid block, the blanket of Carboniferous limestone has worn thin and, through a window in it, we can see basement rocks beneath. These outcrop in upper Ribblesdale, at Ingleton Falls and in Crummackdale. They are of Ordovician and Silurian age (from 480 to 420 million years old) and have names such as Ingleton slates, Horton flags and Austwick grits.

What happens around the margins of the Askrigg block? To the east, beyond Nidderdale, the block gradually tilts and disappears below newer sediments. On the fascinating

Alternating beds of hard and soft rock formed Lower Aysgarth Falls

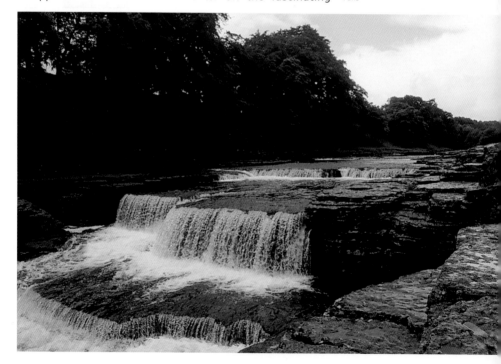

southern edge are the Craven faults along which the rocks to the south sank considerably to form the Bowland basin. Overlooking the basin and between the faults, reefs formed in Carboniferous times with an incredible variety of life around them, including fish, corals, crinoids and even trilobites. Today these reefs have been exhumed by denudation and there is a line of them still looking out over the lowland to the south. They include the reef knolls at Appletreewick and Thorpe in Wharfedale, those at Malham, and below Attermire Scar near Settle, and they often contain well-preserved fossils.

On the western margin of the Askrigg block there is quite a different picture. Here the block is bordered by the Dent fault and, rather than sinking, the land to the west rose up against the block, pushing against it and turning up the limestone at the edges to a vertical position and raising the basement rocks in the Howgill fells so high up that they look down on the younger limestones across the way.

The effects of the Ice Age came when the last advance of the ice peaked about 20,000 years ago, and each dale had its

Limekiln above Coniston Dib, Upper Wharfdale

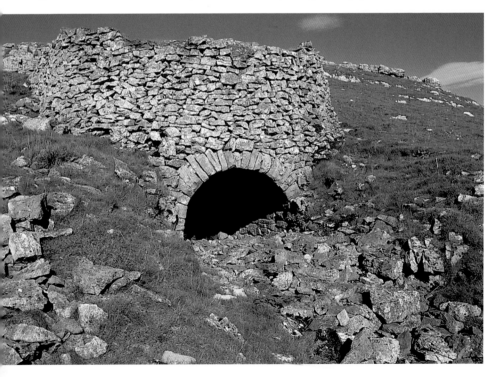

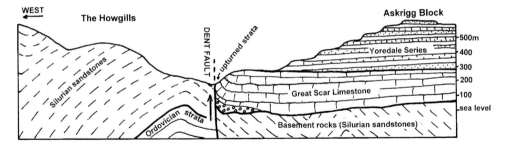

own glacier. The three peaks probably stuck out above the ice sheet but the valleys were deepened into trough-like shapes with steep sides and a flat bottom. As the ice melted it left deposits of glacial debris in the form of large mounds, or drumlins, seen around Ribblehead and between Hellifield and Skipton. It left perched boulders on scoured areas, terminal moraines across the valleys, and generally plastered the lower land with glacial till.

Section on the western side of the Askrigg Block shows the Great Scar limestone pushed up by the movement of the Dent Fault

Man's effect on the landscape started about 6,000 years ago when Neolithic man left occasional burial cairns, stone circles, carvings, henges and flint fragments. The flint was traded from east Yorkshire and was still in use during the Bronze Age (1,800 – 600BC). Field systems and hut circles may date from this time but merge into the Iron Age with the arrival of Celts and Brigantes from the Continent. Maiden Castle in Swaledale is one of the most impressive prehistoric monuments in Yorkshire, and the large embankments nearby on Harkerside are thought to be defensive works by the Brigantes in their struggle against the Romans.

The Romans built forts at Ilkley, Bainbridge and Catterick, and two in the Lune valley. Some of the walks follow stretches of the old Roman roads, the first ever road system in the country. They are to be experienced near Buckden, Carlin Gill, and near Cautley in the Rawthey valley.

Placenames hold the clue as to the origins of the first settlers, and the Angles, who came in the 7th Century from what is now north Germany, left name elements like -ton, -ing and -ley. They lived in close communities around a clearing – the first villages and village greens. Examples are Grassington and Wensley. Two centuries later the Danes left names with -by and -thorp as in Carperby and Agglethorpe. The Norse people arrived in the 10th Century, settling in the upper parts of the valleys and in the western Dales. Dentdale is typical

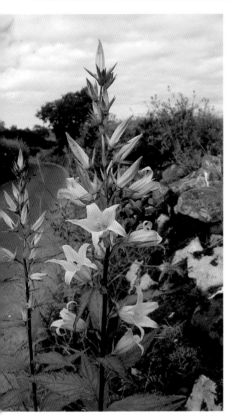

Giant Bellflowers line roadside verges in Dentdale, July

where the farms are spread out along the valley and not clustered into villages. They left elements from names, such as -thwaite and -sett. The Norse had a big influence on the language, especially naming natural features such as gill, scar, beck and dale as well as many words found now in the Yorkshire dialect.

After 1066, the Normans spread north and built castles such as at Middleham, the motte and bailey at Sedbergh and the great fortress at Richmond. In 1069 William the Conqueror responded to local rebellions by his 'harrying of the North'; large numbers of the population were slaughtered and Norman landlords took over. The depopulated upper Dales became hunting forests where settlements mentioned in Domesday survey of 1086 are described as 'waste'.

One of the biggest influences on the landscape came with the growth and power of the monasteries. Norman lords made gifts of land, ensuring them a place in Heaven, and monasteries were founded at Bolton priory, Jervaulx and Coverham among others. The most far-reaching influence came from the great abbeys of Fountains and Furness. Vast sheep ranches were developed connected by drove roads and chains of farms and granges. The production of wool became the wealth of the land with trade going as far as Italy. Sheep rearing heralded an enormous change in the landscape where trees could not survive the grazing and large areas of upland became grassland.

In late medieval times, the use of teams of oxen for ploughing led to the formation of terraces or lynchets where strip farming was continued up the valley sides. They form large steps and can still be seen in many of the Dales. In the 17th Century came 'the great rebuild' when farmhouses were built in stone with stone flagged roofs. Many of them have a lintel over the door with the initials of the farmer and his wife. The typical plan was a long and narrow building with living accommodation at one end and animals at the other.

Scattered barns, or laithes, became an important part of Dales scenery, and drystone walls, built from local stone

without the use of mortar, meant farming could be better organised. Older walls tend to be irregular, but with the 'enclosures', especially from 1780 to 1820, a large part of the land was enclosed in straight geometrical shapes. A good wall builder could put up 7yds (6.4m) of wall a day, moving 12 tons of stone. You are bound to see one or two of the 700 or so limekilns in the Dales. They produced lime to improve the fertility of land, but it was also needed to make mortar for building.

Old and established are the miles of footpaths that reflect centuries of people on the move: along parishioners' ways, monks' trails, drovers' roads, packhorse tracks and miners' paths, a whole network, preserved now for present and future generations of ramblers and hikers. This collection of 30 walks are the best of the bunch, chosen to include a concentration of scenic, wildlife and historic interest for each. They are for those prepared to look around and learn a little something as they ramble through the countryside. You don't have to be a naturalist to appreciate the antics of a raven, the beauty of an orchid or the wily behaviour of a stoat, but such experiences may be the highlight of a walk.

The Yorkshire Dales are a paradise for a rich variety of wildlife and in the spring birdlife is at its busiest. The summer migrants have all arrived and the air is full of song as birds display, pair, mate and build their nests. On the high tops raven and buzzard may be most easily seen but golden plover and dunlin are hardy breeding birds. The heather moors are home to the red grouse, where meadow pipits are common and preyed upon by merlin. The hen harrier and short-eared owl are also occasionally seen. On rough pasture further ground nesting birds include the curlew, lapwing, redshank and, in wetter parts, common snipe. Around rocky crags you may be fortunate to see a peregrine falcon. Ring ouzel and wheatear also prefer rocky areas. Rivers and becks attract dipper, grey wagtail and common sandpiper. Goosanders, rare a few years ago, occupy many of the rivers, where sand martins make use of the sandy banks for nest holes. On farmland and pasture look out for the little owl, linnet, the colourful goldfinch, swifts and house martins. With so many small birds about, the sparrowhawk may be lurking. Woodland provides cover for many summer visitors, the spotted and pied flycatcher and willow, wood and garden warblers, while the treecreeper, nuthatch and greater spotted woodpecker stay all year.

Small skipper, a little butterfly (here on birdsfoot trefoil) that at rest raises its fore-wings

Among the mammals keep an eye open for the unexpected: a mink on the riverbank, a hare in open country, a stoat almost anywhere, or a roe deer crossing your path – moments to savour. Butterflies provide a little magic in the sun and it is surprising how many southern species have spread over the area in the last 20 years or so. These include small skipper, comma, holly blue and gatekeeper. There is a similar story for dragonflies indicating a warming of the climate.

Of the hundreds of flowering plants to be found in the Dales, there is space here to mention a few key species. Cloudberry and purple saxifrage, classed as Arctic Alpines, grow only above 1,650ft (500m) and may disappear altogether, due to global warming. Horseshoe vetch and carline thistle like warm, sunny slopes and are near their northern limits. In this part of the Pennines there is an overlap between northern and southern species, shown clearly by two of the cranesbills: meadow cranesbill is a southern species and is seen, in splashes of blue, lining many of the roadsides in summer, while wood cranesbill, purplish with a white centre, gives its name to the northern hay meadows. Two other northern plants are the beautiful stands of melancholy thistle, also a meadow flower, and seen on the roadsides of Swaledale, while Dentdale is noted for those milky-blue spikes of giant bellflower. The tiny pink heads of birdseye primrose are only found in the north of England, a flower taken as the logo for the Yorkshire Dales Society. The starry white flowers of spring sandwort, also known as leadwort, survive on leadmine spoil heaps.

Old-fashioned hay meadows can still be found in Dentdale, Swaledale and upper Wharfedale. They are being encouraged by designating the land as an Environmentally Sensitive Area (or ESA) so that traditional management can be carried out, allowing seeds to ripen before haymaking, and birds to fledge their young, and using natural fertilisers and no chemicals. Limestone pavements are well known for rare ferns and plants, such as rue-leaved saxifrage and lily-of-the-valley that shelter in the grikes. For the botanist or casual passer-by there is always something exciting to discover.

Walkers have a great advantage as they can experience the landscape first hand and observe the plants and wildlife at close quarters. They can see the changes through the seasons, and many will note when they heard the first cuckoo or saw the last swallow.

Each year 10 million visitors come to the Yorkshire Dales and with a resident population of only 20,000 there is a need to protect the fragile environment. You can help by being a 'green' tourist. This means supporting the local community by using local shops, pubs and tea rooms; respecting other people's peace and quiet; reducing the amount of travel by staying overnight; using public transport where possible and avoiding bank holidays; using stiles and gates; instilling an interest in geology, wildlife and nature conservation, and keeping rivers and streams clean. These are just a few guidelines towards environmental tourism so that this wonderful area can be enjoyed now and in the future.

Cottongrass

Fact file

TOURIST INFORMATION

Aysgarth Falls NPC ☎ 01969 662910
Grassington NPC ☎ 01756 751690
Hawes NPC ☎ 01969 666210
Horton TIC ☎ 01729 860333
Ilkley TIC ☎ 01943 602319
Kirkby Stephen TIC ☎ 01768 371199
Malham NPC ☎ 01969 652380
Pateley Bridge TIC ☎ 01423 711147
Reeth NPC ☎ 01748 884059
Settle TIC ☎ 01729 825192
NPC: National Park Centre TIC: Tourist Information Centre

TRANSPORT & WEATHER

Leeds-Settle-Carlisle Railway and the rail service from Skipton to Carnforth brush the area on the western and southern sides and could be useful for certain walks, National Rail Enquiries: ☎ 08457 484950. Also www.settle-carlisle.co.uk and www.dalesbus.org the official site of the Yorkshire Dales Public Transport Users Group providing bus and train services in the Yorkshire Dales. Dales Leisure Bus Services ☎ 0870 608 2 608 have detailed timetables covering the area and are available from TICs. The Yorkshire Dales National Park can be found online at: www.yorkshiredales.org.uk
Weathercall Yorkshire Dales forecast for today: ☎ 09065 200 617; websites: www.metoffice.gov.uk/weather and www.bbc.co.uk/weather

FIELD GUIDES & FURTHER READING

Birds: *Collins Bird Guide* is the ultimate bird book, but the Collins *Gem Guide Birds* is very handy and easier to use.
Flowers: *Collins Pocket Guide Wild Flowers* by Fitter, Fitter and Blamey, is one of the best.
Butterflies: *Butterflies of the British Isles*, J.A. Thomas, Hamlyn.
Fungi: *Collins Gem Mushrooms and Toadstools*, P. Harding.
Geology: *Yorkshire Rock, A Journey Through Time*, Richard Bell; *Yorkshire Dales Holiday Geology Map*, British Geological Survey.
Archaeology: *English Heritage: Yorkshire Dales*, Robert White
History: *The Story of the Yorkshire Dales*, W R Mitchell, Phillimore; *The Dales of Yorkshire – A Portrait*, Richard Muir, P R Books
Literature: *Yorkshire Dales: A View from the Millennium*, David Joy and Colin Speakman.

How to use this book

This book contains route maps and descriptions for 30 walks. Each walk is graded and areas of interest are indicated by symbols (see below). For each walk particular points of interest are denoted by a number both in the text and on the map (where the number appears in a circle). In the text the route instructions are prefixed by a capital letter. We recommend that you read the whole description, including the tinted box at the start of each walk, before setting out.

Point of interest denoted by a number in the text

Route instruction denoted by a capital letter in the text

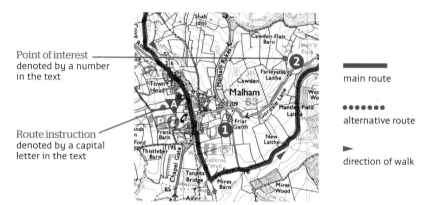

main route

alternative route

direction of walk

Key to walk symbols

The walks in this book are graded from 1–5 according to the level of difficulty, with 1 (green) being the easiest and 5 (red) the most difficult. We recommend that walks graded 4 or higher (or grade 3 (amber) where indicated) should only be undertaken by experienced walkers who are competent in the use of map and compass and who are aware of the difficulties of the terrain they will encounter. The use of detailed maps is recommended for all routes.

At the start of each walk there is a series of symbols that indicate particular areas of interest associated with the route.

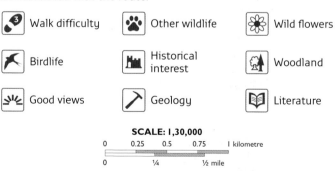

Walk difficulty

Other wildlife

Wild flowers

Birdlife

Historical interest

Woodland

Good views

Geology

Literature

SCALE: 1,30,000

| 0 | 0.25 | 0.5 | 0.75 | 1 kilometre |

| 0 | ¼ | ½ mile |

Please note the scale for maps is 1:30,000 unless otherwise stated
North is always at the top of the page

Ilkley Moor

START/FINISH:
Ilkley town centre, train and bus station, reached by trains and buses from Bradford and Leeds, and buses from Keighley and Skipton. There is a central pay and display car park

DISTANCE:
9 miles (14.5km)

APPROXIMATE TIME:
About 4½ hours

HIGHEST POINT:
1250ft (381m) on Black Hill, immediately before Windgate Nick

MAP:
OS Explorer 297, Lower Wharfedale & Washburn Valley

REFRESHMENTS:
Take enough food and drink for a day's outing; if White Wells is open – near the start of the walk – drinks and light refreshments are available; there are many cafés, pubs and restaurants in Ilkley

ADVICE:
Parts of the walk are rather exposed and rough in places, though mostly on good tracks

LANDSCAPE/WILDLIFE:
Features of millstone grit scenery; dragonflies and damselflies; bilberries and heather in July and August

Ilkley is well known for the folk song On Ilkla Moor Baht 'At, thought to have been composed by a Sunday School party visiting the moor. Hatless or not, this exhilarating walk takes you along the edge of Ilkley Moor, with wonderful views of Wharfedale. The route visits prehistoric rock carvings, rocks carved by nature and some half-hewn millstones. It passes along Addingham Moorside, a collection of old farms and cottages and descends through fields to the banks of the beautiful River Wharfe, with a pleasant stroll back to Ilkley.

1 Ilkley 117 477

Ilkley was founded by the Romans who constructed a fort on the site where the parish church now stands – and left the name Olicana. In late Victorian times, Ilkley grew into an important spa town. The railway arrived in 1865, and many fine spa buildings and gentlemen's residences were built. At the top of Wells Road is Hillside where Charles Darwin stayed when he came for the water cure at Wells House.

A From Ilkley Station Plaza, start off up Wells Road – between bank and estate agent – to pass Rombalds Hotel on the left and Darwin Gardens on the right, while the white-painted cottage of White Wells shows up ahead on the side of the moor. Immediately before the cattle grid go left along the

Approach to White Wells where spring water provided an early water cure

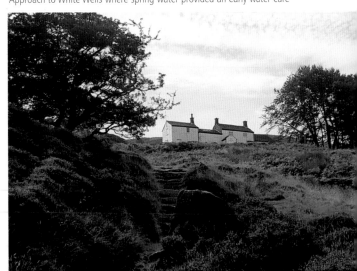

front of Hillside (finger post Dalesway Link), past the paddling pool, to climb steeply with the help of steps to White Wells.

Panorama Reservoir and view back to the Cow and Calf rocks

② White Wells and Ilkley Moor 118 468

White Wells was built by Ilkley's lords of the manor, the Middleton family about the 1790s. In late Victorian times people came here in numbers for the water cure and may have paid Donkey Jackson a penny or two to be carried up the hill. In modern times some hardy souls take a cold dip in the bath on New Year's Day.

Down to the left of the bath house is the Upper Tarn, where in late July and August, you will see a good variety of dragonflies, including the pretty little blue-tailed damselfly, common blue damselfly and emerald damselfly. The small and lively black darter (the male is black and yellow), and common hawker, a large and beautiful dragonfly, also breed here.

Wells House, the large building facing as you look towards the town, was one of the bigger hydropathic establishments. Besides Darwin, whose 'Origin of Species' was published during his stay in the autumn of 1859, the actress Ellen Terry was also a visitor, having written one of her famous letters to

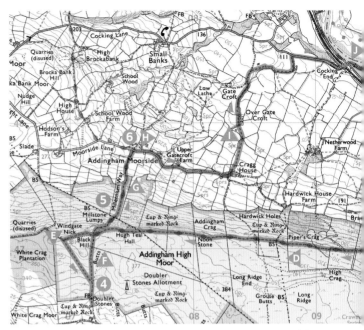

playwright George Bernard Shaw from Wells House. More recently the home of Ilkley College, the listed building is now converted into luxury apartments.

B From White Wells join the broad vehicle track past Willy Hall Spout, a waterfall that only shows much action after heavy rain and 30yds (25m) beyond, turn off on a narrow path to continue in the up-valley direction. Cross the Keighley road, keeping the houses on the right and the partly bracken-covered moor to the left. At the wooden gate you are entering a monitored reserve. High up to the left is Silver Well Cottage, the former moor ranger's house, then on the right is Panorama Reservoir.

C Cross a small wooden footbridge over Hebers Ghyll, immediately after which, cut up steeply to the left, negotiating some large rocks, to an iron kissing gate on a higher track. The route now follows westwards all along the edge of the moor for almost 2 miles (3.2km) to Windgate Nick. But first stop at the Swastika Stone, which is marked by its iron railing.

3 Swastika Stone 094 468

Ilkley Moor is now a Site of Special Scientific Interest (SSSI) and noted for its purple heather in August, for bilberries in July, its

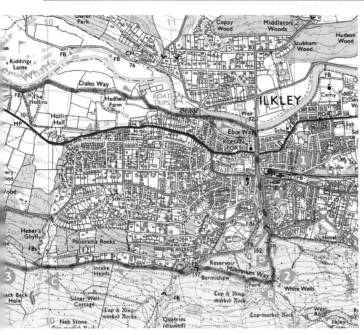

moorland birds, including merlin, dunlin and golden plover, and most of all for its prehistoric 'cup and ring' stone carvings of Neolithic to Bronze Age – about 4,000 to 3,500 years old.

The famous Swastika Stone carving lies on a large slab overlooking the Wharfe Valley and is surrounded by an iron railing. The design has affinities with Celtic art, and dates from the 4th Century BC. It forms a kind of looped swastika or cross with four curved arms and is thought to represent fire. The original carving is the fainter one behind its Victorian replica.

Millstone Lumps near Addingham Moorside

One of the Doubler Stones on
Addingham High Moor

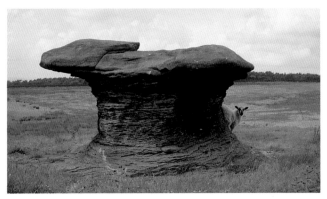

From the edge of the moor there are outstanding views of
Wharfedale, with Almscliffe Crag to the far right, Beamsley
Beacon immediately opposite, just 3½ miles (5.6km) away
and, high up Wharfedale, the peaks of Buckden Pike and
Great Whernside can be made out on a clear day.

D Continue on the trail from the Swastika Stone past the
copse of larches where the Sepulchre Stone stands. Pipers
Crag is the flat, overhanging rock along the route. Cross two
stone walls beyond this and some 30 paces down to the right
is Piper's Crag Stone, with beautifully displayed cup and ring
carvings (see photograph on p.6). The Noon Stone is about ½
mile (800m) further on, soon after which you find you are
walking through open heather terrain. In the distance to the
left is Airedale, and a view of a couple of dozen wind turbines
on Ovenden Moor near Halifax.

E The highest point on the walk is known as Black Hill, at
1250ft (381m), and has a seat with a fine view northwards
across the valley. At the end of the moor edge is Windgate
Nick where a track from Addingham cuts through the ridge
from Wharfedale to Airedale, a good spot for a picnic. Turn
left and squeeze through the wall stile and, heading in a
south-south-east direction, make for the Doubler Stones.

4 Doubler Stones 075 465
These impressive mushroom-shaped rocks stand isolated on
a rocky edge. They are formed of hard gritstone with a softer
layer nearer ground level, and carry one or two cup marks.

F From the Doubler Stones, return to the wooden gate, and
take a different path, aiming due north and left of the stone
grouse butts – and into heather again – to a fine stile in the
wall. Keeping in the same direction, cross the path you came

along (to Windgate Nick), and descend through the Millstone Lumps quarry. Over to the left of the quarry, lies an incomplete millstone half-hewn out of the rock.

⑤ Millstone Lumps 075 474

At the quarry known as Millstone Lumps, millstones have been quarried and masoned since about 1650. Quarrying ended abruptly in about 1800. The stones were worked on-site and lowered on sledge routes, like the sunken track from Windgate Nick to Addingham. Millstone Lumps is now a protected geological site. If you search around you will see a dozen or so millstones widely scattered about in the bracken, many unfinished.

G▷ From the quarry, bear right on a rough path down to a ladder stile over a high wall. Extra care is needed on this path. Over to the right in the next field is a perfect millstone. From the stile, go down the centre of the field, follow a wall to a narrow stile at its bottom left corner and on to Moorside Lane.

⑥ Addingham Moorside 076 478

This scattered village is composed of a string of old stone farmhouses dating from at least the 17th Century. Lumb Beck Farm has been rebuilt in recent times but still has the fine door dated 1670. Cragg House has a door lintel dated 1695, while Upper Gate Croft is late 16th Century with later alterations. Overgate Croft is a 17th Century farm.

Around Lower Gate Croft there are magnificent specimens of giant hogweed which, in July, grow to 12ft (3.5m) with flower heads 2ft (60cm) across. This member of the parsley family contains a volatile substance that sensitises the skin especially in bright sunshine and can lead to bad blisters, so treat it with respect. In the sunken packhorse lane, there is a mass of wild flowers and grasses, including tufted vetch, quaking grass, wild strawberry, white bryony, and giant bellflower.

H▷ Turn right along Moorside Lane for about 600yds (545m), passing Upper Gatecroft Farm, which in the 1680s was licensed to hold Quaker meetings in the porch. Before the large working farm of Cragg House turn left through a gate (with yellow arrow) set back from the road and down an old field boundary.

I▷ Continue to Overgate Croft where the right of way goes down the side of the sunken lane. Rejoin the broad track and, by two fine elms, branch right in front of a ruined barn,

Ilkley Old Bridge, for pedestrian use only

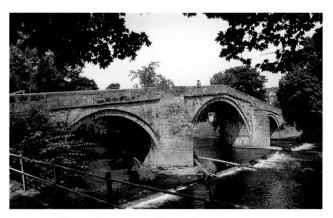

Plumtree Banks Laithe, keeping adjacent to the wall on the right, to the stream crossing. Follow the right-hand edge of the field all the way round to a gate onto Cocking Lane. Turn right down the road to the A65. Cross with care and go down through the trees to the old road, then left and acute right to the riverbank.

⑦ River Wharfe 095 484

This stretch of riverbank is a great place for natural history. Most of the river birds can be seen in the spring and summer (pied and grey wagtail, dipper, moorhen, heron, oystercatcher, common sandpiper and sand martin), though you would be lucky to see them all on one visit. Further back in the trees in Hollins Meadow you may hear the sweet song of the blackcap and the 'weet' call of the redstart.

In summer dame's violet and Himalayan balsam decorate the riverbank, while the damp pasture is a pink mass of ragged robin, together with clumps of yellow St John's-wort. Butterflies include orange tip, holly blue and green-veined white in May, common blue in June. Small skipper, a tiny brown butterfly, can be in abundance in July and August, with the more easily recognisable peacock and small tortoiseshell.

▷ At the river, turn down stream, across Hollins Meadow and a short walled section then, via iron kissing gates, through the fields to Ilkley Lawn Tennis Club. The route regains the riverside and the path emerges at the Old Bridge. Just before the bridge, look for dates and levels carved on the wall on the right. The elegant stone bridge over the river was built to replace one destroyed by a flood in 1673. Continue through the Memorial Gardens to New Bridge to return to Ilkley town centre.

Swinsty

This short walk lies in the heart of the Washburn Valley, a quiet tributary dale of Wharfedale with four reservoirs, open stretches of water that enhance the beauty of the area. The route passes the historic building of Swinsty Hall, crosses Swinsty dam and follows the riverside for a while before climbing to the little village of Timble.

1 Swinsty Reservoir 195 537

Swinsty reservoir was completed in the 1870s, along with Fewston and Lindley Wood, to bring water to the heart of Leeds. The water that runs off the millstone grit is soft and has been particularly valuable in the textile industry, especially for washing greasy wool. In 1850, civil engineer John W Leather of Leeds examined the water and, finding it 'the most beautiful, pellucid water', prepared a scheme for Washburndale. Another 12 years passed when, following a water shortage, engineer Edward Filliter finally recommended the 'four reservoir' scheme, Swinsty being finally completed in 1876. The fourth one at Thruscross was only built in 1965.

A mixed woodland near the lake is now a nature reserve with a display of foxgloves in the summer. In October there is a wide variety of toadstools in the woods, including fly agaric, the bright scarlet mushroom with white spots – a dangerously poisonous species. Fishing is limited to the lower end of the lake to give water birds in the reserve a chance to

Swinsty Hall, rebuilt in 1577

START/FINISH:
Swinsty Moor picnic site and car park (SE 187537) is provided by Yorkshire Water. Take Newall Carr Road, in Otley, straight up the hill from Otley Bridge, and turn right at the sign for Timble, then left before the village. The car park and picnic area is on the right just before Fewston Reservoir dam. A pleasant area with picnic tables, toilets and facilities for the disabled.

DISTANCE:
4½ miles (7.2km)

APPROXIMATE TIME:
2½ to 3 hours

HIGHEST POINT:
Timble village at 740ft (225m)

MAP:
OS Explorer 297, Lower Wharfedale & Washburn Valley

REFRESHMENTS:
Timble Inn (towards the end of the walk) provides meals and refreshments

ADVICE:
In winter and after rain be prepared for muddy stretches

LANDSCAPE/WILDLIFE:
Canada goose, goosander, tufted duck, great crested grebe; foxglove, hemlock, water dropwort, fly agaric

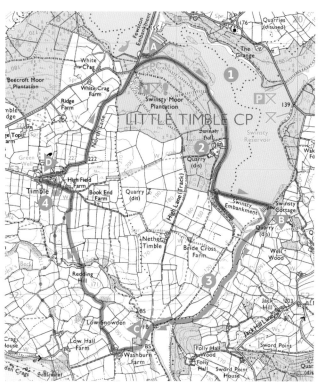

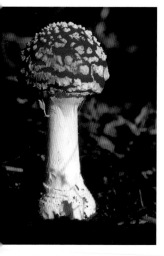

The poisonous toadstool,
Fly Agaric

feed and breed undisturbed. The most obvious are the resident Canada geese, large birds with a white face patch. They feed on grass and nest on adjacent moorland. There may be a few goosander, a large duck with narrow bill, and the smaller tufted duck with a white patch on its side; and there is usually a great-crested grebe present. In winter look out for golden eye, a black and white duck with a white spot near the base of the bill. The grey heron may be about on the water's edge or below the dam.

A On leaving the picnic site at the main entrance, turn immediately right along the unmetalled track through the forest. Pass Swinsty Hall on the right and turn left along the top of Swinsty embankment.

❷ Swinsty Hall 193 532

Swinsty Hall was rebuilt in 1577 for Francis Wood who, 20 years later, fell into debt, so it is said, which resulted in his Lancastrian moneylender, Henry Robinson, taking over the hall. The Robinson family lived here for the next 300 years, investing in the woollen industry. The hall is little altered

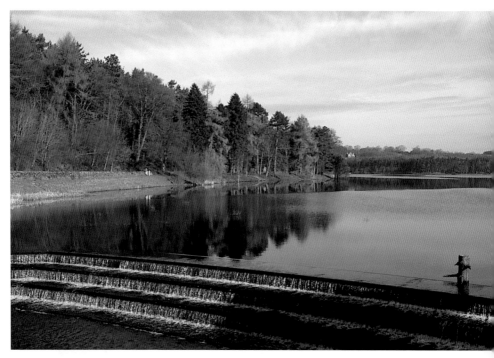

since Elizabethan times. The roof timbers are fastened by oak pegs, without a single nail. Recently, the gardens have been landscaped with added statuary, enhancing the setting.

Swinsty Reservoir. The dam was completed in the 1870s

▶B At the far end of the dam, pass through a gate on the right to keep high to the left on a path along the edge of a pine wood and down to the River Washburn. Follow the normally slow-moving stream for ½ mile (800m) to cross to the other side by the broad gated bridge. About 15yds (140m) further down stream cross Timble Gill Beck, where the former miniature packhorse bridge (Adamson Bridge) once stood.

③ Washburn Valley 192 521

Along the track below the dam you may disturb a green woodpecker, a colourful bird, green with red crown and yellow rump. They feed on the ground looking for insects, especially ants, or even worms or seeds. This part of the Washburn with scattered trees and open spaces is good redstart country. This summer visitor with the reddish tail gives itself away by its 'weet' call. On the river look out for grey wagtail and dipper. In winter, the alders attract redpoll and siskin, and the small birds in turn attract the sparrowhawk, which may

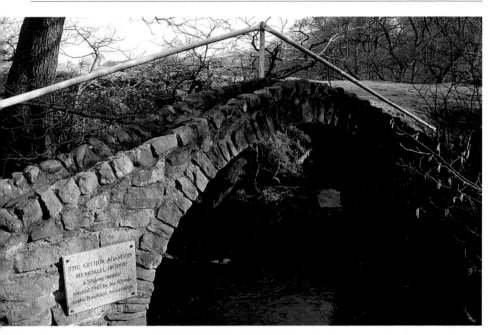

The Arthur Adamson memorial bridge was washed away in June 2009

swoop in unexpectedly. The great spotted woodpecker nests along here. In the River Washburn grows the most poisonous of all flowering plants, an umbellifer known as hemlock water dropwort.

The bridge built in 1967 in memory of Arthur Adamson (Leeds Alderman and Rambler) was washed away during a cloudburst on 22 June 2009. The beck is still fordable. This bit of Timble Gill has an interesting story to it. When Swinsty reservoir was flooded, it submerged Newhall, a house bought by the poet Edward Fairfax in 1579. He lived there from 1600 until his death in 1632. Apart from his poetry, in 1621 he published a work entitled 'A Discourse on Witchcraft, as it was acted in the Family of Mr Edward Fairfax of Friestone' [Fewston]. He claimed that his daughters fell ill under a spell of witchcraft, and blamed local women who gathered in a witches' coven just here at the foot of Timble Gill. Six women were tried at York assizes in 1622 but were released with the support of the vicar of Fewston and others.

▷ After crossing Timble Gill Beck, climb the steep bank, leaving the river (and Timble Gill), and go along the lower side and up the far end of a small wood to Washburn Farm. Enter the farmyard and turn right, round a stone barn to continue first along a path with a wall on left, then down, and up left

through a gate on a well graded track, curving to the right, round the dome-shaped Redding Hill. The path is waymarked with yellow arrows and at the end of a wall crosses Timble Beck, hidden in a gully in the trees. It climbs through fields to join a narrow walled footpath which leads to a wider lane. At the top of this lane, turn left into Timble village.

④ Timble 180 529

Timble village spreads along a hill top ridge and many of the houses face south. Highfield Farm is one of the first you pass as you enter the village. It was built and lived in by John Dickinson (1844–1912) whose personal diaries survived and have been published under the title 'Timble Man, Diaries of a Dalesman' – a fascinating insight into the pattern of rural life of the area. Timble Inn is at the centre of the village and opposite is the Robinson Library, built in 1891, also by John Dickinson. The library is named after a descendant of the Robinsons of Swinsty Hall, Robinson Gill, who emigrated to America, opened stone quarries on the Hudson River and became the president of two New York banks. His memorial library cost him £860 and he spent £100 on books purchased in Leeds.

▶ In Timble, stay on the tarmac, turning right at the top of the village, to pass the library and Timble Inn. Continue along the narrow road, and down the hill back to the picnic site.

Cottages in Timble

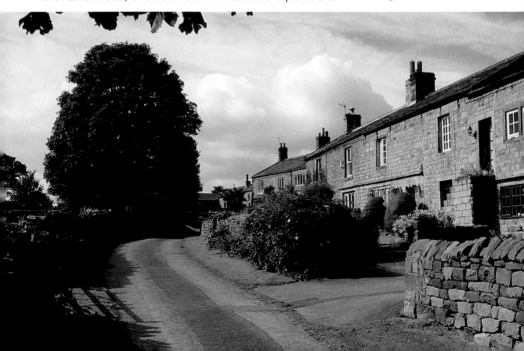

Simon's Seat

START/FINISH:
Barden Bridge SE 052574 is just off the B6160 2 miles (3.2km) north of Bolton Abbey. Free parking by the river. Bus services 74 and 874 run daily from Ilkley

DISTANCE:
9 miles (14.5km)

APPROXIMATE TIME:
About 5 hours

HIGHEST POINT:
1591ft (485m) at the rocky summit of Simon's Seat

MAP:
OS Explorer OL2, Yorkshire Dales, Southern & Western areas

REFRESHMENTS:
Restaurant and tea terrace (closed in winter) at Barden Tower, by Barden Bridge. Tea rooms at Cavendish Pavilion, 2½ miles (4km) after the start

ADVICE:
A full day out to one of the highest points in the area. Much of the walk is in Bolton Abbey Estate's moorland 'access area' where no dogs are allowed. On grouse shooting days or when there is danger of fire, the path may be closed to the public

LANDSCAPE/WILDLIFE:
Features of millstone grit scenery, waterfalls, terminal moraine, abundant wildlife

There is a bit of everything in this splendid circuit. One of the finest stretches of the beautiful River Wharfe includes the Strid where it narrows to little more than a stride, the surrounding woods, rich in wildlife, the hidden dell and waterfalls of the Valley of Desolation, and grouse moors leading to the towering rocky summit of Simon's Seat.

① Barden Tower 051 572

Barden Tower, now a majestic ruin, was built from 1485 to 1523 by Lord Henry Clifford, known as the Shepherd Lord. During the War of the Roses, young Henry Clifford's father was killed in battle, and the boy was taken by his mother to be secretly brought up by shepherds in the Lake District. He returned after 25 years to build his new residence at Barden. In 1513, when 60 years old, Henry Clifford led a troop of men from Wharfedale against the Scots at the battle of Flodden Field in Northumberland. Fifty years later, Lady Anne Clifford rebuilt Barden Tower (one of her many castles) and stayed there in 1663.

The bridge at Barden is one of the most beautiful in the Dales. The large graceful arches that carry the narrow roadway, and the angular cutwaters are most impressive. An inscribed stone, now hardly legible, states: 'This bridge was repaired at the charge of the whole West Riding, 1676'. The former bridge was destroyed in the great flood of 1673.

Barden Tower was rebuilt by Lady Anne Clifford in 1663

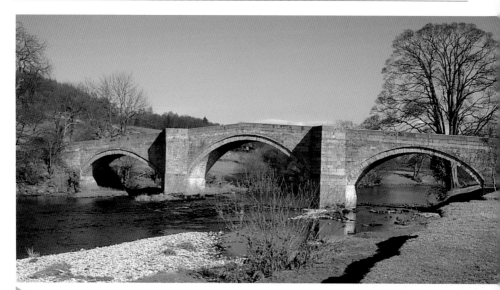

Barden Bridge, a popular stopping place

Ⓐ Follow the right bank down stream to the fine 19th Century, battlemented aqueduct which brings water from Nidderdale to supplement Bradford's supply. Keeping to the right bank, enter Strid Wood, an SSSI for its flowers and birdlife. The river narrows as it runs over a rocky bed, passing first the Upper Strid then The Strid itself.

❷ The Strid 067 562

The river Wharfe becomes so narrow, it is possible to 'stride' across it. It also becomes very deep, up to 25ft (8m) where it surges around and widens below the water. The physical action of the river can be seen in the pot-holing effect in the bedrock where stones are swirled round in the current, becoming rounded and grinding a deep hole. It is potentially dangerous and, over the years, several people have been drowned here, the first recorded victim being the handsome 18 year old, the Boy of Egremont, (named after his Cumbrian estates). He was the son of Alice de Romille who married the son of Malcolm, king of Scotland, the murderer of Macbeth. On a stormy day while out hunting, the Golden Boy was pulled back by his hound just as he was making the leap across the Strid. His foot slipped and he was sucked under by the surging torrent. The legend and story, made famous by Wordsworth, goes on to say that, in memory of her son, Alice de Romille gave the land and means for building Bolton Priory.

In early summer, Strid Wood is rich in wild flowers, with masses of bluebells, bunches of red campion, stretches of

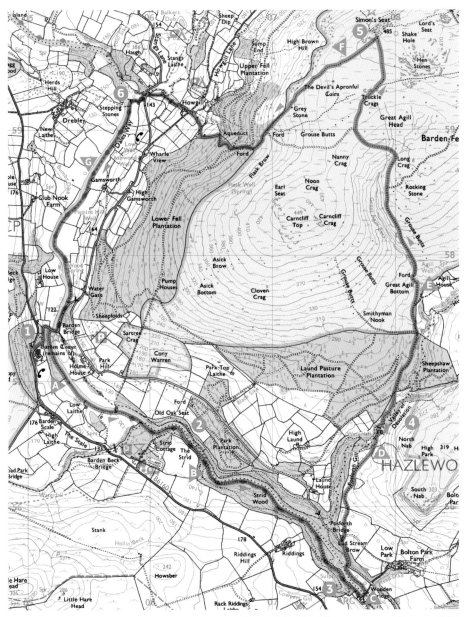

wild garlic and spikes of bugle. There are wood cranesbill, sweet woodruff, wild arum and yellow pimpernel. If you have a good ear for birdsong, among the willow warblers, wrens and blackbirds, listen for the high trill of the wood warbler and the clear warbling notes of the blackcap. In spring you may

catch sight of the pied flycatcher and, through the year, the nuthatch and tree creeper. Roe deer are common in the woods.

B From The Strid, the broad path continues to follow the river until it reaches the Cavendish Pavilion where there are toilets, café and a shop.

❸ Cavendish Pavilion (off map 077 552)
The name is in memory of Lord Frederick Cavendish, son of the 7th Duke of Devonshire who, in 1882, was murdered in Phoenix Park, Dublin, only hours after being appointed Secretary of State for Ireland. The gothic memorial to Lord Cavendish stands by the road near to the Priory.

Across the river from the Cavendish Pavilion and 220yds (200m) upriver, limestone outcrops on the riverbank. The strata have been strongly folded and the beds appear vertical at this point. Round the corner and facing upstream is the hidden entrance to Dob Stream Cave, a trial adit for lead ore, but a safe horizontal tunnel to explore.

C Turn left over the wooden bridge and upstream along the far riverbank through the field. Go up to the road, continuing as far as the brow of the hill. Turn right here through the wooden gate and away from the river. This is one of the access points of Bolton Abbey Estate where the path leads through a parkland area planted in 1980 with 100 young oak trees by the Ramblers Association, a contrast to the ancient old oaks that are dotted about. A little higher, the track descends into the Valley of Desolation, an enchanting place on a sunny day.

❹ Valley of Desolation 080 569
The name comes from a violent storm that ripped through here in 1826 destroying many of the trees and leaving a desolate scene. You may still be able to spot one or two of the blasted oaks that survived. The sheltered and secluded valley is now a green and lovely vale where two waterfalls lend to its attraction. The lower one is a 50ft (15m) drop over gritstone, and along the beck of Posforth Gill are a few limestone boulders that have been etched and scalloped by the action of the acid waters running off Barden Fell.

If you pass through here in May, look out for the green hairstreak butterfly, a tiny thing that looks like a bit of brown paper fluttering about. When it settles it becomes a metallic green, almost disappearing amid the greenery. In full

Posforth Gill Falls in the Valley of Desolation

Primroses in the Valley of Desolation

summer there are small coppers, slightly larger but unmistakable by their bright orange wings. An interesting plant along the wayside above the wooden footbridge is the giant horsetail. They often indicate a calcareous spring and are related to the tree-size specimens of 300 million years ago of the Coal Measure forests.

On the higher parts of Barden Fell, the heather covered moorland is home to the red grouse. Other moorland birds include an elusive small falcon, the merlin, which feeds on meadow pipits, skylarks and twite. You may also be fortunate enough to see a short-eared owl, or a red kite of which a small number have been released in the area.

D Descend at the first opportunity into the Valley of Desolation to cross Posforth Gill by a new footbridge, ascending the far side of the falls and along past a second footbridge. Take the left fork to continue the walk, but a diversion ahead leads to the upper falls, a quiet spot for a picnic. The route, from the fork, leads out of the valley via a ladder stile and a forestry track through the woods to come out onto the open moorland of Barden Fell. Continue to Great Agill Beck.

E After crossing Great Agill Beck (another picnic spot) the route gradually gains height along a well constructed track, surfaced with limestone and suitable for grouse-shooting parties in August and September. It passes a stone table on the left and, higher up, weaves between Truckle Crags and Hen Stones to reach the highest rocky crags of Simon's Seat, with a survey pillar on the top.

5 Simon's Seat 079 597

The steep rocky crag holds a wonderful panorama of the surrounding area, and a surprise view down to Skyreholme as you climb up to the topmost point. In the distance is Grimwith Reservoir with the dark rocks of Fancarl Crag below it. Nearer to are Trollers Gill and Parceval Hall. To the left is Barden Moor and Barden Reservoir. On a clear day you can see Pendle Hill.

Simon's Seat

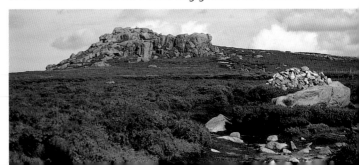

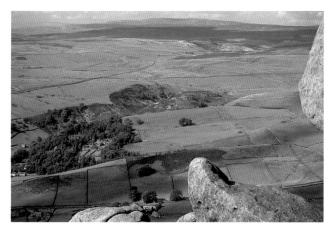

View from Simon's Seat with Parceval Hall, Trollers Gill and Grimwith Reservoir

Across the river at the foot of Simon's Seat is the Drebley terminal moraine, best seen lower down the track. Towards the end of the Ice Age, the snout of the Wharfe glacier remained stationary here as it pushed boulders and clay into a heap across the valley, damming it completely. The river has since cut a gorge through the mound, and the Drebley stepping stones are situated below it.

From Simon's Seat, follow the Howgill footpath sign along the margin of the moor in a south-westerly direction. The track turns steeply down to the right to descend the wooded hillside to Howgill, and walled path to the road. Cross the road to continue by farm buildings to gain the riverbank near Drebley steppingstones.

⑥ Drebley Stepping Stones 058 591

You may have to look out for these among the trees. They are in good shape and have been well used, but are not on our route. They link the hamlets of Howgill and Drebley. The nearest bridge is at Barden, over 1 mile (2km) downstream.

The riverbank from Drebley to Barden is good for birdwatching, especially in the spring. Sand martins nest in sandy banks and swallows fly over the water. The common sandpiper is well camouflaged but its piping call and the way it flicks and glides over the water will give it away. Look out also for reed bunting, great spotted woodpecker or kingfisher along this stretch. Goosanders also frequent the river.

The riverside footpath is easy to follow as it hugs the left bank of the River Wharfe before joining the road leading to Barden Bridge and the end of the walk.

Trollers Gill

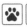

Appletreewick is an attractive Dales village with a good deal of historical interest and this short, interesting walk includes a lovely stretch of the River Wharfe, and goes on to explore the impressive narrow limestone gorge of Trollers Gill and its leadmining area. The upland limestone pasture is good for moorland birds.

1 Appletreewick 054 601

Locally pronounced 'Aptrick', this delightful south-facing village on a limestone hillside has some pretty stone cottages, and boasts four 'halls', two pubs and a Lord Mayor of London. Monk's Hall was once a grange of Bolton Priory and High Hall, with a minstrel's gallery, was built by Sir William Craven. William was born in a small cottage here in 1548 and sent to London on the back of a cart, to be a draper's apprentice. When he reached the age of 50 he became Lord Mayor of London, after which he returned to his home village. His son distinguished himself as a soldier and married a princess, the sister of Charles I, to become the first Earl of Craven.

In the 18th and 19th Century, Appletreewick became a leadmining village and several miners' tracks and green lanes spread out from here to the old leadmines of Trollers Gill, Dry Gill and Greenhow.

Monk's Hall, Appletreewick, was once a grange of Bolton Priory

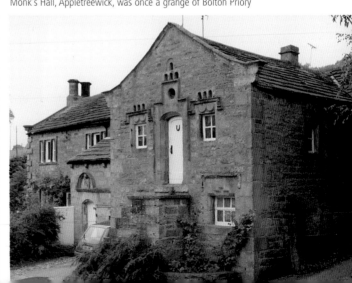

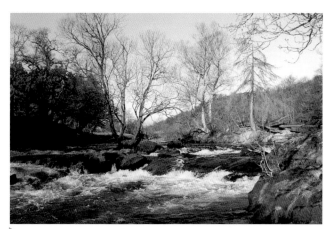

River Wharfe below
Appletreewick

A Walk out of the village towards Burnsall (west) past the two inns and, past the farm of Low Hall. Continue to the caravan site and pick up the path to the riverside. Follow the river downstream and into a deep wooded gorge.

❷ River Wharfe 055 596

Except after a particularly severe winter, a breeding pair of kingfishers may be found every mile or so along the dale. The great spotted woodpecker also inhabits this area. In the autumn the hips and haws in an extensive bushy area attract flocks of blackbirds, redwings and fieldfares. Below the gorge, listen for the high pitched song of the goldcrest in the larches, or look for the long-tailed tit in the alders.

B On reaching the road, turn left for about 110yds (100m) past a former Methodist chapel, and cross the stile on the right, signposted Skyreholme. This brings you onto a ridge with a splendid view. Skyreholme Beck, having descended from Trollers Gill, runs in the deep valley to the right, and the slopes beyond lead up to Simon's Seat. At the farm, join the road again, passing through Skyreholme.

C Walk along the road through this scattered village and turn right over Skyreholme Beck then left, taking the field path, signed Parceval Hall. The path soon comes out onto the lane (with Parceval Hall and tea room to the right).

❸ Parceval Hall 069 612

Parceval Hall, is a 17th Century residence, dated 1671, the finest in Wharfedale. The lovely gardens are open to the public in the summer months.

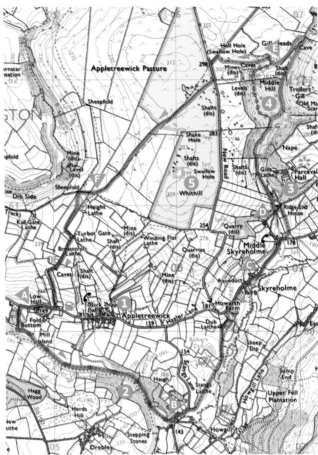

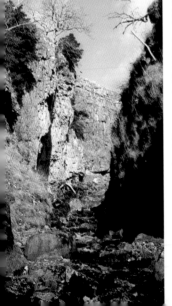

Trollers Gill where you might see the spectre hound of Craven

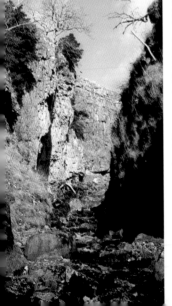

D▶ At the lane, left and right turns lead up the left side of the beck signed to Gill Heads and New Road. The path passes Skyreholme dam, which once supplied water for a paper mill in the village. The dam burst in 1899 and was never repaired. Nearing Trollers Gill, ignore the path up the valley to the left and keep straight on. The scenery is dramatic and you pass one or two strong springs of clear water, before entering Trollers Gill. Walk up the gorge as far as the ladder stile which takes you away from the beck and up to the left. Follow the marker posts, join the track and turn left for 220yds (200m) for an optional visit to Gill Head Mine.

④ Trollers Gill 068 618

Near the junction of valleys (and paths), the steep banks are spectacular in the spring when dotted with the pink flowers of

Gill Heads looking towards the
old leadmine

dovesfoot cranesbill and, in early summer, as yellow
rockroses and hawkweeds take over. This is a sheltered spot
for butterflies and, in July or August, you may see common
blue, small copper, meadow brown, small skipper and green-
veined white. The gatekeeper, an orange and brown butterfly,
rare in Wharfedale is also present.

Impermeable rock not far beneath the surface forces the
water to break out here in strong springs where wild
watercress grows. Trollers Gill is an impressive miniature
gorge cut into the Great Scar limestone – about 330yds
(300m) long, and on the right is the old mine entrance of Nick
Level. In the stream bed you may find lumps of crystalline
calcite, a white milky mineral that splits into 'rhombs' like a
cube knocked sideways. Although normally dry, the result of
water erosion is clearly seen in the undercutting of the
limestone.

There are one or two folktales about Trollers Gill. The
barguest, the spectre hound of Craven, is said to have a cave
in the gill. Once a cobbler from Thorpe lost his way here and
saw the huge shaggy beast with yellow eyes as big as
saucers and thought his time was up. And then there are the
trolls that roll stones down...

Gill Head Mine was worked originally for galena, the ore of
lead, but in the 1970s was re-opened to obtain fluorite, used
in the steel industry. The line of the vein can be followed on
the hillside above the mine and on the slopes opposite.
Scattered about are fragments of fluorite, which have a
watery appearance and form cubic crystals; the heavier
galena, which also forms cubes is a bright silvery-grey when
freshly broken. Little vegetation grows on the mine debris

because of the poisonous presence of lead, except for the tiny white flowers of spring sandwort.

▶ Return from the mine and leave the track where it swings to the right to follow the marker posts. In the hollow on the right is Hell Hole, where a small stream disappears down a vertical shaft in the Great Scar limestone, 100ft (30m) deep. From the ladder stile onto the road, go left for 220yds (200m) to double wooden gates, to take the broad track to 'Hartlington' on the right.

⑤ Whithill 060 611

In spring and early summer, on the high limestone pasture, you may see the broad white wingbars of redshank in a rather erratic flight, adding a loud scolding call. Another bird which gives itself away by the sound it makes is the snipe; not a song, but a drumming created by air vibrating its tail feathers as it glides sharply downward. Other ground-nesting birds present are the golden plover and lapwing.

From here you can see the dark gritstone crags of Simon's Seat to the south and Fancarl Crag to the north. These form the two margins of the Skyreholme anticline, an upfold in the strata, which brings the limestone to the surface in Trollers Gill. Notice also the perched and erratic blocks of gritstone – abandoned at the end of the Ice Age.

▶ The limestone plateau of Whithill is the highest part of the walk and the good track eventually becomes a walled lane then, at the crossroad of footpaths, take the left one that winds down to Appletreewick. The track becomes walled, narrows and steepens as it ends at the village stocks by the Craven Arms.

Village stocks, Appletreewick

Mossdale Scar

Grassington is an attractive little town and the main centre for upper Wharfedale. The whole of the walk is on limestone – the Great Scar and Yoredale limestones – a case study of limestone scenery at one's leisure. Mossdale Scar, the aim of the walk, is a swallow hole and cave entrance, with a tragic history.

1 Grassington 002 640

Now a tourist centre, Grassington was formerly an important lead mining town and many of the houses and cottages have dated door lintels. A shop on Main Street was the smithy of Tom Lee, the murderer of Dr Richard Petty in 1766. After being hung in York, Tom Lee's body was brought to Grassington and hung in chains. Today, Grassington has a lively music festival in June, often joined by celebrities. The Upper Wharfedale Museum in the cobbled square has Dales' mining and farming displays.

Conistone village

On the slopes just above the town there is an area of 'Celtic fields'. If the sun is low, or there is a dusting of snow, you may be able to pick out the outlines of these Romano-British fields. They cover 150 acres (61ha) and form a network of small oblong field boundaries and rectangular huts.

START/FINISH:
Grassington, upper Wharfedale. The National Park Visitor Centre and car park is conveniently placed and there is another car park that avoids the busy town square. Buses from Ilkley (72) and Skipton (74) most days

DISTANCE:
12 miles (19.3km)

APPROXIMATE TIME:
5 to 6 hours

HIGHEST POINT:
1,410ft (430m) at Mossdale Scar

MAP:
OS Explorer OL2, Yorkshire Dales, Southern & Western areas

REFRESHMENTS:
Cafés, pubs and bakers shops in Grassington but, at present, none in Conistone

ADVICE:
Much of the walk is on exposed upland, but tracks are good and, being on limestone, mostly dry underfoot. There is one very short but manageable scramble at the top of Conistone Dib

LANDSCAPE/WILDLIFE:
Limestone scenery, gorge and pavements, fossils, galena, disappearing stream, reef knolls; northern brown argus butterfly; ferns, lily of the valley, heather, lapwing, skylark, curlew

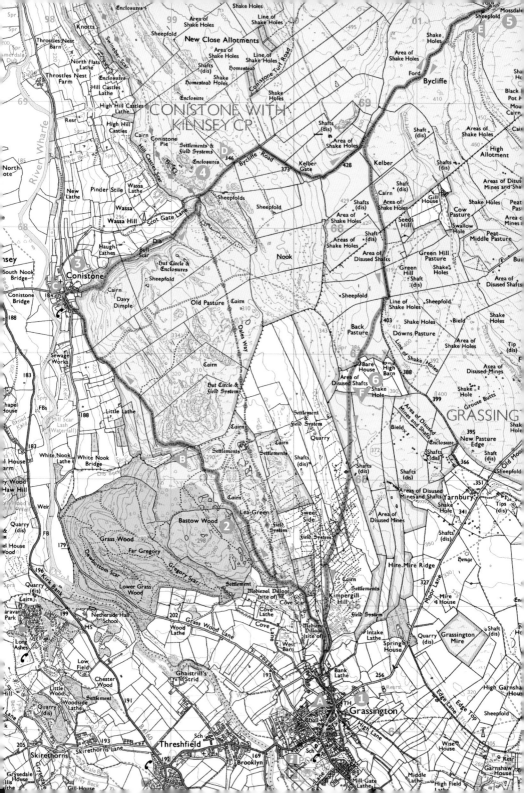

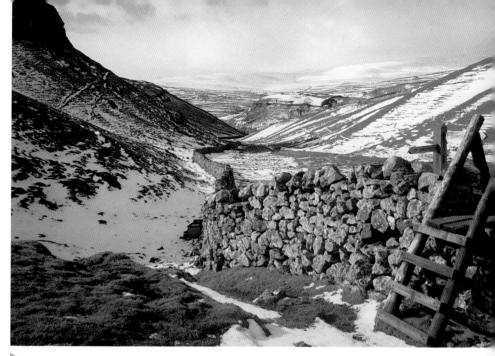

Looking down Conistone Dib

A From the cobbled square go up Main Street, past Tom Lee's 'smiddy', left along Chapel Street and at the end of Chapel Street turn right following the sign for the Dales Way and Conistone. Along the lane look for the Dales Way sign and follow it across fields. After three stone stiles, branch off to the left without dropping down too far, keeping above some bare limestone pavement, soon to come alongside a strong stone wall on the left. This is Lea Green and, where the path crosses a line of old mine diggings, there is the course of a lead vein.

② Bastow Wood 993 654

The Yorkshire Wildlife Trust reserve of Grass Wood, with Bastow Wood above it, is rich in flowering plants and wildlife and, in June, the wood is noted for its display of the sweetly scented lily of the valley. Among the butterflies in Bastow Wood is the diminutive Northern Brown Argus, a rare relative of the common blue.

B Go over the ladder stile and continue in the same direction on the left side of the wall. Cross the upper end of a dry limestone gorge known as The Dib, skirting round the far side of it, amid dramatic scenery. Turn away from the gorge to a view of Wharfedale to the west, across to Malham Moor and along to Kilnsey Crag to the northwest, on a fine path of short green turf. The wheel tracks lead you down to Conistone.

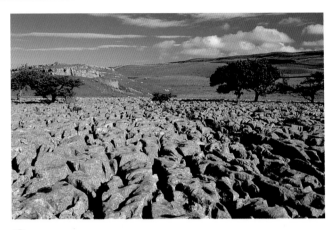

③ Conistone 674 981

Here is a very attractive village built on a gravel patch, above the valley flood level. The old farms, barns and cottages are haphazardly built around the small green, where the tall maypole stands. The Anglian name means 'farmstead of cows' and is mentioned in Domesday Book. Only a few years ago the village had a café, post office and shop, but now there is a horse riding centre. Above the village is some of the best limestone scenery in Wharfedale, with Conistone Dib, a fine example of a dry valley that narrows to a tight gorge near the bottom, known as Gurling Trough.

▷ Turn right at the village green in Conistone and up Conistone Dib – the last building is the former schoolhouse. The mini gorge soon narrows to about 2ft (65cm) at the narrowest and you can appreciate how water once surged down here as it carved it out. Continue ever more steeply to the top of this dry gorge to a short scramble in the last few feet. Mount the stile and turn left over some gritstone slabs, then through the gate. Climb up opposite the gate to see the limestone pavement.

④ Limestone pavements 991 684

At the top of Conistone Dib there is a stretch of remarkable limestone pavement. Incredibly, out of cracks (grikes), grow lone hawthorn and ash trees which accentuate the desolate, fretted rock surface. The scene may look deserted but in the cracks there are hart's-tongue fern and maidenhair spleenwort. Larger ferns include male fern, broad buckler fern and the delicate lady fern. On the far side of the limestone pavement is a well preserved limekiln.

▷ Continue up the track, and turn right on a track signed Middlesmoor, a village in Nidderdale. The double track gradually gains height and curves round to the left forging on across wide open moorland, with a shallow limestone scar on the right and heather covered moors ahead. This is Bycliffe Road, an old packhorse route to Nidderdale and leadmine track. The bearing for the final 1 mile (1.6km) is 40° from North, useful in mist. Mossdale Scar is the low limestone cliff at the foot of which the waters of Mossdale Beck rapidly disappear.

❺ Mossdale Scar 014 695

The Scar is a 50ft (15m) cliff of Yoredale limestone at the foot of which Mossdale Beck swirls and disappears completely. The water re-emerges 5 miles (8km) away at Grassington old mill to join the River Wharfe. The blocks of limestone here contain good examples of the large, thick-shelled brachiopod (or lampshell), gigantoproductus. The rock often shines like glass where acid water has etched it.

Many cavers used to visit Mossdale, and in his book 'Yorkshire Dales: Limestone Country', Tony Waltham describes the tragic event that occurred here on 24 June 1967 when six young and experienced potholers died in Mossdale Caverns. The small 1,000-yard long Marathon Passage acts as an overflow for the main stream and, because it is so small, can be rapidly filled to the roof with floodwater. The six cavers were on their way back along this tight crawl when, above ground, an intense rainstorm turned the beck into a raging torrent. The ensuing floodwaters rushed along the overflow to meet them, where they drowned. There is a gravestone in Coniston churchard with the men's names on it.

Dew pond near the track to Mossdale Scar

The track goes up to Mossdale leadmines where you can see mine tips and the former manager's house. Gravel for the road has come from the spoil heaps and contains good examples of galena – lead sulphide and the ore of lead.

E Return by the same route for 1 mile (1.6km), first fording Gill House Beck, and then nearing the large drystone wall on the right. At this point look for a small cairn where our route leaves the main double track and forks gently to the left, aiming due south. It crosses a tumble down wall, and the next broken wall contains beautifully weathered crinoidal limestone. The path passes an old mine shaft just before a ladder stile, and after crossing another vein with diggings and old bell pits, it turns into a short green lane, with a bench mark on the gate post. At the end of the lane cut across diagonally to a gated stile and aim for the roof and chimney stack, just visible, of Bare House.

⑥ Bare House 005 669

The abandoned farmstead of Bare House or Barras – the name comes from bargh-hus meaning hill farm – is a typical Dales longhouse with living quarters, animals and barn, all under one roof. This is good bird country with lapwings, skylarks and curlews adding their memorable songs to the moorland landscape. There is a view up Littondale to the right, of the limestone pavements above Conistone Dib below, and soon the line of limestone reef knolls beyond Grassington, which stand out against the darker, gritstone background of Thorpe Fell.

F From Bare House cross the field full of mole hills and pass an interesting old walled dewpond. The path continually cuts across walled pastures at an angle as it descends gradually to a walled lane, Town Head and Grassington Main Street.

Kilnsey Crag from Scot Gate Lane

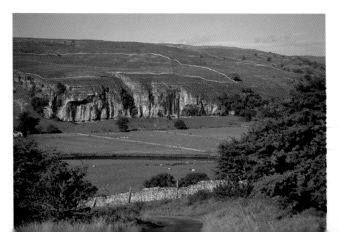

Buckden Rake & Yockenthwaite

Here is an old favourite that connects the village of Buckden at the head of Wharfedale with the small hamlets of Cray, Yockenthwaite and Hubberholme. It includes a section of Roman road on the incline of Buckden Rake and has outstanding views of the dale from a gallery footpath on a natural shelf of limestone along the 1150ft (350m) contour. Included is a visit to Hubberholme church and a stroll along the young river Wharfe, part of the Dales Way. This is an area of traditional hill farming and the walk is entirely on limestone.

① Buckden 942 772

The village is popular among walkers, with paths in all directions in a variety of beautiful scenery, Buckden Pike at 2,300ft (702m) being the highest point in the area. Buckden Rake is a surviving part of the Roman road that joined Ilkley in Wharfedale with Bainbridge in Wensleydale. Where it ascends through Rakes Wood, the road has been finely engineered – cut into the limestone on one side and built up on the other with an even gradient.

A Start at north side of the car park in Buckden by going through the wooden gate. The track maintains a steady climb of about 1 in 7 for the first ½ mile (800m) through

Gatepost, Buckden Rake, Upper Wharfedale

START/FINISH:
Buckden, National Park car park; Buckden is at the head of Wharfedale on the B6160. Bus service 72 runs from Skipton to Buckden, Monday to Saturday

DISTANCE:
7 miles (11.3km)

APPROXIMATE TIME:
3 to 4 hours

HIGHEST POINT:
1180ft (360m) reached soon after the start of the walk at the top of Buckden Rake

MAP:
OS Explorer OL30, Yorkshire Dales, Northern & Central areas

REFRESHMENTS:
In Buckden there are two tea rooms, a restaurant, the Buck Inn, and village shop. At Cray there is the White Lion pub and at Hubberholme, the George Inn

ADVICE:
Footpaths are generally good, some being maintained by the National Trust. There is good birdwatching, especially in the early summer

LANDSCAPE/WILDLIFE:
Limestone scars and pavements, underground river; early purple orchid, wood cranesbill, yellow pimpernel; wheatear, redstart, yellow, pied and grey wagtail, dipper, common sandpiper

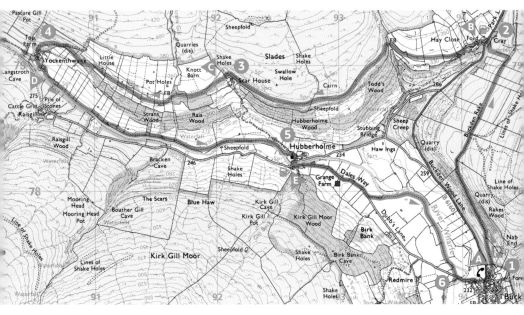

Rakes Wood. At the brow of the hill keep along the wall, passing though a gate with a big limestone boulder for a gate post. Turn left to drop down to the hamlet of Cray and stepping stones over Cray Gill.

2 Cray 942 793

In Cray the White Lion pub is the focus of a few scattered farm buildings where formerly a larger farming population lived. The road from here goes over to Wensleydale via Bishopdale.

Stepping stones and White Lion Inn, Cray

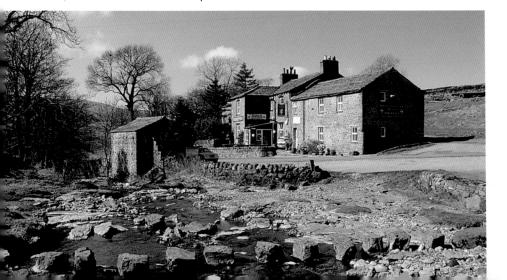

Scar House where there is an old Quaker burial ground

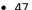 Continue behind the White Lion for a beautiful mid-level walk to Scar House, passing on the way a small barn with an arched door and a bridge over a narrow limestone gorge.

❸ Scar House 921 789
The present building is Victorian but the original Scar House was visited by George Fox in 1652 when he travelled through the north-west of England, convincing many Seekers to become Quakers. That year saw the beginning of the Society of Friends. Fox stayed here with the family of James Tennant who later died for his beliefs in York Castle. The Quaker burial ground at Scar House was the first piece of land owned by the Quakers. There are no headstones to mark the graves.

The path between Scar House and Yockenthwaite is known as the postman's walk. The ash wood on limestone is a remnant of ancient woodland hanging to the limestone scars – mainly ash mixed with hawthorn and hazel. The rich variety of plantlife includes early purple orchid, wood cranesbill and yellow pimpernel. Among the birds, summer visitors include wheatear and redstart with, occasionally, the yellow wagtail.

The delightful path continues past limestone pavements, through a small wood of pines and sycamores, across a miniature limestone canyon and descends to Yockenthwaite.

Yockenthwaite in Langstrothdale

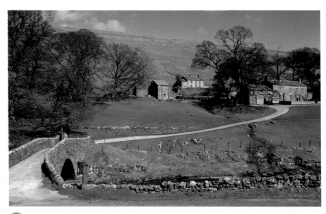

④ Yockenthwaite 905 791

The picturesque group of buildings and the graceful stone bridge have survived well. The river is often dry in the summer when the little water there is, flows below ground.

▶ **D** From Yockenthwaite, turn left to follow the left bank of the infant River Wharfe, following the Dales Way to Hubberholme.

⑤ Hubberholme 927 782

The dignified old church is well worth a visit and must be one of the most attractive in the Dales with a sturdy tower and broad low roof in a perfect setting by the river. It dates mainly from the 12th Century. The fine oak rood loft dates from 1558, and the oak pews were made in 1930 by 'Mouseman' Robert Thompson of Kilburn, his mouse trademark hidden in the woodwork.

Hubberholme was a favourite place of the writer and dramatist, J B Priestly, who wrote that it was 'the smallest, pleasantest place in the world', and whose ashes are buried in the churchyard.

The George Inn, once the vicarage, is still the scene of a candle auction, held on the first Monday of the New Year. It is for the lease of 16 acres (6.5ha) of grazing land, a 200-year tradition that raises money for the poor of the parish. The auction must be over before the candle burns out, but it is a festive occasion and serious bids don't come until the very last minute.

▶ **E** The route crosses the river at Hubberholme and follows the road down the valley for about 730m/800yds before

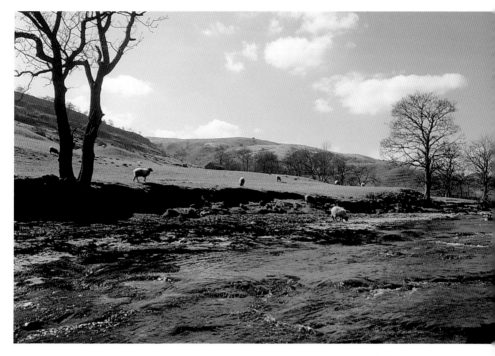

River Wharfe above Hubberholme

turning once again to the riverside. The path then returns to the road at Buckden Bridge, and back to the village.

⑥ Buckden Bridge 940 773

The bridge at Buckden replaces an old one that was washed away in about 1748, and is known as the 'election bridge' after a prospective Member of Parliament promised a new bridge to the people of Buckden if they voted for him. From it you may catch sight of pied and grey wagtails, common sandpiper and dipper.

The ashes of J B Priestly are buried in Hubberholme churchyard

Penyghent from Litton

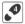 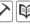

START/FINISH:
Litton is 9 miles (14.5km) north of Grassington, turning left off the B6160 beyond Kilnsey and through Arncliffe. Parking is limited – be careful not to cause inconvenience to villagers. ½ mile (800m) further up the dale there is an unsurfaced lane on the left which can be used; this is also a convenient place to start and finish the walk (cuts 1 mile (1.5km) off total distance).

DISTANCE:
14 miles (22.5km)

APPROXIMATE TIME:
6 to 7 hours

HIGHEST POINT:
2277ft (694m), the top of Penyghent, the least high of the 'Three Peaks'

MAP:
OS Explorer OL30, Yorkshire Dales Northern & Central areas; OS Explorer OL2, Yorkshire Dales, Western & Southern areas; the walk overlaps the two sheets

REFRESHMENTS:
In Litton, The Queens Arms

ADVICE:
The longest walk in the book, but many of the tracks are good, making for easy walking; even the steep ascent is split into shorter bursts. In wet conditions the path coming down off Plover Hill is boggy

LANDSCAPE/WILDLIFE:
Panoramic views, golden plover, raven, purple saxifrage

The main aim is the ascent of Penyghent, the most distinctively shaped of the Three Peaks, but there is more to this walk than just a straight up and down. Littondale is a beautiful, unspoilt valley – flat-floored and steep-sided, a typical glaciated shape. The valley sides climb in steps as the Yoredale strata change from limestone to shale and sandstone. The southern nose of Penyghent shows this to the best effect and the summit is capped with the first layer of Millstone Grit, from where on clear days there are tremendous views.

① Litton 905 741

The hamlet of stone cottages, mostly 18th Century, has a pub, the Queen's Arms, and a post office. There used to be a school, but no church or chapel. A low hollow nearer the river was once a cock-fighting pit. The River Skirfare is not always to be seen since, over the limestone, the water finds an underground route. However there is a powerful spring nearby which gives the village a good water supply.

The barns at Spittle Croft, just across the river, were once the site of a monk's rest house or hospice that belonged to Fountains Abbey. A story is told of buried treasure here, left by a farmer who lived at Spittle Croft and minted coins in an underground room.

Farm at Nether Hesleden

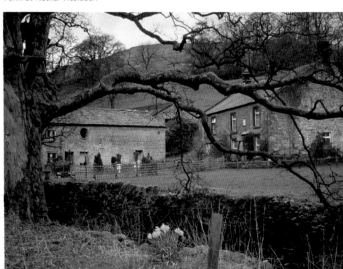

The valley to Foxup has both river and moorland birds. There are curlews, lapwings, wheatears, oystercatchers and black-headed gulls. From February to October you will hear the call of the curlew on any part of the walk, as the thrilling liquid notes and bubbling trill pour from this elegant bird.

Hamlet of Halton Gill from the bank of the River Skirfare

A From the village green go down to the footbridge over the – mostly dried-up – river and across the fields to the barns of Spittle Croft. Continue along a green lane in the up-valley direction to a stone bridge. (This is where the lane comes in from the road and a possible parking place.) Keep as near as possible to the river, ignoring the track up the hill to the left, which is the return route. After passing a series of field barns, approach Nether Hesleden farmhouse, with a first view of Penyghent. Cross Penyghent Gill, following the signs to Halton Gill and Foxup. The path turns away from the farmhouse and continues through the fields to Foxup, with views of Halton Gill neatly tucked in at the foot of Horse Head Moor.

❷ Foxup 872 767

The two streams of Cosh Beck and Foxup Beck come together here to make the River Skirfare, and the road up Littondale comes to an end. The farmhouses are picturesquely situated overlooking the beck, each being connected by its own stone bridge to the front door.

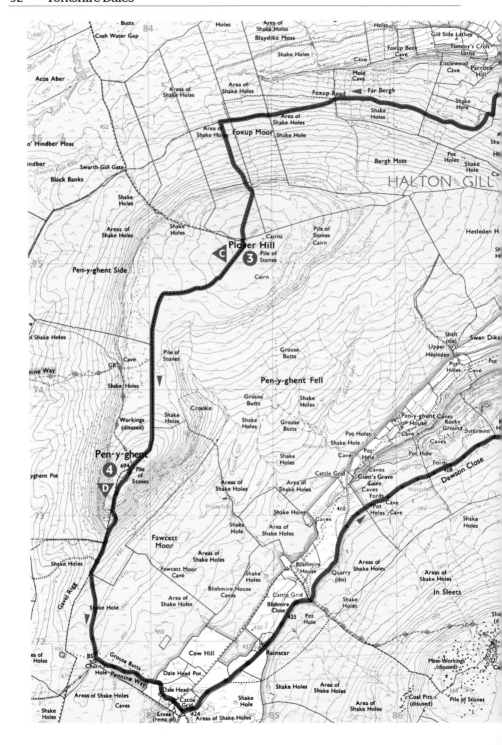

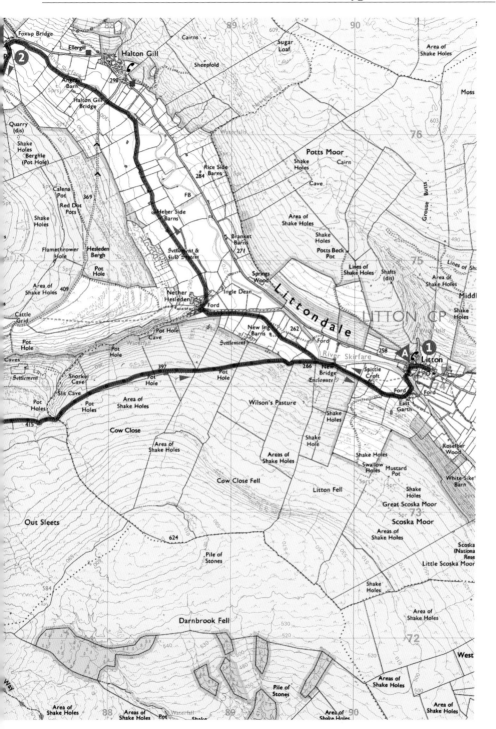

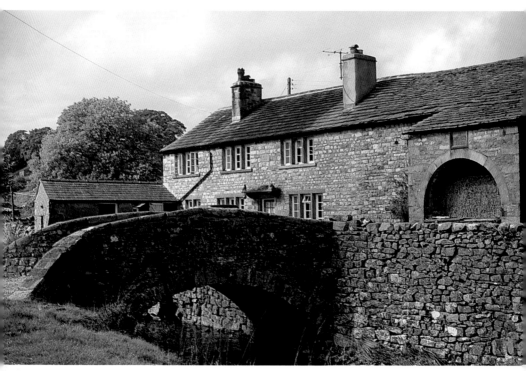

A farmhouse in Foxup has its own bridge

Foxup Road is an old monastic road that leads over to Horton in Ribblesdale. It occupies a position high above Foxup Beck and contours along the side of Plover Hill and Penyghent. For a stretch it occupies a well-drained limestone shelf above a line of springs.

B▶ From the first group of farmhouses, turn left up the hillside, following the Horton-in-Ribblesdale sign, and up to a gate on the right. The bridleway is known as the Foxup Road and at first climbs steeply up to a shelf of limestone with potholes, after which the going is easy. Parts of the path are boggy and hard to find – follow the blue marker posts carefully. After 1½ miles (2.4km) along here at the fingerpost signed 'Penyghent 2', turn up to the left for the steep climb to the top of Plover Hill.

❸ Plover Hill 849 752

Plover Hill is a subsidiary summit with a slight downhill before the final ascent. From the scar leading up to Plover Hill there is a fine view of the Foxup Road as it continues to Horton. Two birds to look out for on the top here are the golden plover which has a mournful whistle, and the raven, some 15cm/6ins longer

than the carrion crow, and with more powerful and slower wingbeats. The raven's deep throated 'prrk prrk' is a good give-away. The skylark still frequents the area, too.

The ridge from Plover Hill to Penyghent forms part of the watershed of England where streams on the west side go to the River Ribble and the Irish Sea, while those on the east make their way to the North Sea.

▶ From Plover Hill there are good views of both Ingleborough and Whernside, that make up the trio of the Three Peaks. The path is rather boggy as you descend 150ft (45m) before the final ascent to the summit of Penyghent.

④ Penyghent 838 734
At 2277ft (694m) the top is grassy with wonderful views. It is one of the finest panoramas in the Pennines with the Lake District mountains, Ribblesdale, Ingleborough and Whernside, Morecambe Bay, Pendle Hill and Fountains Fell all visible on a clear day.

On the first limestone scar from the top, if you are there around Easter, look out for splashes of magenta on the white rock; these are cushions of the beautiful and rare, purple saxifrage. This arctic-alpine only grows in this cold environment and global warming could lead to its disappearance altogether.

Purple saxifrage on Penyghent

In the 1750s, a parson from Halton Gill wrote a story called The Man on the Moon in which a local cobbler put a ladder on top of Penyghent to reach the moon. The man soon returned as he didn't like the food there.

▶ From the top of Penyghent continue in the same southerly direction to descend steeply on rough steps. The path is well used but footpath restoration has been carried out and includes a section of boardwalk. At Churn Milk Hole there is a crossing of the ways but keep left here to Dale Head and the road. Turn left along the road for a pleasant 1½ miles (2.4km), passing Rainscar Farm, then fork right on the track to Litton. This is Dawson Close, an old monastic route from Ribblesdale to Halton Gill in Littondale. It makes for a splendid walk with fine views which change as the track turns direction round the hill and eventually descends to rejoin the early part of the walk at the stone bridge above Litton. Return along the green lane, between the barns of Spittle Croft and along the field path back to the village.

Gordale Scar & Malham Tarn

START/FINISH:
Malham village, reached by turning off the A65 at either Gargrave or Coniston Cold; National Park information centre and car park. Buses run daily between Skipton and Malham (services 210 and 211)

DISTANCE:
8½ miles (13.6km); Add 1 mile (1.6km) for alternative route avoiding Gordale Scar

APPROXIMATE TIME:
4 to 5 hours

HIGHEST POINT:
Tarn House on the north side of Malham Tarn is at the highest point, being 1310ft (400m) above sea level

MAP:
OS Explorer OL2, Yorkshire Dales, Southern & Western areas

REFRESHMENTS:
Buck Inn, Listers Arms Hotel, Beck Hall Tea Room in Malham village

ADVICE:
Go to Malham at off-peak times to avoid the crowds. The climb up Gordale Scar may be too difficult when icy or when there is much water in the falls; for a gentler route, an alternative is given; take care on wet limestone

LANDSCAPE/WILDLIFE:
Limestone scenery, gorge, scars, tufa screen, streams, dry valley; tufted duck, ferns

A classic walk by any standards, this circuit of the best limestone scenery in the Dales takes in the Janet's Foss waterfall, the mighty chasm of Gordale Scar, visits Malham Tarn, Tarn House, the Dry Valley and towering cliff of Malham Scar – a study in limestone, but there is also a long history to the area, with prehistory, medieval fields, mining and literary connections.

❶ Malham 901 629
The charming village of Malham is clustered around Malham Beck and the village green and has become the most popular centre within the Yorkshire Dales National Park. The view of Malham as you approach it from the top of the hill to the south is a memorable one, set cosily in its own Malhamdale and backed by the magnificent cliff of Malham Cove.

▶ From the stone bridge at the centre of the village, walk down the left bank of Malham Beck, or join it by crossing the stone footbridge just below the Buck Inn, or stepping stones lower down. After a field or two turn left to follow the sign to Janet's Foss. Enter an ash wood which in spring is carpeted with wild garlic to bring you to the little waterfall.

❷ Janet's Foss 911 633
The waterfall of Janet's Foss is small and picturesque. Janet is said to be queen of the fairies hereabouts and lives in the

Malham village

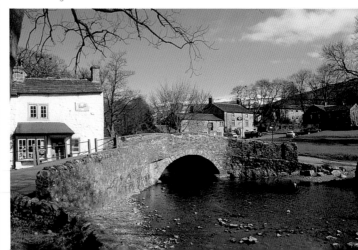

Ash woods with wild garlic below Janet's Foss

small cave behind the falls. The water that comes over the beautiful tufa screen is saturated with lime and continues to deposit it as some of the spray evaporates. There is a larger cave on the right.

B Continue up to the road, turn right for a short way before turning through the gate to Goredale Scar, and the surprise view as you turn the final corner.

❸ Gordale Scar 915 641

Visitors have been arriving here for over 200 years to see the awe-inspiring chasm of Gordale. The poet Thomas Gray came in 1769 and 'shuddered' at the sight of the huge cliffs hung with ivy and yew. William and Dorothy Wordsworth came in 1807 and 'rested under the huge rock for several hours and drank of its cold waters', and James Ward painted a large canvass of it for Lord Ribblesdale.

The 160ft (50m) cliffs of Gordale Scar are a result of the presence of the Mid Craven Fault, a little to the south. The gorge has been eroded by the torrents of water that came down here before much of it seeped underground. Like Janet's Foss, there is also a large mass of tufa on the main waterfall. The top fall comes through a window in the limestone, making a dramatic scene. The deep gorge above the falls is equally impressive and continues for a mile (1500m), walled by almost vertical cliffs along its length.

C Climb the waterfalls, a moderate scramble, by following yellow spots on the rocks with plenty of hand and foot holds. Steeply up again and you soon look down into the long gorge of Gordale Beck and a stile in the wall.

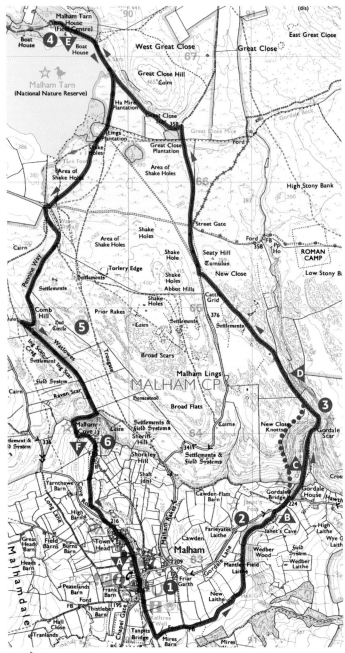

(alternative) If the waterfalls of Gordale Scar are icy, or there is too much water, or if you wish to avoid the short

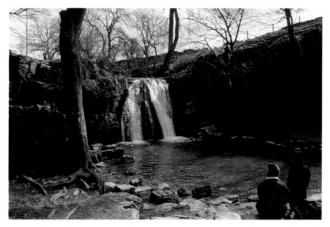
Janet's Foss

scramble, there is another very pleasant option, adding 1 mile (1.5km) to the length of the walk. Return to the road, turn right and cross the old Gordale Bridge. Go through the kissing gate on a path signed 'Malham Cove' and at the top of the wall, from where there are fine views back, turn sharp right across a grassy area with ancient field boundaries to a small gate in a wall. A discernible path winds up the steep and rocky hillside of New Close Knotts and higher up you get a splendid view of Gordale from above. After a slight descent, the path rejoins that from Gordale Scar at a stile in a wall.

▶ Continue for 1 mile (1.5km) on the path and cross to a stone stile. Turn right and follow the wall for 200yds (190m) to Street Gate. Keep in the same direction on a broad track signed Arncliffe, cross a dip, and go left, round the far side of a small wood (Great Close Plantation), to gain a fine view of Malham Tarn, and the cliffs of Great Close Scar. Enter the woodland to reach Malham Tarn House.

④ Tarn House and Malham Tarn 894 672
Charles Kingsley, in the 1860s, was Professor of Modern History at Cambridge and often stayed here with his friend Walter Morrison, where he gained ideas for his famous

Section through the Malham area shows how rocks have slipped down against the Craven Faults

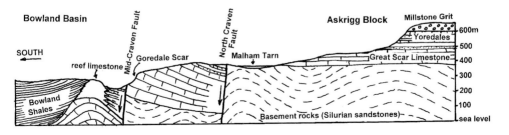

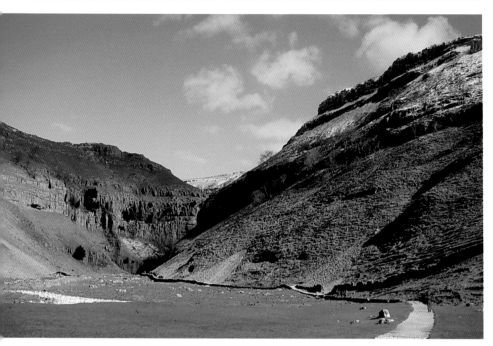

Approach to Gordale Scar

children's book The Water-Babies, published in 1863. After a fire in 1873 Morrison rebuilt the house to its present form. Malham Tarn House is now a field study centre.

Malham Tarn is a shallow lake of 150 acres (61ha) and although within a limestone area, it is held up by a stretch of ancient, impervious slates, brought to the surface by the North Craven Fault. Birds on the lake include great crested grebe, teal, tufted duck and coot. At Water Sinks, the stream soon finds its way underground on reaching limestone, emerging at Airehead Springs below Malham village. It is the water from the smelt mill that comes out at the foot of the Cove.

From a point between the Tarn and Water Sinks there is a view to the west of the smelt mill chimney where, in the early 19th Century, calamine, the ore of zinc and mined at nearby Pikedaw, was washed and 'roasted' with coal coming from the pits on Fountains Fell. The treated calamine was stored in a house in Malham before going to the canal at Gargrave. It was used in the making of brass.

▶ Return along the track back to the Tarn side and continue to the gate, leave the road and follow the sign: 'Water Sinks Gate ½' across open grassland to a car park. Turn right for

about 100yds (90m) along the road, and off to the left signed Pennine Way to Water Sinks. The path returns to the river bed which is usually dry, the beck having disappeared underground some way between the road and Water Sinks. Follow the wall to the Dry Valley (and dry waterfall) which leads to the limestone pavements at the top of Malham Cove.

⑤ The Dry Valley 894 646

The Dry Valley of Watlowes was cut by floodwater during a time when underground water remained frozen for much of the year, after the end of the Ice Age. At its upper end is a 'dry waterfall'. The resulting waterfall over Malham Cove must have been one of the wonders of ancient Britain. A search among molehills along the Dry Valley may reward you with an occasional fragment of flint, not naturally occurring but brought here by Neolithic or Bronze Age man – from East Yorkshire.

⑥ Malham Cove 897 642

The top of the Cove forms one of the finest of limestone pavements. The huge square blocks, or clints, are separated by deep fissures, or grikes. Some of the blocks rock gently when you tread on them. In the grikes grow ferns and woodland plants. The pavement is the result of a more-or-

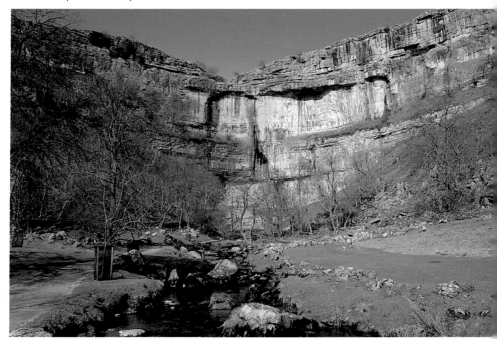

Malham Cove

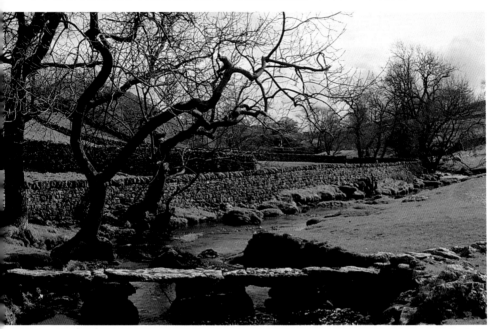

Clapper bridge, Malham

less level, thickly-bedded limestone with regular, but widely spaced joints. Soil has been removed long ago when the river came down from Malham Tarn and poured over the 260ft (80m) high cliff in a dramatic waterfall, roughly the height of Niagara.

The high cliff of the Cove, like Gordale Scar, is due to the presence of the Mid Craven Fault which here crosses the dale half way between the Malham Cove and the village. The 'downthrow' of the fault is to the south where the rock at the surface is more easily eroded. House martins nest on the cliff and, in recent years, peregrine falcon.

Below the Cove on each side of the valley are parallel terraces, the remains of 'lynchets' ploughed by Anglian farmers from the 7th Century AD. They were probably in full use when the Normans arrived.

▶ Cross the limestone pavements to the right to descend on the stepped footpath, and visit the Cove from below, where the infant River Aire begins its journey to Leeds and the North Sea. The path back to Malham passes an old clapper bridge, of large stone slabs, before returning to the road. Turn left to Malham.

Brimham Rocks

The wonderful naturally sculptured Brimham Rocks are owned by the National Trust and have become one of the most popular attractions in the Dales. This delightful walk holds more variety than most, with riverside, woodland and moor combining to give a very satisfying ramble.

① Glasshouses 173 645

Glasshouses has grown round a 19th Century flax-spinning mill, though its name suggests glass was made here in earlier times. The mill was built in 1812 and, under the care of brothers John and George Metcalfe, business flourished, so much so that by mid Century, they employed 264 workers, mostly women and girls. Though the spinning was done by machinery in the mill, linen weaving was continued by hand in the cottages. The mill is now occupied by small businesses, one of which is a winery where you can taste country wines and in the season obtain refreshments. The village is built on a terminal moraine of the Nidderdale glacier, and so stands well above the river level.

The river is narrow and deep, and alders grow along the banks. The shelves of land on each side are river terraces, remnants of a former floodplain. Among the birds, you may see the green woodpecker and, near the railway arch where there is plenty of cover, look out for long-tailed tits in the company of bluetits and great-tits. On the river, mallard and grey wagtail stay close to the water.

Looking back to Glasshouses from the riverside footpath

START/FINISH:
Glasshouses. The village lies off the B6165, a mile south of Pateley Bridge. Limited parking near the green or down the hill near the school. The 24 bus from Harrogate to Pateley Bridge runs hourly via Glasshouses

DISTANCE:
8 miles (13km)

APPROXIMATE TIME:
4 hours, but add half an hour to wander round Brimham Rocks

HIGHEST POINT:
950ft (290m) at Brimham Rocks visitor centre

MAP:
OS Explorer 298, Nidderdale

REFRESHMENTS:
Refreshment kiosk at Brimham Rocks (not daily in winter). Cafés and restaurants in Pateley Bridge. Tearoom at Glasshouses Winery (Wed-Sun in summer)

ADVICE:
Route-finding can be a challenge in the Brimham area, and this walk is no exception, so keep a wary eye on the directions, and the landscape

LANDSCAPE/WILDLIFE:
Weird rock shapes, green woodpecker, long-tailed tit, grey wagtail, grouse, curlew; holly blue butterfly; bluebells, wild garlic, wood sorrel, climbing corydalis, sweet cicely, foxglove, bilberry, bog asphodel, cranberry, sundew, birch bracket fungus

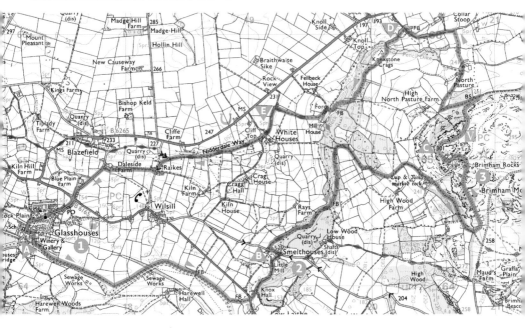

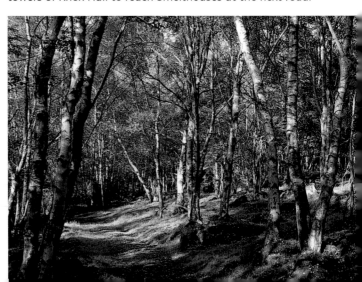

A Walk down Glasshouses main street almost to the river, through the mill yard, past the clock and down a track to the right of the buildings to reach the riverside footpath. After ¾ mile (1.2km), go under the old railway arch, continue past a river footbridge, and eventually turn away from the river, to cross a small footbridge over a tributary stream and exit with care onto the road (B6165). The path continues uphill directly opposite between a former mill and the twin rounded towers of Knox Hall to reach Smelthouses at the next road.

Birch wood below Brimham Rocks

Birch bracket fungus

② Smelthouses 192 642

The side stream is Fell Beck and Smelthouses was where the monks of Fountains Abbey smelted the ore of lead brought from the Greenhow mines. In 1795, the Kirkby family built the earliest flax spinning mill in Nidderdale on the side of Fell Beck.

There is a variety of wild flowers in the wooded ravine above Smelthouses. In spring, among bluebells, greater stitchwort, wood sorrel and wild garlic, there are the creamy heads of climbing corydalis, and in the summer sweet cicely and foxglove.

In the birch woods you will come across the birch bracket, or razor strop fungus, a thin slice of which mounted on a piece of wood served as a cheap and effective strop. In May, the many holly bushes attract the beautiful holly blue butterfly, a close view revealing the lovely silvery blue underside. The holly blue is a recent addition to the butterflies of Nidderdale, having extended its territory from the warmer south.

B▸ Turn left along the road in Smelthouses over the bridge and right, signed Whitehouses and the Nidderdale Way. The solid stone wall on the left supported the mill race which is followed by the path for a short way. Beyond a small weir, cross a wooden footbridge and turn back up the opposite bank. After 50 paces or so and before some red brick ruins, turn sharply left through the birch trees. At a small clearing, go forward, following the sign 'way to Brimham rocks', then turn right, and curve right again, eventually emerging at a

metal stile half-hidden in holly bushes to join a good double track which loops round again, gaining height to the car park and entrance to Brimham Rocks. From below you will catch glimpses of the rocks on the skyline. Follow the tourist route from the car park information board past the rock formations to Brimham House and the refreshment kiosk.

❸ Brimham Rocks 207 650

There are usually a few visitors even in the off season as Brimham Rocks is one of the main attractions in the Dales. There is something for everyone, families, young rock climbers and their instructors, ramblers and sightseers, elderly and infirm, all find a sense of wonder at the weird rock shapes and the distant views of Nidderdale. The rocks have been given names such as the Turtle, Eagle, Anvil, Sphinx and Dancing Bear and were once described as 'druidical monuments' when a little sculpturing to improve the shapes was quite in order. The Dancing Bear is just to the left of the

The Idol Rock, Brimham Rocks

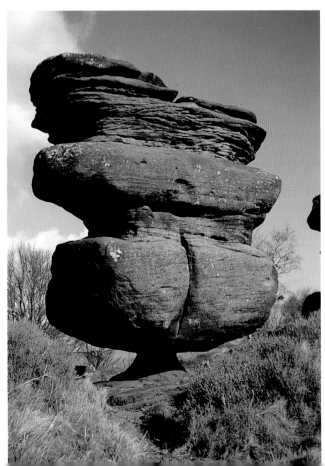

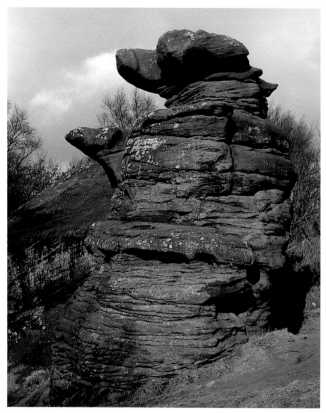

Dancing Bear, Brimham Rocks

visitor centre and one of the best of the pedestal rocks, the Idol Rock can be seen well to the rear.

Brimham House was built in 1792 by Lord Grantley 'for the accommodation of persons whose curiosity might prompt them to visit this world of wonders'. It has a fine vantage point, and was acquired and restored by the National Trust in 1970. The moor is covered in heather and around the rocks there are some of the biggest bilberry plants (and fruits) you are likely to come across. Other interesting plants include bog asphodel with yellow spikes in July, cranberry which creeps over sphagnum trailing delicate pink flowers, and sundew, the tiny insectivorous plant. Among the moorland birds are grouse, curlew, meadow pipit and snipe. You may be lucky and see a red deer.

Route finding can be difficult in this section of the walk as there are many small paths. From Brimham House go to the right of the refreshment kiosk until you meet a slightly larger,

Raikes, near Glasshouses

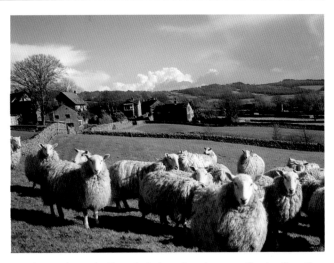

north-south path. Turn left, heading in a northerly direction for about 500yds (450m) and drop down on a narrower path through bracken to a farm track, turning left. After leaving a birch wood, leave the farm track to strike backward, to the right, through a field gate (no waymark) with a wall on the left, aiming for farm buildings at North Pasture. Go to the right of the buildings and left through a metal gate, to follow a line of telephone poles. Take the walled path down the hill to the group of cottages known as Fell Beck.

D Turn left round the last cottage, cross two fields then, on entering the wood by a small stream, strike up to the left to the rocks of Knoxstone Crags. Turn right to enter and skirt the upper edge of the wood, on leaving which, descend to a sturdy footbridge. Proceed for a few paces up the lane, joining the route of the Nidderdale Way, turn left along a farm track and leave it to follow the yellow-topped posts up to the right, climbing out of the valley of Fell Beck. There are extensive views down the valley and across to the 'golf balls' of Menwith Hill.

E At the cottages, turn left to White Houses, crossing to a gate and a fine walk below a steep rocky scarp, the slopes of which are covered with gorse, bilberry, bracken and brambles. The view across Nidderdale is to Guisecliff, topped by a TV mast. At the road turn down for 180yds (165m), then go right through a gate, (marked 'path diverted') following the contour along the top of some fields to a minor road, down which is the return to Glasshouses.

Scar House & Dale Edge

Nidderdale is an Area of Outstanding Natural Beauty and this invigorating walk explores the upper dale. Part of it is in the valley bottom passing some interesting caves and potholes, and another section follows the high margin of the moor, known as Dale Edge. The route crosses Scar House dam, one of the most impressive structures in Yorkshire and an outstanding monument to the men who built it.

1 Lofthouse 101 734

The road up the dale from Pateley Bridge leaves the valley here to wind up through Lofthouse and over to Masham in Wensleydale. Lofthouse is a collection of stone cottages and farmhouses on the slopes above the River Nidd. For 30 years, until 1936, it was the passenger terminus of the Nidd Valley Light Railway, built by Bradford Corporation for building the two reservoirs higher up. The continuation of the former rail track to Scar House dam is now a narrow motor road owned by Yorkshire Water and makes for pleasant walking.

Lofthouse is in the township of Fountains Earth. The name comes from monastic days when the monks of Fountains Abbey had a large grange and dairy farm here, supplying butter and cheese to the abbey. Land on the other side of the valley belonged to Byland Abbey.

Lofthouse village, Upper Nidderdale

START/FINISH:
Lofthouse, situated 7 miles (11.3km) higher up the dale from Pateley Bridge. There is a small car park in the village. On summer Sundays and bank holidays a bus runs from Harrogate

DISTANCE:
11½ miles (18.5km)

APPROXIMATE TIME:
6 hours

HIGHEST POINT:
The track along Dale Edge reaches 1,476ft (450m)

MAP:
OS Explorer 298, Nidderdale

REFRESHMENTS:
Crown Hotel and village shop; a variety of cafés and restaurants in Pateley Bridge

ADVICE:
Be self contained for a full day; paths are generally good

LANDSCAPE/WILDLIFE:
Caves, potholes, underground river, fossils, coal pits in the millstone grit; green woodpecker, little owl, blackcap, yellow wagtail, cuckoo, grey wagtail, dipper, red grouse, golden plover, curlew

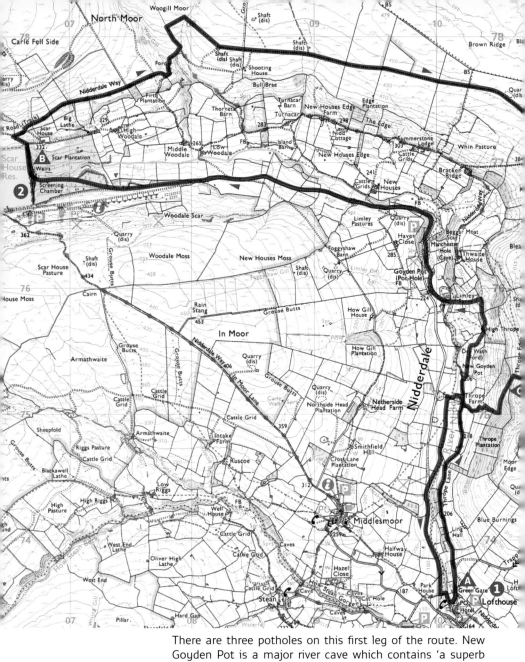

There are three potholes on this first leg of the route. New Goyden Pot is a major river cave which contains 'a superb railway-tunnel main streamway'. Goyden Pot is a cave you can explore the entrance of with a strong torch, an entrance to two miles of passages. Boulders round about contain the large fossil shells of gigantoproductus. Manchester Hole can also be explored at the immediate entrance where you can see and hear the rush of the river as it sweeps along

underground. When the river is in flood, all three potholes fill completely with water, and become extremely dangerous, though normally the riverbed is dry.

Birds to spot in the valley include green woodpecker and little owl and, in the spring, blackcap, yellow wagtail and cuckoo.

A Start by going up through the village and, just before the first bend, leave the road to go straight forward along a path named Thrope Lane. It has a fine position above the river, with a view across to the village of Middlesmoor on the hillside opposite and soon with an uninterrupted view ahead, up the dale. The path follows the Nidderdale Way and after Thrope Farm descends to the riverbed – often dry. At this point you can see the entrance to New Goyden Pot under the far bank. Cross the river on large rocks and, after a step stile, note the coal spoil heap that makes up the riverbank with the entrance to the coal pit a few paces further on. At Limley Farm go into the farmyard and left of the cottage to continue along the left side of the river. Pass Goyden Pot at an angle in the riverbed, then on to Manchester Hole and a stile up to the road. On the road there is a walled-up tunnel entrance where the railway used to go. The route is up the access road to the reservoir, with varying views of the valley, past the site of the shanty town and to the dam. There are some slippery and unstable sections on this part of the walk.

2 Scar House Reservoir 067 769
Built to supply Bradford with water, the dam was begun in 1921 and took 15 years to build with 700 men working on it. A shanty town was created on the site where there was a grocer, hairdresser, butcher, fishmonger and newsagent. There was also a church, school, cinema, concert hall, billiards

Thrope Lane, Upper Nidderdale

Limley Farm, Upper Nidderdale

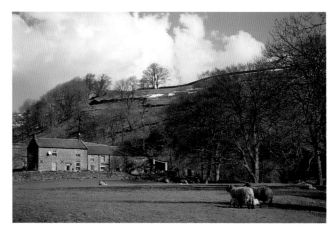

room and tennis courts. The men were housed in 10 hostels and 60 bungalows, the foundations of which can still be seen. The dam is 1800ft (550m) long and 170ft (52m) high and when opened in 1936 it was the biggest masonry dam in Europe holding 2,200 million gallons (10 million m³) of water.

The high level walk along Dale Edge is 3 miles (5km) of good track on the border of open heather moors. The views are extensive with the rather flat outlines of Great Whernside and Little Whernside and below them the two reservoirs of Angram and Scar House, to the left being the cone-shaped top of Meugher, a rarely visited peak.

Many of the moorland birds are here with red grouse, golden plover, curlew, and meadow pipit, being easily heard or seen. On the way there are two coal mines, one of which is close to the path with a deep mine shaft and spoil heap of black shale. The two coal seams on this walk, one mined in the valley bottom and the other here from the moor top, both occur

Scar House Reservoir and Dead Man's Hill

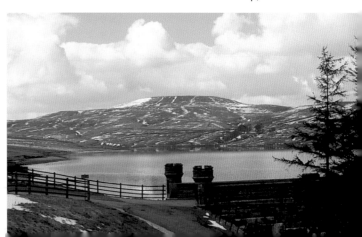

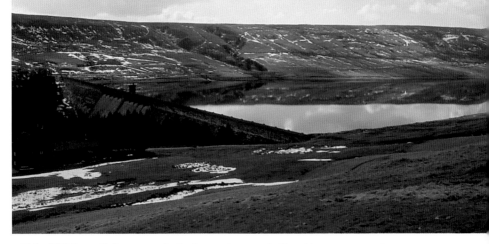

within Millstone Grit group of strata, and come before the true Coal Measures.

Scar House dam

B Following the Nidderdale Way, cross the dam and turn half left up the hillside, turning right after passing a shelter (a possible picnic spot in inclement weather). The track is broad and peaty, and descends to a wooden bridge made of railway sleepers over Woo Gill. At 85yds (80m) after the bridge, the route strikes off left up through the bracken up the centre of a tongue of land between two head streams. (If you miss the turn, the grouse-shooting track will bring you up onto Dale Edge.) Almost 200yds (180m) up the slope, meet a level track coming along at right angles. Turn right, curving round again after crossing the small head streams of Twizling Gill and on to a coal tip heap and shaft. From here you can stride out for 3 miles (5km) along Dale Edge on mossy, stony, heathery paths with a gradually changing distant view and without a care in the world. This section requires careful navigation as it is not waymarked and the path is indistinct in places.

❸ Shooting House 107 753
The building has a tower attached and a date of 1912. Nearby, gritstone has been quarried and there is a small collection of stone gateposts still lying in the grass near the first gate. Down by the river look out for grey wagtail, with yellow underparts and the dipper, with white shirt front.

C Immediately before the shooting house with the tower, descend steeply, winding down to Thrope Farm. The path is slippery in places. Cross the lane and the farmyard to go right of the main buildings, and down to the river bridge. Turn down the right bank of the river through about four fields and to the reservoir road. After another ½ mile (800m) or so, turn left over the stone bridge and to the middle of Lofthouse.

Penhill & Templars Chapel

A walk soaked in legend and history takes you to the top of Penhill, a renowned landmark associated with giants and beacon fires. The hill is part of a broader moorland with a good variety of associated plants and birds. At Templars Chapel are stone coffins and the remains of a 13th-Century house of the Knights Templar. The walk touches on Middleham High Moor where racehorses are given a good workout on the fine turf and wide open spaces.

① West Witton 060 884

The village is noted for once being a centre for wool dying and the making of wooden butter tubs. There are some old buildings though many are 19th Century miners' cottages. The church was rebuilt in Victorian times but has a 16th Century tower and is dedicated to St Bartholomew. An old tradition is the burning of Old Bartle on the Saturday nearest to St Bartholomew's Day, the 24th August. Old Bartle could represent the saint, rescued from the church during the Reformation, though others believe he was a pig thief who stole from the monks of Jervaulx.

Approaching Penhill

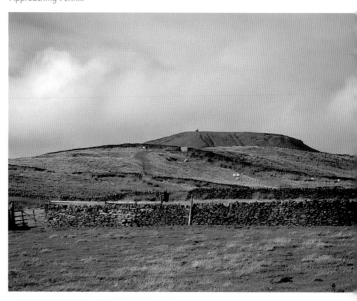

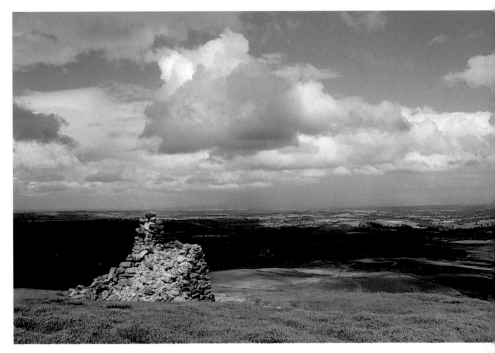

View of lower Wensleydale from the Pile of Stones on Penhill

From the top (west) end of the village, turn left up the lane that leads to the caravan site. After a right turn, take a sharp left onto a woodland path, labelled 'Moor Bank'. The path climbs steeply up the wooded hillside and then goes through Chantry caravan site. Cross the stream and play area before going diagonally across the next field to a barn, to follow a green lane and a path through gated stiles parallel to it. This lane can be flooded in wet weather – an alternative is to take the first field stile after the barn up to High Lane and turn left to reach the road.

At the road, go right, to turn off at the hairpin bend through a shapely stile leading to Penhill Farm, a section known as Witton Steeps with fine views to the tower of Wensley church, Bolton Hall and Bolton Castle.

Regain the road to pass in front of Penhill Farm and up the hill with Middleham Moor training course on the left. When you can see the cattle grid turn right through the metal gate and up the grassy slope. The track leads through a series of gates and gate gaps straight up to the stone tower ('pile of stones') on the skyline. From here take a half right to reach the Penhill Beacon.

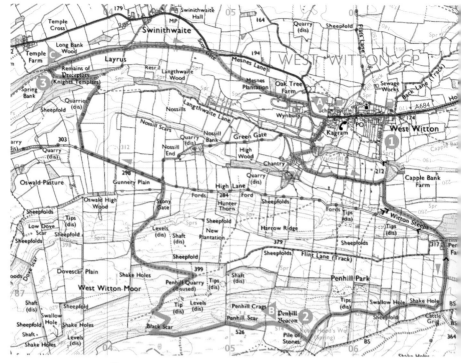

➋ Penhill Beacon 054 867

The view is of lower Wensleydale and across to the North York Moors with Darlington in the distance. Recently, the Beacon had a large fire lit in celebration of the millennium in a tradition going back hundreds of years. It is one of a series of beacons across the country where fires were lit to carry news of national celebrations or impending disaster. The Beacon is a popular walk and may be the source of the legend of the

Cranberry, seen on Penhill

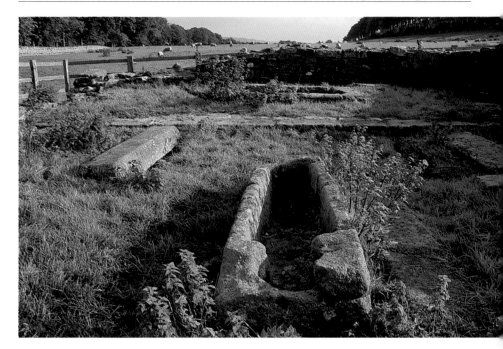

Knights Templars' graves

giant of Penhill. The long story is retold by Mike Harding in his 'Walking the Dales' and ends with the giant falling to his death from Penhill Crags.

The cliffs of Penhill Crags and Black Scar are the result of landslips, active at one time, which have left a jumble of rocks and hummocky ground below, now covered with bilberry and rabbit holes.

The crags are the haunt of ravens and peregrines while on gentler slopes there are curlews, skylarks, lapwings, wheatears and meadow pipits. The acid moor on top of Penhill has some interesting plants among the heather and sphagnum moss. Look for the tiny pink flowers of cranberry that trail over the moss, also round-leaved sundew, cross-leaved heath and cotton grass. A rare plant on Penhill is the cloudberry, one of the brambles, with bright green leaves and white flowers, the fruit turning yellow in the autumn.

B▶ Go along the edge from the Beacon and pass the stone 'trig point' on the other side of the wall, the highest point of the walk. At a gate opening in this wall, take the slanting and deeply incised track, descend in broad zigzags until you cross the remains of a wall near a line of tip heaps. Turn diagonally

left and make your way down to the wall and a good path coming in from the right. Continue in a westerly direction as the track becomes bigger, turns through the wall and curves round to a gate and exits onto High Lane.

Turn left along this green lane then right to zigzag down a concrete section of the road. Leave it (going left) at a hairpin for a grassy path above woods in the up-dale direction that leads down to a small enclosure in the corner of a field – Templars Chapel.

❸ Templars Chapel 035 887

The remains are of a house for travellers to the Holy Land (a preceptory), built about the year 1200 by the community of Knights Templars. A chapel is thought also to have existed here, too. The Knights Templar, a military religious order, was founded by the Crusaders in Jerusalem and suppressed in 1312. The most interesting remains are the stone coffins which are so small they look as though they were made for children.

The woods on the steeper slopes offer a haven for wildlife. There is a wide variety of deciduous trees and flowering plants on the limestone. Look out for the sparrowhawk making a surprise attack, and in the intervening meadows, the brown hare, distinguished by its long, black-tipped ears.

All the limestones form shelves around Penhill, often wooded, and are typical scenery of the Yoredale strata, alternating beds of limestone, shale and sandstone.

▶ Go east along the margin of several fields, above woodland, crossing a lane then, when near to the road, turn diagonally up to a narrow stile and the same easterly direction which brings you out onto the main road and back to the village of West Witton.

Characteristic Wensleydale stile near West Witton

Aysgarth Falls & Bolton Castle

 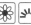

Visits to two of the most popular attractions in the Yorkshire Dales – Aysgarth Falls and Bolton Castle – are included in this pleasant circuit. Splendid views are obtained from higher up on the valley side. There is opportunity for bird-watching and the flowers are exceptional. Bolton Castle dates back to the 13th Century, providing a fascinating journey in time.

1 Aysgarth Falls 013 887

There are three separate falls at Aysgarth where the River Ure cascades over the stepped formation of thick limestones separated by thin shales. The Upper Falls can be seen from the road bridge and can be visited before the walk begins. The Middle Falls are rather screened off by trees but a viewing

Aysgarth church

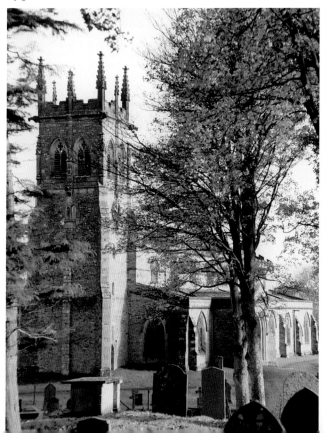

START/FINISH:
Aysgarth Falls National Park Visitor Centre (SE 110888) and large car park; also a car park up the hill above the church. Bus 156 runs Monday to Saturday between Bedale and Northallerton to Hawes. An infrequent service (127) runs from Ripon to Hawes

DISTANCE:
7 miles (11.3km)

APPROXIMATE TIME:
About 4 hours

HIGHEST POINT:
An altitude of 1,017ft (310m) is reached on the valley slopes before descending to Carperby

MAP:
OS Explorer OL30, Yorkshire Dales, Northern & Central areas

REFRESHMENTS:
A restaurant and two tea rooms at Aysgarth Falls; tea room at Bolton Castle, half way

ADVICE:
Leave time to linger at the falls and also to have a worthwhile tour of Bolton Castle; mostly good paths and easy walking

LANDSCAPE/WILDLIFE:
Great scar limestone; good birdwatching with lapwing, curlew, redshank, snipe; primrose, cowslip, wood sanicle, goldilocks, herb bennet, wild arum, yellow pimpernel, herb Paris, wood melick, butterwort, birdseye primrose, watercress, meadowsweet, St John's-wort

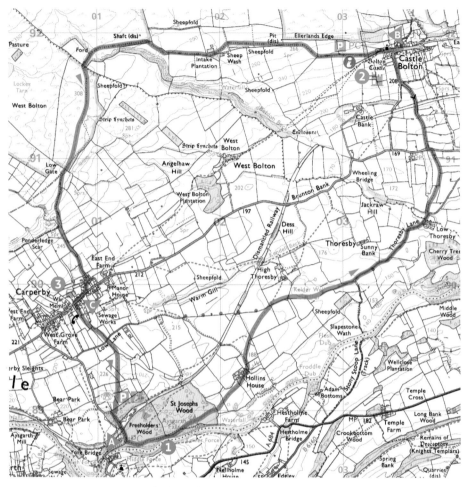

platform has been provided, where they cascade over the Great Scar limestone, including a drop of 16ft (5m), spectacular when the river is full. The Lower Falls bring the waters of the Ure down another 26ft staircase and can be viewed from above, and then from the limestone slabs on the riverbank, where fossil corals and shells can be seen.

Freeholders' Wood is an ancient woodland that has been coppiced for hundreds of years. This system of cutting back trees to ground level every seven to twenty years has now been started again after a long gap. The coppicing provided firewood for the people of Carperby who have the right of 'estovers' (gathering sticks in the winter months), and it allows the trees to live on indefinitely. Only silver birch and

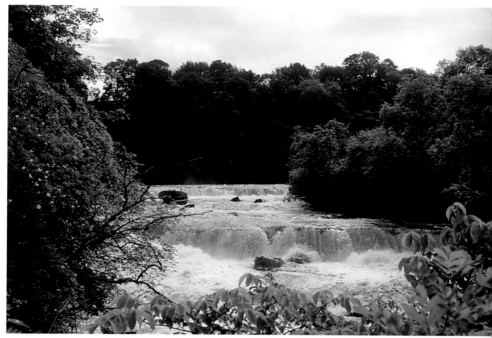

conifers do not respond to coppicing. Hazel is the most common tree with birch, bird cherry, hawthorn and others.

Aysgarth upper falls

This system of woodland management is not common but does provide light for a variety of flowering plants, including primroses, cowslips, wood sanicle, goldilocks, herb bennet, wild arum, yellow pimpernel and, hidden away, the rare herb Paris, a true sign of ancient woodland. The tufts of lime-green grass that border the path are wood melick, with a dainty flowering head. By the riverside are butterwort and birdseye primrose.

The meadows and damp open grassland between the falls and Thoresby Lane are a breeding place for ground nesting birds such as lapwing, a large member of the plover family with a wisp of a crest, the larger curlew, the nervous redshank and the secretive snipe. Thoresby Lane is lined with hazel, holly, blackthorn and wild roses. Wetter parts have watercress, marsh marigold and meadowsweet, while all along grow cow parsley, St John's-wort, goosegrass, crosswort, speedwell, and wood avens. Further on are red campion, wood cranesbill, white deadnettle and giant bellflower.

Over to the right of Thoresby Lane, not seen from the path, is the site of the lost village of Thoresby which may have been

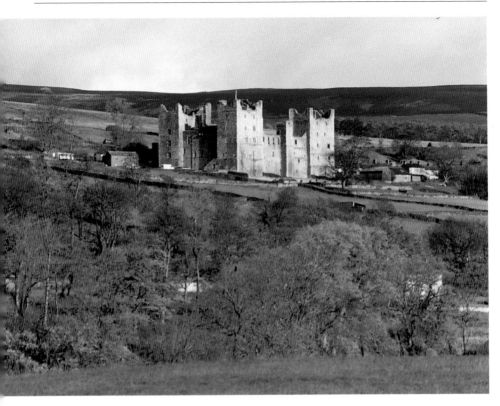

Bolton Castle

wiped out by the plague, as it was mentioned in Domesday Book. Today there are a few mounds that might suggest a street of dwellings.

A From the Visitor Centre turn right on the path to the Middle and Lower falls, crossing the road and entering Freeholders' Wood. Visit the Middle Falls then the Lower Falls, returning on a loop from the riverbank. The sign for Bolton Castle points away from the river and along a wooden fence (north-west). The path takes you through Hollins House farm, soon after which you leave the farm track for a path on the right across a meadow. Do not cross the wall to High Thoresby Farm, but go through two gates and, keeping the wall on your right, reach the start of Thoresby Lane. Keeping Bolton Castle in view continue along the lane, a narrow flowery track, to reach Low Thoresby farm. Some 50yds (50m) further on, turn left via a footbridge, built on a large stone slab, and through two narrow hay meadows to the road. Take the road opposite leading to Bolton Castle.

② Bolton Castle 033 918

This huge, impressive building dates from the 14th Century and was completed in 1399. It was home to the Scrope family and built by Richard, Lord Scrope, Chancellor of England in 1378. The Scropes are mentioned in Shakespeare, and Mary Queen of Scots was imprisoned in the south-west tower for six months in 1568. She was 26 years old and had a retinue of 40 servants, who lived in the village. The castle was partly destroyed in November 1645 during the Civil War when the royalist stronghold was defeated following a siege and the north-east tower was hit by cannon fire.

Today a descendant of Lord Scrope has opened the castle to visitors, after being made safe in 1991 by a grant from English Heritage. It is the finest example of a fortified manor house and the best preserved medieval castle in the country. There are tremendous views from the upper floors, and a tour of the castle, brought to life by life size models, is a fascinating experience.

▶ Go round the castle and past the parish church of St Oswald, through the gate, to follow a double track where you

Carperby village

can enjoy 2½ miles (4km) of easy walking. When the farm road ends, go through the gate and, keeping the wall on your left, follow the track after crossing a stream. The path leads onto the highest part of the walk with views up the dale of Ivy Scar and Greenhaw hut on the horizon. Across the dale are the gritstone scars of Penhill and the valleys of Bishopdale and Waldon. The path descends to join a walled lane into Carperby.

③ Carperby 008 898

The village was first settled by the Danes as the 'by' suggests. It is an attractive linear village with a small village green and ancient, stepped market cross, dated 1674. Carperby was one of the earliest villages in the dale to obtain a market charter, which it received in 1305. George Fox, founder of the Quakers, once preached here, though the tall meeting house as well as one of the Methodist chapels are now private dwellings. The Wensleydale breed of sheep originated here in 1838. They were once known as 'mugs' – large sheep with wool down to the ground. Today they are mainly used for cross-breeding.

Go as far as the Wheatsheaf and take the path opposite that leads through fields to Freeholders' Wood. Just inside the wood do a right and left to bring you to the road, and pass under the railway bridge to reach the visitor centre at Aysgarth Falls.

Lane leading to Carperby

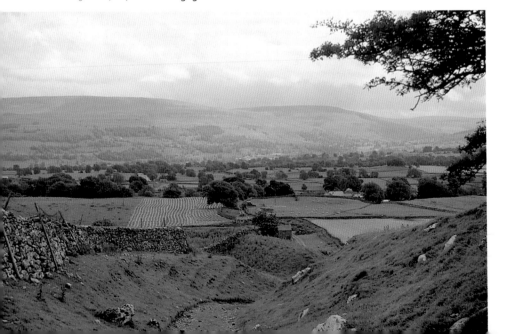

Mill Gill

This short walk is full of interest and should be taken at a leisurely pace. On a fine day it makes a good family outing, visiting Mill Gill Force and Whitfield Force, which are two of the most beautiful waterfalls in Wensleydale. They are very dramatic after rain, but this is also when paths deteriorate. The woods are rich in birdlife and flowers and the geology is outstanding.

1 Askrigg 949 911

Askrigg is a small market town with a delightful character. It grew as a market centre on the edge of a hunting forest that occupied upper Wensleydale. Many of the large houses in the main street were built in its heyday in the 17th and 18th centuries. It was a clock-making centre and had a reputation for hand-knitting. The church is one of the finest in Wensleydale and dates from the early 16th Century. After 1795 when the new turnpike road was built, Hawes took over as the main market centre.

In the woodland of Mill Gill in spring and early summer there is a profusion of flowers: bluebells, wild garlic, wood sanicle, water avens, herb bennet, wood stitchwort and greater stitchwort. There is also an abundance of mosses, liverworts

Mill Gill Force near Askrigg

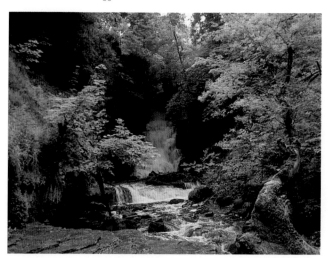

START/FINISH:
Askrigg in Wensleydale is on a minor road north of the river 4 miles (6.5km) below Hawes. Buses 157 from Bedale and X59 from Richmond run to Hawes via Askrigg

DISTANCE:
3½ miles (5.6km)

APPROXIMATE TIME:
2½ hours

HIGHEST POINT:
1,115ft (340m); comes after climbing out of Whitfield Gill to the top end of the track called Low Straights Lane

MAP:
OS Explorer OL30, Yorkshire Dales, Northern & Central areas

REFRESHMENTS:
The Crown and Kings Head in Askrigg provide bar meals; there are also two restaurants

ADVICE:
Some of the woodland paths in Mill Gill and Whitfield Gill are narrow and steep and can be slippery in wet weather

LANDSCAPE/WILDLIFE:
Classic exposure of Yoredale strata in the waterfalls, a coal seam, fossils; wood warbler, nuthatch, tree creeper, willow warbler; common spotted orchid, fragrant orchid

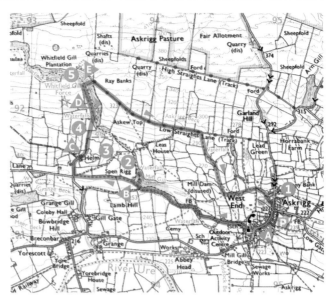

and ferns, especially near the spray from the falls or around seepages. Among the birds are wood warbler, nuthatch, tree creeper, willow warbler, long-tailed tit, greenfinch, chaffinch and wren. Near the water are grey wagtail and dipper while, up above, jackdaws circle round calling 'jack'.

View across Wensleydale to Addlebrough

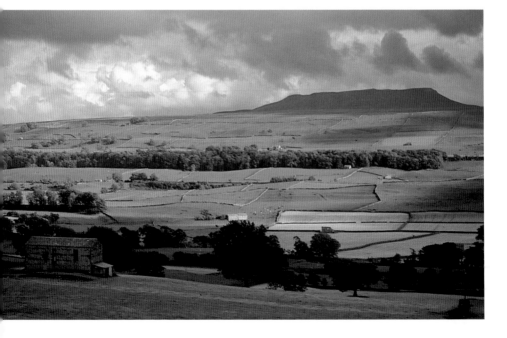

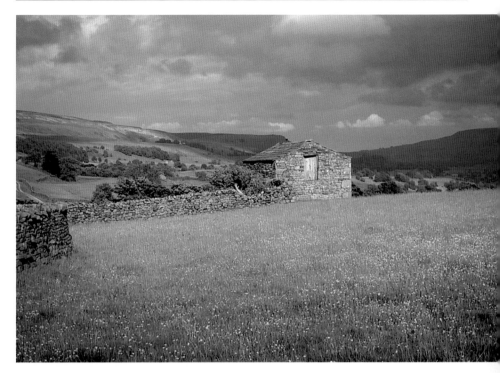

Barn and meadow above Askrigg

A Start from the church along West End, at the end of which cross an ancient meadow on a paved path to a former saw mill. The overhead channel which took water to the water wheel inside the building is still in place. The path crosses the bridge and continues up the left side of the beck to enter woodland. Follow the 'Mill Gill only' sign to reach the falls.

❷ Mill Gill 939 914

The ravine of shows a classic exposure of Yoredale strata, which continues up to Whitfield Gill. The Yoredales form alternating limestones, shales and sandstones, representing deeper clear sea, less deep sea with muddy seabed and shallow sea with sand. The sea may have receded altogether as coal measure trees established themselves, eventually to produce a thin coal seam. At the waterfall of Mill Gill the pale rock at the top is Hardraw limestone and half way down you can make out a darker sandstone and at the base black shales outcrop. Below the falls the softer shales have eroded by falling water to form a plunge pool.

B Return to the path that leads up the side of the wood and, at the top corner, leave the wood and follow the sign to Helm,

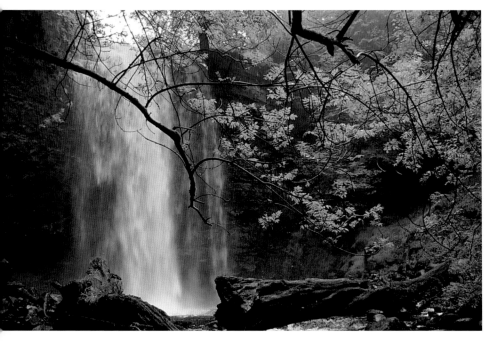

Whitfield Gill Force, near Askrigg

through fields known as Spenn Rigg. From here there are wide open views across Wensleydale to Bainbridge and into Raydale. At the road turn right up to Helm.

❸ Helm 933 915

This little hamlet lies on the old route over into the Eden valley known as Lady Ann Clifford's Way. As High Sheriff of Westmorland Lady Ann would have passed by here in the 1660s with her huge retinue, a train of 300 people in coaches, on horseback and driving wagons as they made their way from one of her castles to the next. Country folk's memories are long and they must have spoken of the amazing processions for many generations.

Go in front of Helm guesthouse to climb up through fields and turn right to arrive at the gill again at stream level.

❹ Whitfield Gill 935 920

On reaching the beck from Helm, there are some beds of limestone with shale beneath that form a small waterfall. Below the shale and seen in the bank is an 8in (20cm) coal seam. The coal is rain forest peat that has been compressed and altered over some 330 million years, from when the sea receded for a time.

High on the side of the gill there are common spotted orchid in various tints of pink and white, and fragrant orchid that smells of carnations. Other woodland flowers include yellow pimpernel, woodruff, a sweet-smelling member of the bedstraw family, wood speedwell, wood sorrel and wood cranesbill.

D Keep up on the left side of the ravine before a fairly gentle descent to the water level again. Only at the last minute do you see the single drop of Whitfield Force. If the river is in spate you may not be able to get near it.

5 Whitfield Force 933 922
Whitfield Force has a thin sandstone at the top with a mass of shales below. At the foot of the falls you may be able to make out fragments of fossil corals and shells preserved in the shale. The gorge below the falls is in Simonstone limestone.

E Return to go over the footbridge and steeply up the other side of the gill onto Low Straights Lane, the highest point of the walk. About 1 mile (1.5km) down the lane, just before a ford, turn right through a gate and straight down through fields. There are two gated stiles one on each side of a walled 'lane' and the path continues to the far (left) corner of the next field to a squeezer stile. Bear left below a barn with an arched doorway on a path that leads down into Askrigg and emerges next to the Crown Inn.

Evening light, near Askrigg

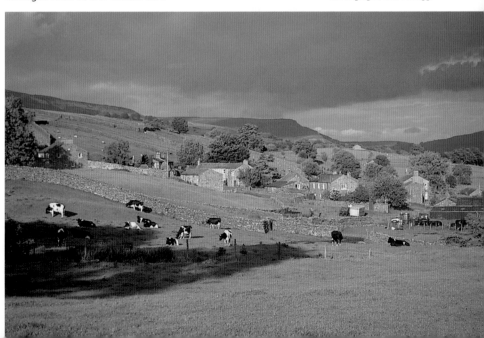

Hardraw Force

The main aim of this walk is a visit to Hardraw Force, one of the highest single drop waterfalls in Britain, combined with a stroll along the banks of the River Ure where there is good bird watching. The route includes part of Lady Ann Clifford's Way, and Sedbusk is an attractive stone-built village off the beaten track.

START/FINISH:
Hawes in Wensleydale; a large car park at the National Park visitor centre. Buses 156 and 157 run from Bedale and Northallerton, and X59 from Darlington via Richmond. On Sundays and Bank Holidays in the summer a bus runs from Leeds and Bradford via Ilkley and from Leeds via Harrogate

DISTANCE:
5 miles (8km)

APPROXIMATE TIME:
About 3 hours

HIGHEST POINT:
970ft (295m) at the village of Sedbusk

MAP:
OS Explorer OL30, Yorkshire Dales, Northern & Central areas

REFRESHMENTS:
Hawes is well provided for pubs, cafés and restaurants, and shops sell good pies and pastries; in Hardraw there is a tea room and the Green Dragon pub

ADVICE:
Easy walking mostly on good paths

LANDSCAPE/WILDLIFE:
Hardraw limestone, sandstone and shale, fossil amphibian footprints, drumlin; grey and yellow wagtail, snipe, redshank, redstart; sweet cicely, water avens, meadow vetchling, crosswort, lady's bedstraw, wood cranesbill, good-King-Henry

Hardraw Force

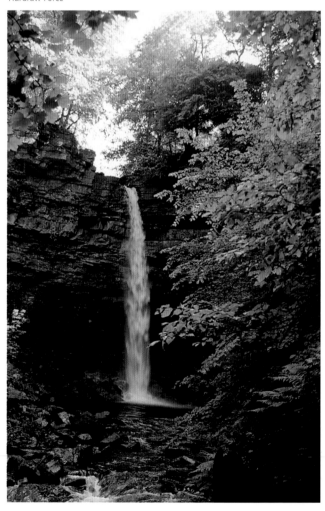

Hamlet of Hardraw

① Hawes 875 898

Hawes only grew in importance during the 19th Century after the turnpike road from Richmond to Lancaster was completed, with further growth after the coming of the railway in 1875. The town is still the centre of an important sheep and cattle market and cheese making business. It is now the main tourist centre for Upper Wensleydale. Visit the Dales Countryside Museum, based round the old railway station, the rope-makers, or see cheese-making in operation at the Wesleydale Creamery towards Gayle Village. On Tuesdays there is an indoor and a street market.

The riverside walk is along a flood bank of the river and is a good vantage point for birdwatching. Sand martins nest in the riverbank and swallows dive about over the water. Pied, grey and yellow wagtails frequent the river meadows. The brightly coloured yellow wagtail is a summer visitor and a delight to see. The poorly drained flood plain is also a good place to observe redshank and snipe. Redshank are easy to see as they are restless birds with a noisy call and jerky flight, dangling their red legs as they scold predators. The snipe is less easily seen, but on a summer's evening may be heard

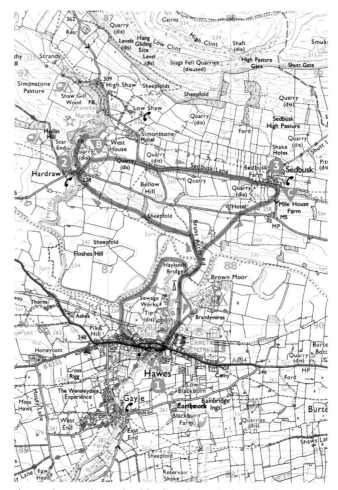

drumming as the male side slips through the air, vibrating its outer tail feathers.

A Start at the upper end of Hawes, across from the fish and chip shop to go behind the builders' merchants on a path that leads under the old railway bridge and straight down to the river. Walk downstream following the raised bank. Leave the riverside at the last iron ladder stile and go right to the large footbridge over Gayle Beck. Reach the road and then turn left to the two elegant stone arches of Haylands Bridge. Take the first path to the left across a field with a tree covered scar to the right to cross a ladder stile. Over to the left the knoll is a drumlin, moulded and deposited beneath the Wensleydale glacier. Join the wall ahead to the right and cross the step

stile in it to join the Pennine Way and a flagstone path to Hardraw village. The falls are accessible though the Green Dragon for a small fee.

Village green, Sedbusk

2 Hardraw 869 915

The waterfall of Hardraw Force has been a tourist attraction for over 200 years and it was in 1799 that William Wordsworth and his sister Dorothy came on a winter's day and stood behind the falls with icicles hanging from the rocks above. 'Lofty and magnificent' he described it. Turner did a painting of the falls from which was made a well known engraving. There have been dramatic moments. In 1899 a cloudburst flooded the inn with 6ft (1.8m) of water, while in 1739 and 1881 the falls froze solid into a pillar of ice. The amphitheatre has such good acoustics that a famous brass band contest is held each summer.

The 90ft (27m) drop of falling water is impressive and it is possible to stand behind and see the water racing down in front of you. The lower third of the cliff is made up of black shales, then come sandstone and Hardraw limestone at the top, a complete cycle of Yoredale strata known as the Yoredale Series. Some years ago, a piece of flagstone was found here by a Bradford schoolboy which contained the fossil footprints of an armoured, flesh-eating amphibian

called Megapezia. They are the oldest tracks of a four-legged animal yet found in Britain and are now in the Natural History Museum in London. Of the Lower Carboniferous period, they are about 330 million years old.

Sedbusk Lane is an ancient road and in the untouched verges are a profusion of wild flowers. These include sweet cicely, water avens, meadow vetchling, crosswort, lady's bedstraw, wood cranesbill and good king henry. This last one is a sort of medieval cabbage and looks like a tall dock. Look out for the redstart along here and its 'weet' call.

B From the falls return to the Green Dragon and take the path, to the right of the pub, through somebody's back yard and labelled Simonstone. After about 164yds (150m), branch off right on a faint path up a grassy slope to a stile below some trees. The half-hidden path needs care. It leads along the lower side of a deciduous wood to an angle in the road where there is a seat. Take the small lane in the same direction to the little hamlet of Sedbusk.

③ Sedbusk 883 911
Sedbusk Lane is a section of Lady Ann Clifford's Way. As

described in her diaries, Lady Ann and her huge retinue travelled like royalty from Nappa Hall where her cousin Thomas Metcalfe lived, via Askrigg, Helm, Sedbusk, Hardraw, Cotter End and a difficult upland route, crossing Hell Gill and in to the Eden Valley, descending to her Pendragon Castle.

Sedbusk is a pretty hamlet in the district of Low Abbotside, a name dating from the time it belonged to Jervaulx Abbey. It is a quiet and compact village of farms and cottages with wonderful views across Wensleydale to Wether Fell, Burtersett, Hawes and Gayle. It lies on the 950ft (300m) contour and is backed by the high wild area of Stagsfell and Abbotside Common where, formerly, inhabitants were employed in the flagstone quarries and lead mines. There is a Victorian letter box, a telephone and village green.

From Sedbusk go south down the lane, soon to take the stile on the right. The path leads across fields, across a road and down to a cobbled packhorse bridge. At the road go left and over Haylands Bridge, then through fields on a charcoal flagstone path into Hawes. On the left is the National Park centre and there is a train waiting in the old station.

Haylands Bridge, Hawes

Maiden Castle & Harkerside

Reeth is the main centre for upper Swaledale and this
walk includes a wonderful stretch of the River Swale
where the birdwatching is good and climbs to Maiden
Castle, the best preserved hill-fort in Yorkshire. On
Harkerside there are leadmining remains and bell pits,
then some giant pre-historic earthworks. The circuit visits
the attractive village of Grinton and its splendid church,
returning along the river at its widest point.

① Reeth 038 993

The attractive village of Reeth lies in a commanding position
on the sunny side of the dale and at the junction with
Arkengarthdale – wonderfully placed for the walker. Even in
the 18th and early 19th centuries Reeth was a thriving little
town, a focus of the dale with markets, fairs and leadmining,

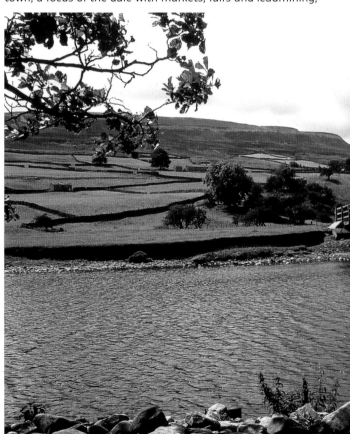

as the fine Georgian buildings reflect. There is a National Park Centre, a Folk Museum and a huge village green.

A Begin the walk by going past the Black Bull and Half Moon, winding between buildings and modern bungalows to reach Quaker Lane. Turn right to the end of the lane, then left down to the riverside. Cross the Swing Bridge.

② Swing Bridge 032 989

Near the Swing Bridge the river floods regularly, the main channel changing course, erosion occurring and new gravel banks appearing. Here oystercatchers nest among the pebbles and you may see sandpiper and goosander. Upstream look out for yellow wagtail, spotted flycatcher and redstart. Both mink and stoat inhabit the riverbank. Looking back towards Reeth and below Reeth School, the slopes are terraced by fine examples of medieval strip lynchets, narrow fields for crops, thought to have been formed by constant ploughing in one direction.

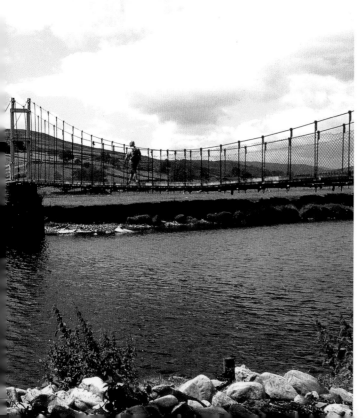

The Swing Bridge was washed away in floods in 2001 and replaced by an exact copy in 2002

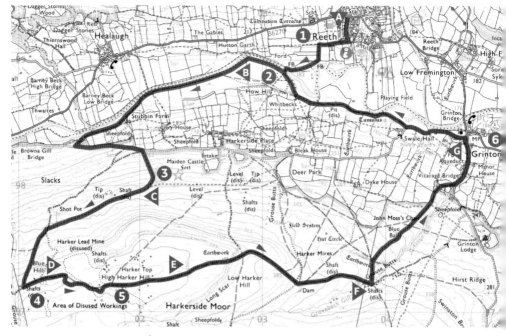

B Continue upstream along the riverbank, open at first then wooded. Soon after some stepping stones in the river there is a stile. From here climb up to walk by the wall to a road. Turn

Healaugh and Calver Hill from the banks of the Swale

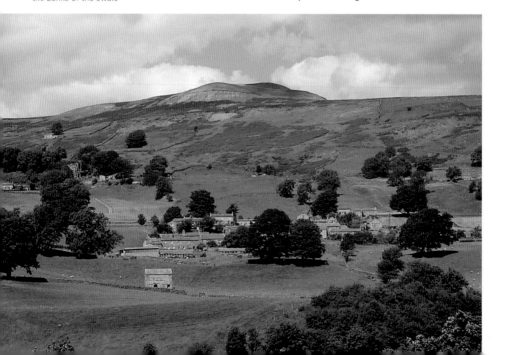

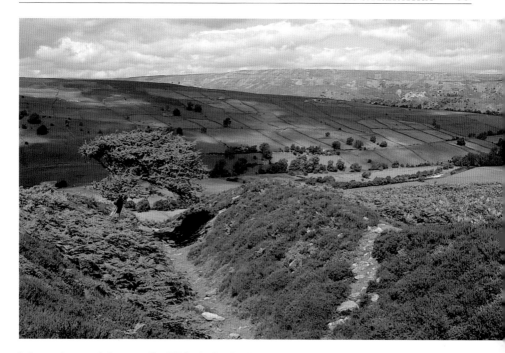

left up the road for ⅓ mile (500m). At the brow of the hill, strike up right, aiming for a Hawthorn tree on the horizon, and Maiden Castle hill-fort.

Embankment and ditch, Maiden Castle, with Fremington Edge

❸ Maiden Castle 022 981

Maiden Castle is a large hill fort, reminiscent of those on Ingleborough and Mam Tor in Derbyshire, except that this one is on the sloping hillside rather than on a summit. It is squarish in shape with a deep ditch and embankment all the way round. The long stone corridor entrance is also impressive. The fort, from pre-Roman times, must have dominated and defended an important Iron Age community in Swaledale. It is worth a walk round the rim to appreciate it fully.

▶ From the top (south-west) corner of the hill-fort climb away from it up the side of a shallow depression to a cairn on a mound. From here aim for the shooting box below the horizon (to the west-south-west, a bearing of 240°). The route roughly follows the contour on a shelf of land with a gentle rise. There is no path, only sheep tracks through the heather and bracken. After ½ mile (800m) there is the reddish-brown tip heap of Harker leadmine and a broad track.

Welted thistles on Harker leadmine tip heap and view to upper Swaledale

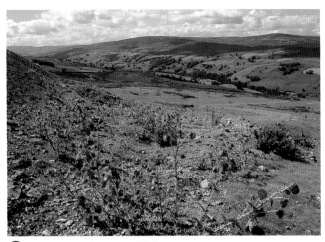

④ Harker Leadmine spoil heap 012 971

On and around the tip heap of Harker leadmine grow the little white flowers of spring sandwort, an indication of lead and known as leadwort and, bigger than spring sandwort, the pretty mossy saxifrage, and a good growth of welted thistle, with large nodding purple heads. The leadmine, bell pits and hushes were all means of extracting galena, the ore of lead, from the rich vein in the highest of the Yoredale limestones.

▶ Follow the track up, turning left before reaching the shooting box, and on to Harker Top, the flat summit of the broad fell of Harkerside. In a strong wind the grassy bell pits may give some shelter.

⑤ Harker Top 018 972

Millstone grit caps Harkerside where several neat bell pits, grassy mounds with a hollow at the centre, contrast with the surrounding heather moors. The pits cut down to the lead vein in the limestone beneath and the debris has given rise to sweeter soils and greener vegetation. Heather stretches south to the horizon where golden plover, red grouse and merlin are birds to look out for. About ½ mile (800m) from the summit, the route crosses the great Grinton-Fremington dykes, each with a huge bank and ditch commanding a view down the valley. They appear to be a large scale defensive system aimed, possibly, at the Roman advance.

▶ Continue along the summit bridleway in an easterly direction, with Fremington Edge to the left and the plain of York ahead. From the large earthworks on a limestone scar, the castellated tower of Grinton Lodge comes into view ahead

with Reeth over to the left. Keep straight on at a crossing of tracks to reach the beck (Grinton Gill).

F Go through the gate, down to the beck, along it for a few paces, up to the left, then across another major earth work. The path leads to a stile and gate in a fence and descends to Grinton village, first along the beckside past old cottages before crossing a stone bridge.

⑥ Grinton 046 984

The attractive village has some of the best traditional cottages in Swaledale with lintel dates of 1648 and 1666. Next to the church is the remarkable old building of Blackburn Hall formerly home of the Blackburn family and lords of Grinton. The church is dedicated to St Andrew and known as the 'Cathedral of the Dales'. It was built to serve a large parish stretching to the head of the Swaledale and as parishioners had far to come, market day was held on a Sunday to save an added journey. The church has much Norman and medieval work and is full of interesting features.

G Go through the church grounds and back onto the road that runs along the left side of the church. After 330yds (300m), turn off right along a walled path which brings you near the river. Cross the Swing Bridge and retrace your steps to the right, up the narrow walled path and along the lane back to Reeth.

River Swale and Calver Hill

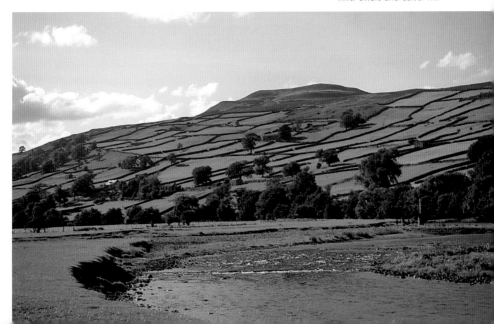

Gunnerside Gill

Gunnerside Gill is a long, narrow and dramatic gorge, a
tributary of the Swale. The lower part is clothed in rich
woodland, but most forms an austere landscape,
epitomising the human endeavour of the old leadmining
industry. North Swaledale is the most highly mineralised
part of the north Pennine orefield. Remains of crushing
floors, smelt mills, mine levels, kilns, spoil heaps, dams
and hushes provide a lunar landscape of industrial
archaeology – the perfect leadmining trail.

1 Gunnerside 951 982

Gunnerside is a lovely unspoilt village set in the heart of
Swaledale. Through its centre runs Gunnerside Beck dividing
the Lodge Green part of the village from Gunnerside proper.
The large Methodist chapel, built in 1789, is one of the
earliest and the Literary Institute, which sports a new
millennium clock, is dated 1877. The village has a character
very much in keeping with the dale and was the home of
scores of lead miners who walked to work in the mines and
smelt mills.

The boom in leadmining came between 1780 and 1820 but
lead continued to be mined until the 1880s when a real
slump brought misery and migration. Large families lived in
small cottages, two of which now make a modern home.
Conditions in the mines were terrible and the average age for

Cottages in Lodge Green, Gunnerside

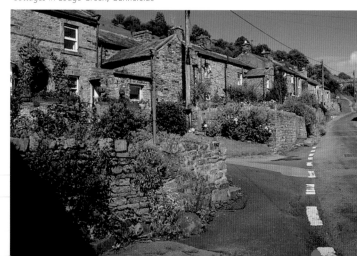

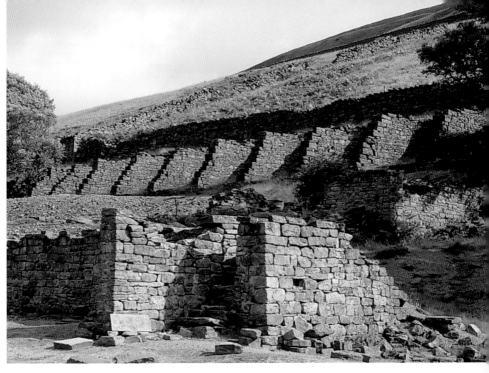

Sir Francis Mine, Gunnerside Gill

death was only 46, though for non-miners it was 61. Accidents, lung diseases, lead poisoning and tuberculosis all took their toll. With the decline in leadmining many left to find jobs elsewhere, including the United States.

Above the village, there is an open stretch, then a lovely woodland covers the steep valley sides. The old ash wood also has hazel, rowan, bird cherry and oak and, looking over the treetops, one can observe the birdlife. Besides the usual residents look out for the pied flycatcher – about the size of a robin. The male is a handsome black and white, and both adults swoop on the wing for insects.

There's a wealth of flowering plants, too, including St John's-wort, early purple and common spotted orchid, wild strawberry, coltsfoot, wood sage and angelica. In wet patches grow marsh valerian, large bittercress and meadowsweet. You may also see creamy coloured toothwort, a plant with no green leaves, being parasitic on hazel roots. In June above the wood grow the beautiful yellow flowers of mountain pansy and the little white stars of spring sandwort, indicator of lead.

A From the Kings Head go opposite, along the side of the beck, and to the rear of the old school. Soon enter a dramatic stretch of precious woodland full of flowers. Exit onto a grassy plain and the remains of Sir Francis Mine.

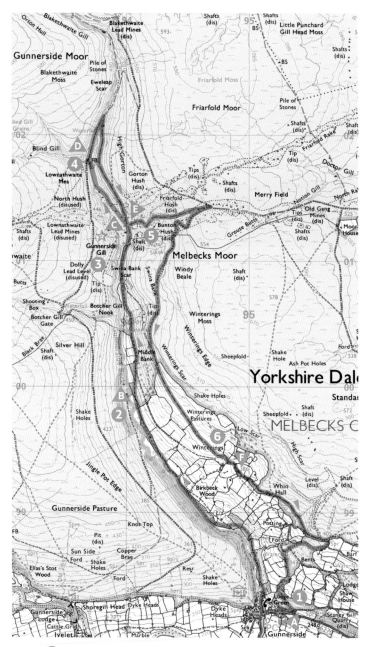

② Sir Francis Mine 940 999

Bouse bays for storing the raw ore and two crushing mills make up the remains of Sir Francis Mine. Across the beck is a

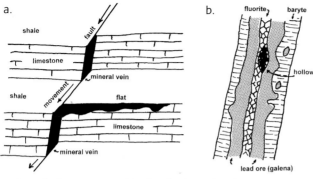

a. How a small fault can make space for a mineral vein

b. Minerals in a typical vein, about 20in (51cm) across

rusty cylinder, once used in the digging of an important level. The entrance can still be seen and the tunnel, begun in 1864, was cut to drain water from deep mines higher up the valley. Slow progress was made until the use of compressed air and then dynamite which speeded things up considerably so that by 1877 the level hit the rich Friarfold vein, 1,500yds (1,400m) to the north. A new shaft was sunk and the mine became highly mechanised resulting, for a few years, in profits which today would be measured in millions of pounds. The mine closed in 1882 when cheap imported ore caused prices to slump.

B Continue up the side of the valley to join a high miners' track. Opposite there is the gully of Botcher Gill Nook then the huge mine tip of Dolly Mine. The track leads to Bunton Mine and dressing floor, a fingerpost and Bunton Hush up to the right.

3 Bunton Mine 940 010
The mine and dressing floor is almost on the track itself and the ruined buildings include former offices, stables and blacksmith's shop. The bouse bays and waterwheel pit are also clearly seen. The mine tapped the Friarfold vein complex and the richest ore in Swaledale. Examples of the main minerals of galena, sphalerite, fluorite and baryte are abundant in the dumps and debris from the hushes. Galena is distinguished by its high density and lead-grey colour, being silvery when freshly broken; sphalerite, the ore of zinc is a waxy brown; the white, heavy mineral is baryte; fluorite has a watery appearance, whereas calcite is milky white and scratches with a copper coin.

This is a favourite haunt of the ring ouzel or mountain blackbird, a summer visitor distinguished by its white crescent bib and chat chat alarm call.

Mountain pansies,
Gunnerside Gill

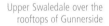

Descend on a narrow path to the floor of the gill and arrive at the Blakethwaite peat store and smelt mill at the junction of Blind Gill.

4 Blakethwaite Smelt Mill 936 017

At the junction with Blind Gill are the stone arches of the peat store and Blakethwaite smelt mill The furnace was between the cast iron pillars and behind it the flues carried the noxious fumes to a small chimney 150ft (45m) up the hillside. The long flues created the strong draught needed for the high temperatures in the smelting process. The smelt mill was in use during much of the 19th Century.

Ascend the valley side below the limekiln and along to a waterfall, crossing over to further ruins of Blakethwaite Low Level. Return on a higher track on the east side of the gill, descending slightly to Bunton Hush once again and the fingerpost.

5 Bunton Hush 942 013

Hushing is a method of opencast mining, so ancient that British miners were using it when the Romans arrived 2,000 years ago. Water was ponded up behind a dam and released in a flood to wash away the top soil. This was repeated many times revealing the vein, its nature and trend, giving useful information for the driving of levels and sinking of bell pits. There are several large hushes on the sides of Gunnerside Gill

Upper Swaledale over the
rooftops of Gunnerside

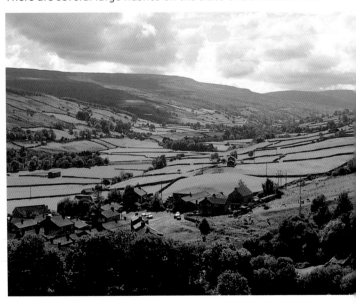

Barns and meadows, Gunnerside

that date to the 17th Century and Bunton Hush is the middle one of three. They were a devastating alteration to the landscape and now serve as incredible monuments to man's ingenuity.

E Go straight up the gully known as Bunton Hush, where boulders and rocks make rough going. Where the path becomes less steep and there is an open view to the right, turn off and aim for a sheep fold and two iron gateposts from where there is a good track on the slopes of Melbecks Moor, though not at the highest level. Under Winterings Scar the path is joined by a bridleway coming up from Gunnerside Gill with a fine limekiln. Keep on to the first farmsteads at Winterings.

6 Winterings 946 996
These scattered farms in fertile hollows below the higher scars are reminiscent of Alpine pastures, hidden from the world and of another age. The stone walls of the irregular shaped fields suggest they were built before the enclosures, and may be the result of sporadic clearing of woodland.

F Continue past the old farms of Winterings and Whin Hall, passing above the settlement of Potting to reach a gate and tarred road on the right. This winds steeply down back to Gunnerside with a bird's-eye view of the village and fine views of field barns and the length of upper Swaledale.

START/FINISH:
Muker, village at the head of Swaledale on the B6270 with car park by bridge. An infrequent daily bus service runs from Richmond and on summer Sundays from Leeds, Harrogate and Skipton

DISTANCE:
7½ miles (12km)

APPROXIMATE TIME:
About 4 hours

HIGHEST POINT:
490m on the upper slopes of Kisdon

MAP:
OS Explorer OL30, Yorkshire Dales Northern & Central areas

REFRESHMENTS:
Muker has village tea shop and Farmers Arms with bar food; Park Lodge in Keld, about two thirds the way round, has light refreshments

ADVICE:
Mostly broad easy paths, except approaches to Swinnergill Kirk and Kisdon Force, both of which need care

LANDSCAPE/WILDLIFE:
Good exposure of Yoredale limestones, sandstones and shales in Swinner Gill. Glacial diversion of the River Swale; wood cranesbill, melancholy thistle, meadow vetchling, rough hawkbit, tufted vetch, harebell; ferns, mosses and liverworts at Swinnergill Kirk; ring ouzel

An exceptional walk visits two delightful villages in upper Swaledale, has glorious views from Swinner Gill and Kisdon, passes through flowery meadows and a dramatic gorge, visits a cave where dissenters once worshipped and two picturesque waterfalls, then follows a stretch of the 'corpse road'. It is a real favourite and Kisdon Gorge is a part of Swaledale where there is no road and no traffic – perfect!

① Muker 910 978
The village of Muker, like others in the upper dale, was founded by Norse Vikings whose placenames and dialect words still survive. Muker means narrow cultivated strip. Edmund Cooper in his book Muker, the Story of a Yorkshire Parish, tells of the great characters and families, of the hardships and festivities. There was the Christmas feast known as 'Muker Awd Roy' when work was suspended in the leadmines, wives baked cheesecakes, Christmas loaves and 'secret cakes', stalls were set up, there were outdoor sports and the silver band played. The merrymaking continued in the three Muker inns where fiddlers entertained to singing and dancing.

The most famous residents of the area were the brothers Richard and Cherry Kearton who became pioneers in wildlife photography. They were also naturalists, writers and

Muker and Kisdon Hill

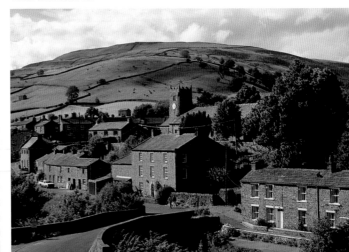

Kisdon Gorge and creeping thistle

explorers. The younger brother, Cherry (1871-1940) produced wildlife films and was known for his radio broadcasts. Plaques on Muker old school commemorate them. The Literary Institute with reading room and library used to host lectures, band concerts, evening classes and dances. The village silver band has still played in recent years.

Today Muker is a most picturesque village in beautiful surroundings, having changed little over the last 100 years, with a quaint collection of stone cottages dominated by the church and clock tower. The village store, teashop and pub provide good services for visitors.

The meadows near Muker are part of an ESA or Environmentally Sensitive Area where traditional management allows the growth of northern species such as wood cranesbill and melancholy thistle while other flowers include meadow vetchling, rough hawkbit, tufted vetch and harebell.

A Go up through the village where, to the right of the middle, a sign directs to 'Gunnerside and Keld'. A paved path leads through meadows to the river's edge. Turn right here, cross the footbridge then turn left up the right side of the River Swale.

B About 1½ miles (2.4km) beyond the footbridge and before arriving at the entrance to Swinner Gill and the site of a smelter, turn off the main track to the right. The turnoff point comes near a fence corner and where a small streamlet crosses the track and the narrow path through bracken is seen climbing up onto the right side of Swinner Gill. This takes you first to a crossing place of the beck, by a stone mine entrance gushing with clear water, then up the left side to the

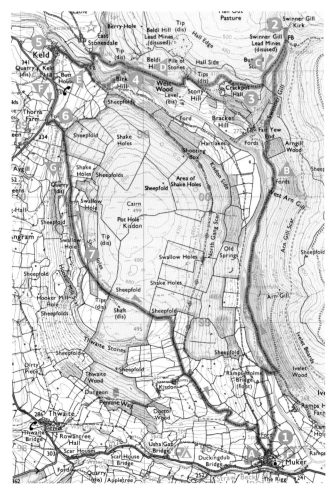

stone bridge at the head of the ravine, and the junction with Grain Gill. To visit Swinner Gill Kirk carry on up the bed of the gill for about 220yds (200m) as far as a waterfall with the cave on its left.

② Swinner Gill Kirk 912 015

At the head of Swinner Gill is a fine stone bridge, a waterfall and an entrance to Swinner Gill leadmine. There are also the ruins of a smelt mill and a dressing floor. The prospect from the bridge is breathtaking, a sort of keyhole view down this steep ravine, the length of Kisdon Gorge and beyond. The ring ouzel has its territory along the rocky gorges.

Next to Swinner Gill Falls is the cave of Swinner Gill Kirk, the

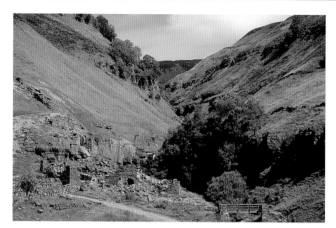

Smelt mill at the foot of Swinner Gill

scene of services held by dissenters during a time of religious intolerance in the 1670s and 1680s. It is possible to enter the cave safely for a short way even without a torch. The damp atmosphere around the cave entrance has created a habitat for ferns with maidenhair and green spleenwort, hard shield fern and brittle bladder fern. A liverwort with green flat lobes grows well together with mosses on the waterfall.

Between Swinner Gill Kirk and the main track is a well exposed unit of Yoredale strata. Below the limestone near the cave is a sandstone, making a small step in the gill, then black shale, then comes a thick limestone, scalloped and glazed by the acid waters that have poured over it.

C Take the upper path with views down Swinner Gill and Kisdon Gorge. The first ruin is a smithy with a forge still to be seen within. Below the smithy is Crackpot Hall.

❸ Crackpot Hall 906 008
The old farmhouse of Crackpot Hall was built by Lord Wharton for his keeper who looked after the red deer that roamed around here in the 17th Century. The house was occupied until the 1950s and is being restored. It has one of the finest views in the Dales. Above the hall is the smithy complete with forge, and the remains of a crushing mill and tips of the Beldi Hill Mines can also be explored.

D Carry on above the wooded gorge to a tributary waterfall – East Gill Falls. Go down to the footbridge over the Swale and up to join a path from the left. To visit Kisdon Force turn left along here to the fingerpost then left along a narrow path to the impressive waterfall of Kisdon Force.

4 Kisdon Force 897 015

The path to Kisdon Force is across a former landslip and into a steep limestone gorge, cut by torrents of glacial meltwater. It passes a large pinnacle of rock that has become detached from the cliff face. The double waterfall is most impressive and one of many along the Swale created by the differing rock layers of the Yoredales. Catrake Force is just above the village and even more hidden, while East Gill Falls is on a tributary stream.

E Return from the falls by the same route and to the hamlet of Keld.

5 Keld 892 009

Keld is an ideal centre for walkers. The open moors extend in all directions while on the river and side valleys there are half a dozen exciting waterfalls. The Pennine Way and Coast to Coast routes cross here so the Youth Hostel and camp site keep busy through the year. The village is 1,050ft (320m) above sea level but nestles comfortably in a hollow. One inhabitant was Richard Alderson or Neddy Nick, known for his 'rock band', a series of musical stones with which he entertained the locals. In the graveyard is the grave of Susan Peacock, the proprietress and personality of Tan Hill Inn for 35 years. At her funeral in 1937, 40 cars joined the cortège from Tan Hill to Keld.

F Leave Keld by following the road, keeping left at the junctions. Turn next left from the road along a cart track over the little stream of Skeb Skeugh.

6 Skeb Skeugh 893 006

The name means 'sheep wood' and the tiny stream is all that

Swinner Gill

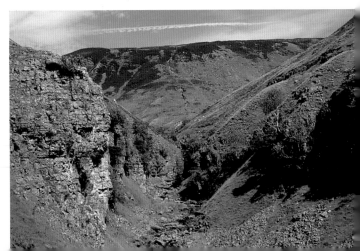

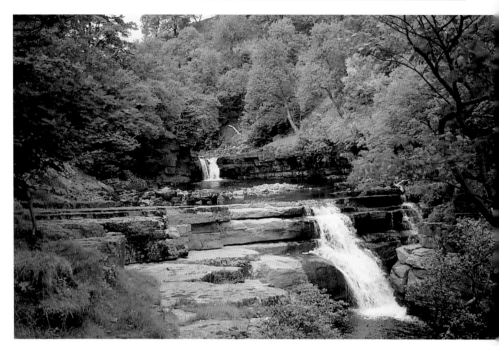

Kisdon Force

remains to drain this huge valley. This was the course of the Swale before the Ice Age when it became clogged with debris and ice, and a powerful overflow cut through where Kisdon Force is, to join and deepen the Swinner Gill valley. The River Swale now follows that route through Kisdon Gorge.

G▷ The broad track, the 'corpse road' leads up onto the side of Kisdon Hill and views ahead are of the Buttertubs road with Lovely Seat to the left and Great Shunner Fell to the right. Continue over the shoulder of Kisdon Hill for a splendid view of Swaledale and the rooftops of Muker below and a descent to the village.

7 The Corpse Road 896 995

The track over Kisdon hill was in use as a corpse road only before 1580 when Muker acquired its own church and burial ground. Pall bearers had a two day trek to the church at Grinton, with a night on the way at the Punchbowl Inn. The coffin was a wicker basket and relief bearers took over at intervals along the route. They rested their burden on specially placed coffin stones like those remaining at Gunnerside and Ivelet Bridge.

Whernside from Dent

Here is the best of all the routes up Whernside and certainly the quietest – a combination of riverside, fell and dale that is hard to beat. This is the highest mountain in the book, the track up is gradual and full of interest, and the views outstanding. Whernside is the least shapely of the three peaks, but its 8-mile (13km), massive, whaleback shape is impressive if only by its bulk. It has two or three surprisingly large tarns high on its flanks and occasional tall cairns or 'stone men' dotted here and there.

① Dent 705 870
The prettiest village in the Dales, Dent has narrow, winding cobbled streets, two attractive pubs, whitewashed cottages and a fine old church. Two large hunks of Shap granite commemorate the great geologist Adam Sedgwick who was born here. The village is famous for its 'terrible knitters' and its 'marble'. Men and women both used to knit socks and woollen garments, 'terrible' meaning remarkable. The marble is actually a polished limestone containing beautiful fossil crinoid stems and corals. Fine examples of the grey and black types can be seen in the church on the floor of the chancel. The limestone was also made into tables, fireplaces and ornaments. The Norman church was rebuilt in 1417 and the chancel added in the 1770s. The tower was rebuilt in 1787 and the clock dates from 1828.

A damp field – the Keld Habitat – by the footbridge has a variety of interesting plants including mint, marsh marigold, hay rattle, marsh ragwort, common spotted orchid and a rare and unobtrusive plant called marsh arrowgrass. In full summer along the riverbank grow wild roses, honeysuckle and that lovely hallmark of Dentdale, the giant bellflower.

Ⓐ From the car park go along the main street past the Sun Inn and the George and Dragon, bearing left to Church Bridge over the River Dee. Take the path up the right side of the river by the games field, keeping on this side of the tributary stream, known as the Keld, cross the narrow concrete footbridge to the left side and turn right to enter the 'Keld Habitat'. Go through the fields to Double Croft, cross the lane and another field to join the Dales Way and the riverside. At

the road, go in the up-dale direction, turning right past the old Methodist chapel, then left on the Craven Way. There is a steady but gradual pull up the main bridle track with views into Deepdale and back into Dentdale. Higher up, the track is walled with new gateposts and gates. On the left is a limekiln soon after which is the right turn at the wall corner, where the Craven Way carries on across open country. This is Boot of the Wold.

② Boot of the Wold 746 845

The bridleway is an old packhorse route from Dent to Ingleton along which coal, Dent marble, wool and knitted socks were carried. It was known as the Craven Old Way from which the long distance footpath takes its name. The area known as the Wold is a fine limestone shelf, dry underfoot and good for grazing. Here is the lower end of the Wold – hence the boot.

Whernside Tarns are shallow but when full are unexpected and impressive. If you come up to them in the mist with a strong westerly, you might for an instant think you were by a huge inland lake with the waves dashing and the far shore out of sight. In the sunshine they can be dazzling and blue, and frequented by black-headed gulls.

The millstone grit topped mountain produces acid soils and muted colours in the vegetation, a contrast from limestone in the valleys. The coarse sandstone also makes good drystone walling. Over millennia, sphagnum bogs have led to the formation of peat, which has caused so much trouble to restorers of footpaths. But all is transformed in August when the heather is in bloom.

Sedgwick memorial, Dent

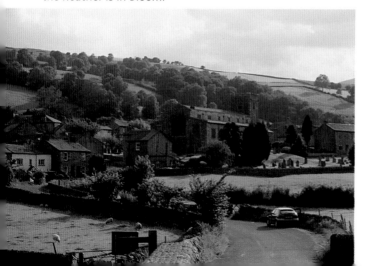

Dent from Church Bridge

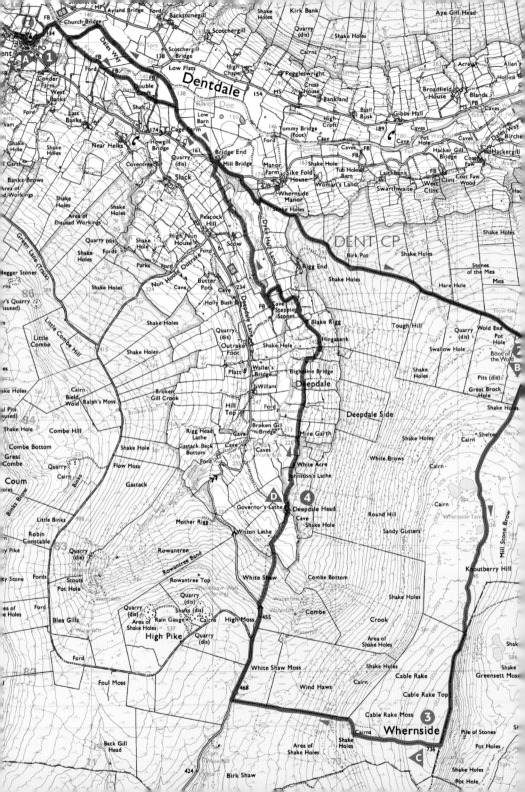

Green lane on the Craven Way, looking into Dentdale

B Turn north alongside the stone wall, leaving it as you head towards higher ground and the water's edge of Whernside Tarns. The path is discernible but it is worth keeping a compass bearing of 195° (roughly south) if the cloud is down. The path winds slightly and gradually approaches then crosses the wire fence on the left to join a main track up from Ribblehead. Follow the wall to the summit which is marked by a survey pillar.

③ Whernside 738 814
The Three Peaks path has been repaired into a hard-wearing track to avoid further erosion from the thousands of three peak walkers that pass this way. From the summit there are extensive views with Ribblehead viaduct and Ingleborough being most prominent. Unlike many survey pillars, the one on the top of Whernside is still in use, forming part of the national GPS network.

Golden plover nest among the sparse vegetation. They have a dark back that sparkles with gold in the sun. Dunlin is a smaller wader that likes to be near a tarn. Its high trill on a calm evening is an magical sound.

Occupation Road is a possible alternative route back to Dent but is frequently so wet and boggy that, as Mike Harding puts it 'you need the agility of a ballerina and the balance of a goat to skirt round it'. The name comes from the enclosure times, referring to land that was 'occupied'. The old packhorse walled track follows the contour as it winds along towards Barbondale. A prettier route is the one described below, down the length of Deepdale.

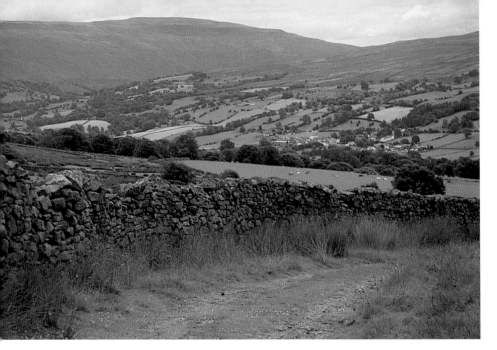

Whernside and Dentdale from Long Moor

C ▶ Turn right from the summit to head west to a stone tower and views along Kingsdale. Turn right to the wall corner and follow the wall down to the road, a quiet, gated road from Ingleton to Dent. Turn right, passing the end of Occupation Road and, after a short steep bit, leave the road for a path, labelled Mire Garth, down over rough pasture to Deepdale Head farm.

4 Deepdale Head 726 833

Deepdale is a quiet tributary dale to Dentdale. Its history goes far back and, since most of it is an Environmentally Sensitive Area (ESA), haymaking is carried on in the traditional way. As the hay meadows are full of flowers and may have ground nesting birds, cutting is postponed until about 10th July so that seeds have time to set and nestlings to fledge. The old hay meadows are a rarity in Britain and may contain 20 or more plant species per square metre. Among them are wood cranesbill, melancholy thistle and globe flower, all northern species. Pignut, two of the buttercups and hawkweeds, yellow rattle and knapweed are common and, in damp corners, common bistort and lady's smock.

Rigg End is a large working farm lower down on the right side of the dale which once kept Negro slaves – used to build Whernside Manor. They are said to have lived in a cellar under an outhouse, connected to the farmhouse by a secret passage, which became haunted by their ghosts.

Bracket fungus on Elm, Deepdale

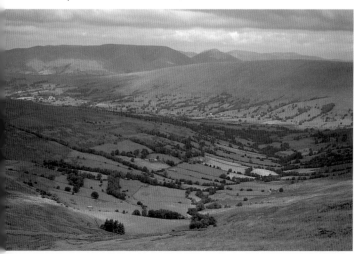

▶ At Deepdale Head farm, the path crosses Coombe Gill which here is carving out a mini limestone gorge. Turn away from the beck and through fields to the holiday cottage of Mire Garth. Keeping below the wall, pass a derelict cottage then, when approaching a barn, continue to walk roughly parallel with the river, but keeping up, crossing several stiles until a farm track is reached. Continue on the track and turn left into the bridleway marked Deepdale Lane. Follow the way to a footbridge, cross and turn right, keeping close contact with the tree-lined beck. Turn up above the fir trees to a gated stile and a lime kiln. In the next big field (before an electricity pole) slip between some ash trees on the right to reach the road. Cross the road and continue along the Dales Way and the banks of the River Dee to Church Bridge, then left up the road and into Dent.

Deepdale and Dentdale from Whernside

Sedbergh to Dent & Back

START/FINISH:
Sedbergh, Cumbria. There are two car parks in Sedbergh, one free. Buses run from Kendal to Sedbergh Monday to Saturday

DISTANCE:
11 miles (17.5km)

APPROXIMATE TIME:
6 hours

HIGHEST POINT:
290m/950ft on Long Moor (Frostrow Fells)

MAP:
Coverage for the whole walk appears on Harveys Superwalker, Yorkshire Dales, Three Peaks with the Sedbergh bit on the reverse side; two OS Explorer maps are needed, OL19, Howgill Fells & Upper Eden Valley and OS Explorer OL2, Yorkshire Dales, Southern & Western areas

REFRESHMENTS:
In Dent, at the half-way stage, there is an excellent choice of tea rooms, pubs and restaurants; there is also a wide choice in Sedbergh

ADVICE:
Walk includes open moorland. Carry a map and compass in poor weather; as way finding needs care in some places

LANDSCAPE/WILDLIFE:
Cranberry, sundew, tormentil; black-headed gull

The full day's walk uses two quite different routes between Dent and Sedbergh, the visit to Dent town coming conveniently half way. With wonderful views, it passes over Frostrow Fells and descends through farms and hay meadows to the River Dee. Dent is the most charming village in the Dales and worth a linger. The return is along the riverside then up and over the hill with great views of Sedbergh and the Howgills. There is a variety of habitats for birds and flowers and the route passes some ancient farmhouses.

1 Sedbergh 657 921

This great little town was formerly in Yorkshire but from 1974 became part of Cumbria. The old market town received its charter in 1251 and there is still a market on Wednesdays when stalls spring up in the upper car park. With hand knitted woollens and the establishment of several cotton mills, Sedbergh grew in size and importance. Many of the yards off the main street, such as Weavers Yard, Kings Yard and Davis Yard, date from this time. The school also grew: 'It is Cautley, Calf and Winder, that makes the Sedbergh man' says the school song, and training runs up Winder may have been the basis for the making of several great Rugby Union players from the school.

Across the Rawthey valley to the Howgills from Side Farm

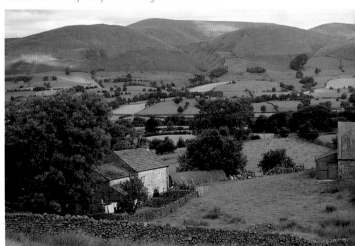

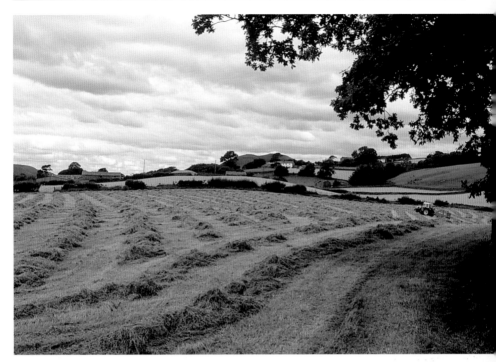

The village of Millthrop is based on the cotton mill built in the 1790s. The mill was destroyed by fire in the 1940s and the village today has become an attractive group of cottages with flowery gardens and roses round the door. The main part of Millthrop is seen towards the end of the walk.

Haymaking in Dentdale

In this first section of the walk there is a Blandses farm and a Wardses, and on the return there is a Leakses. These are just what they appear to be. The Bland, Ward and Leake families established the farms, and people would say 'that's the Leakse's place', and so on, thus leaving their name in the placename.

Ⓐ Starting in Sedbergh on the A684, walk east to the end of the street and cross over to take the path past the playing fields and over the hill. Branch right at the stile to descend to Mill Bridge. Over the bridge turn left along the river for a few paces then follow the wall round to the right into a walled path and the tail end of Millthrop village. Go left, passing the entrance to Blandses Farm and take the next right, a stile by a seat. At the metal gate, take the stile to the left of it, contouring the hillside and finding three or four stiles leading gradually down to a farm track, then a lane. Here turn right

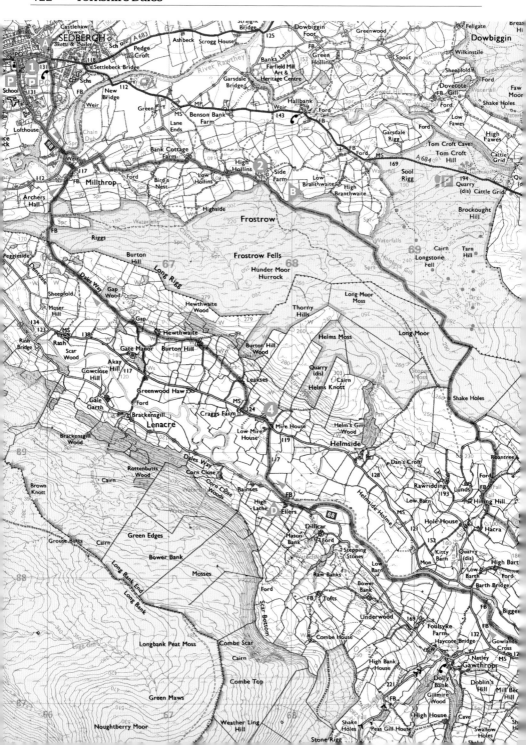

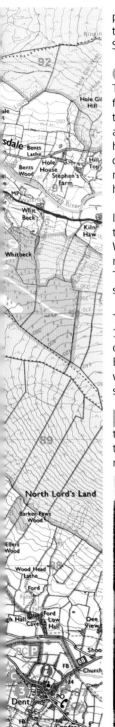

past Wardses Cottage and along the lane to the end and open moor. The last building is Side Farm.

2 Side Farm 677 911

These fells are not high but there is a feeling of freedom and openness and a great view back to the Howgills. In the wet places grow sundew and cranberry and, if you pass by in August, hundreds of sundew will be in flower with red cranberries scattered on a bed of sphagnum moss. Other flowers on the acid grassland are heath bedstraw, tormentil and milkwort.

In good visibility there is an unbroken view to the Lakeland fells while you can see Whernside, the flat-topped Crag Hill and the more hummocky outline of Middleton Fell. Then Dentdale appears with Dent cosily situated in the centre of it.

The ancient farmhouse of High Hall, dated 1625, really does look its age. It was the home of the Sill family for a time and is said to be Emily Brontë's model for Wuthering Heights. It was the Sills who built Whernside Manor using slaves, when it was known as West House.

B▶ Once on the open moor, follow the wheeled track, forking right and heading for a sunken track up the hillside ahead – the route is up the right side of Holbeck Gill. On higher ground, the

Church Bridge and Dent

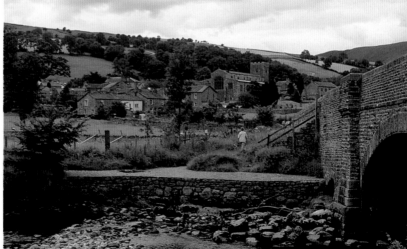

Meadow cranesbill along the River Dee

path picks up a wall on the right and there is a large boggy patch (with sundew and cranberry). Soon after the highest point, with fine panoramic views, turn right on a bridleway 'to Lunds'.

Pass a pond and enter a green lane. After only 130yds (120m) turn left through a gate and follow the wall round on the right and down to a gate gap then Blea Beck Gill, shrouded in trees. At the foot of the gill go left through fields, at one point keeping up above some oak trees. At the ruin of Thackthwaite, go left of the building to a hidden stile opposite a small barn which leads through fields to the old farm buildings of High Hall. Continue down the farm track, left along the tarred lane and over the stile to the banks of the Dee and Church Bridge. From here it is just a short stroll into Dent.

③ Dent 705 870

Cobbled streets, two pubs, cafés, cottages and a huge church, Dent town is full of character and charm. Near the fountain at the centre of the village there once stood a market cross. Dent fair was held each June when the place was crowded with people. There is the story of Old Willan, a pauper who in 1854 inherited a large sum of money. As soon as the news came, the church bells were rung, but Old Willan kept to his odd ways and continued to wander around wearing his night cap.

There is a scenic river walk between Dent and Ellers, some of it on raised banks where flooding has been a problem. Birds that like to visit the riverside include black-headed gulls, pied and grey wagtails, dippers, herons and curlews. The oystercatcher has taken to river stretches in the dale, even nesting in meadow grass. You will also notice a lot of bistort, a leafy plant with pink flower spikes. The young leaves were used to make Easter-ledge pudding, which provided some of the vitamins the winter diet lacked.

Go past the National Park car park and, just after the Methodist chapel, turn right to the riverbank then left for a 2 mile (3.2km) walk to Ellers footbridge. Pass Barth Bridge and turn across a field to the road for the last few yards.

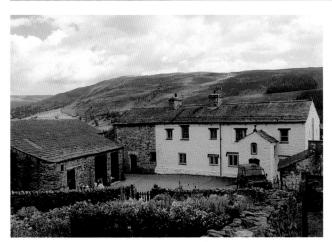

Very old farmhouse of Burton Hill with Whernside and Crag Hill

④ Ellers 677 892

Some of the farmhouses are very old. Mire House is dated 1635, and Burton Hill, which is thought to have been an inn on an old packhorse route, is now believed to date as far back as 1545.

▶ Cross the footbridge and follow the right bank for a couple of fields, then right to reach the Dent to Sedbergh road. Go left past Mire House for 300yds (275m) as far as Cragg Farm then right, 'FP to Millthrop 1½'. At Leakses go up steps and in front of the farmhouse, continuing past Burton Hill, Hewthwaite and Gap farms. Pass along the lower edge of Gap Wood, after which there is a good track, walled to start with. Curve right over the shoulder of the hill with new views of the Howgills and Sedbergh. Descend to Millthrop village and turn left then right to Mill Bridge, ending with a stroll up the road into Sedbergh.

Sedbergh and the Howgills

Dentdale & Craven Wold

START/FINISH:
Ewegales Bridge, 3 miles (5km) above Dent on the road to Hawes/Ribblehead. Vehicles may be left at the Ewegales camp site, the field opposite the bridge; the farmer there will be pleased to receive a small fee in return for parking. Also access the route via roadside car park at Ibbeth Peril; the walk may be started from Dent station (add 1 mile, or 1.6km)

DISTANCE:
10 miles (16km)

APPROXIMATE TIME:
About 5-6 hours (no stops)

HIGHEST POINT:
1,770ft (540m) on Craven Wold, the northern slopes of Whernside

MAP:
Harveys Superwalker, Yorkshire Dales, Three Peaks. OS Explorer OL2, Yorkshire Dales, Southern & Western areas

REFRESHMENTS:
The Sportsman's Inn, a mile after the start, then nothing except in Dent, where there are plenty of eating venues

ADVICE:
Be equipped for a full day's outing

LANDSCAPE/WILDLIFE:
Railway scenery; fossils; grey wagtail, dipper, house martin, swallow, pied flycatcher, spotted flycatcher; orchids, common twayblade, greater birdsfoot trefoil, bush vetch, eyebright, cranesbills

This splendid walk explores the upper part of the River Dee, passes over the Blea Moor railway tunnel and an aqueduct where a beck flows over the railway, and traverses the Craven Old Way to return through a string of Dentdale farms. The views are always changing and often extensive, and the walk is full of interest.

❶ Ewegales Bridge 755 868

From spring and into summer there is a delightful wealth of flowers in local hay meadows, in unused field corners, the riverbank and on roadside verges. At Ewegales, especially on the steep slopes which are left uncul, and in the next little area there are hundreds of orchids, especially common spotted orchid but also common twayblade and the occasional greater butterfly orchid. Greater birdsfoot trefoil, bush vetch, eyebright, wood cranesbill and meadow vetchling are also common. Along the road three more cranesbills flourish, meadow cranesbill, shining cranesbill and herb robert. They are so named as each brown seedpod has a long beak.

Cottage at Lea Yeat built as a Quaker Meeting House

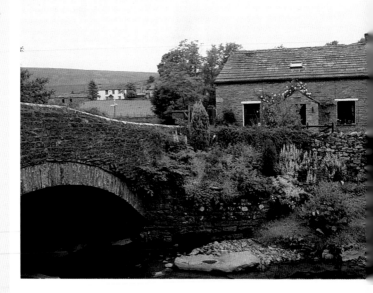

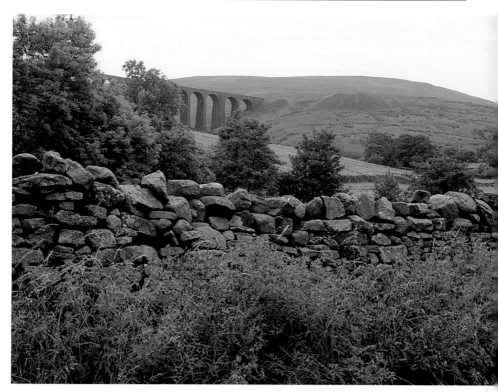

Meadow cranesbill and Arten Gill railway viaduct

Grey wagtails and dippers like to be near the water while house martins and swallows prefer the old farms. Look out for two other summer visitors, the pied flycatcher and spotted flycatcher which nest in trees along the roadside. The river sometimes disappears altogether where it passes over limestone, yet at other times it can swell to a torrent. Large trout manage to survive these changes.

A Starting from the campsite, walk along the bank of the river, soon to join the road at Lea Yeat Bridge. The next almost 2 miles (3.2km) is along the road, but a very pleasant stretch it is, passing the Sportsman's Inn and then Stonehouse near the Arten Gill railway viaduct. The Youth Hostel is on the right, then at Bridge End Cottage, turn right over the packhorse bridge to go up through rush-filled fields to Dent Head.

2 Dent Head 774 842
The old restored farmhouse stands in a sheltered hollow 1,000ft (305m) above sea level, the right of way passing the front door.

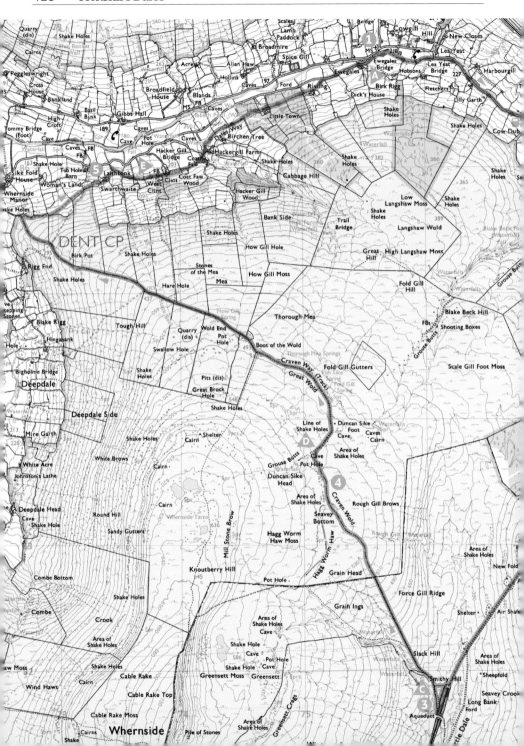

Well-preserved fossils often occur in shale, a hard, fine grained mudstone. Trilobites have been found in shales outcropping above Bridge End and the shales by a footbridge above Dent Head contain fossil shells (brachiopods) and solitary corals. There is also a non-marine bed with plant remains. Because of compaction over geological time, mudstone also tends to distort the fossils.

The 1½ mile (2.4km) tunnel of Blea Moor is the most famous on the Settle-Carlisle line. In the 1870s it took four years to build and cost £120,000 with 300 men employed. The highest part of the path over the tunnel is 500ft (150m) above the railway tunnel.

Greater butterfly orchid, Dentdale

B Beyond the farmyard, follow the beck up to the railway and spoil heaps from Blea Tunnel. Go steeply up through the conifer plantation and onto the open moor with fine views back along the railway line to Dent station. Pass three ventilation shafts and the highest point at 1,640ft (500m) above sea level with a view of Ingleborough ahead. Half a mile beyond the third vent leave the track to cross Little Dale Beck and a bridge over the railway. Beside the bridge the beck flows over the railway line along a beautifully built stone aqueduct. (If Little Dale Beck is in spate, go further on to a bridge.)

③ Force Gill Aqueduct 761 816

The aqueduct provides the unusual occurrence of a humble beck off the fells being channelled in a magnificent construction over the railway which here runs in a deep cutting before disappearing into Blea Tunnel. Force Gill is Norse for 'waterfall ravine', an appropriate description for the attractive waterfall that comes into view.

C The route is joined now by the Craven Way and the path has been upgraded to take the thousands of walkers who do the Three Peaks to the top of Whernside. The route is up to the right of Force Gill and its fine waterfall, with the bulk of Whernside to the left.

④ Craven Wold 753 835

Old Craven Way is an ancient Packhorse route from Dent to Ingleton along which horse trains and travellers carried coal, wool and farm produce. Duncan Sike is a peaty rivulet high on the Craven Wold which disappears into the limestone in a swallow hole before the ruined barn. The barn suggests that the grazing was good here on the limestone and that cattle were brought up here in the summer months.

▶ On reaching limestone, the grass is greener and dry underfoot. This is a section known as Craven Wold where the highest point of the walk is reached at 1,770ft (540m). Pass a ruined barn with views ahead now of Great Knoutberry Hill and Arten Gill viaduct. The path curves to the left and continues in splendid style on grass-covered limestone pavement. Pass the wall corner known as Boot of the Wold and on to the green lane which leads down into Dentdale and views left into Deepdale.

Entrance to Blea Moor tunnel

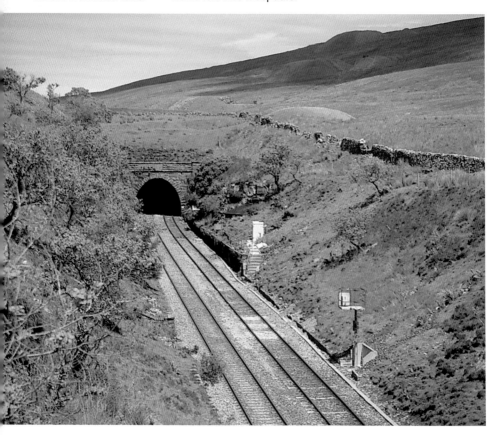

Outhouses of a Dentdale farm

Just before another wall corner, take the path signed for Laithbank to the right, descending through some rush-covered pasture. Follow the marker poles curving right and at the last one head down half right to a ladder stile. Cross more ladder stiles to reach the old renovated farmhouse of Laithbank.

❺ Laithbank 732 856

Many of the farmhouses are old established and tend to be dotted along the sides of the valley about every ¼ mile (400m). Their names contain Norse elements such as -laith, -clint, -gill, -thwaite, -scale and -dub. The Norsemen arrived in the 10th Century via the Isle of Man, Cumbria and Lancashire and must have felt at home in the high Dales country. They were herdsmen who hunted and had no wish to sow crops, so they spread out in an independence that suited them.

▶ Halfway down the drive, turn off, round a barn to continue up to Clint and on to Coat Faw, then in front of the old farmhouse of Hackergill. After crossing a meadow, the path passes through the dark conifers of Little Town plantation. After Rivling, the route joins the road to Ewegales Bridge.

Cautley Spout & The Calf

Sedbergh, at the foot of the Howgills where so many valleys meet, is a great centre for walks, and this one explores the Rawthey Valley before a steep climb up the side of Cautley Spout waterfalls on an ascent to the highest point in the Howgills – The Calf. The return is on a fine track over Bram Rigg, Calders and Arant Haw, descending via Settlebeck Gill.

1 Sedbergh 657 921
The town is famous for its public school, founded in 1525, former pupils including Adam Sedgwick, professor of geology at Cambridge, and the son of poet William Wordsworth. Woollens and especially hand knitting became an established

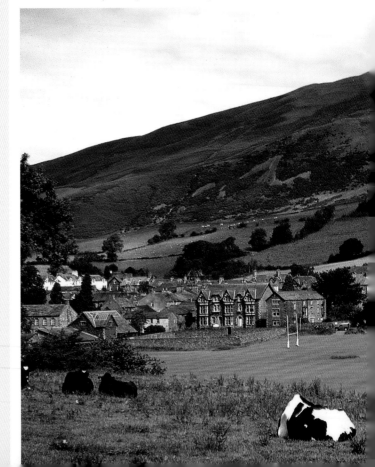

trade, and there is still an old spinning gallery in Railton's yard. St Andrews church dates back to Norman origins, but was largely restored in 1886. The Normans also built a motte and bailey castle, the remains of which are still to be seen on Castle Haw. In 1652, at the Whitsun fair, George Fox preached here for several hours to a large crowd. The following Sunday he went on to address a thousand people on Firbank Fell, an event that saw the beginnings of the Society of Friends (Quakers). There is a busy market on Wednesdays and a livestock auction on Fridays. The town is the largest in the Yorkshire Dales National Park and is a thriving, friendly place, where tourism is prospering.

The attractive farmhouses between Sedbergh and Cautley all vary in appearance and have seen some interesting history. Roger Moister, born at Underbank, went to Pennsylvania and became an ardent Methodist preacher. Stone Hall has Westmorland style chimneys, a three-storied porch and

Sedbergh and Winder

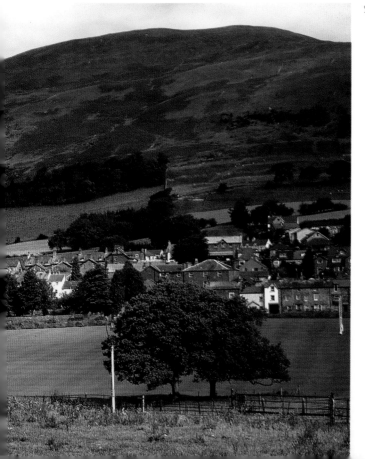

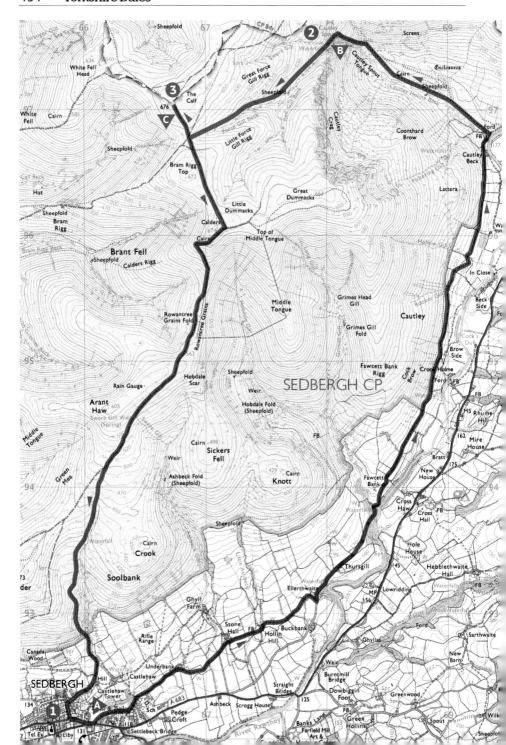

Birdcherry in the Rawthey valley

dates back to 1595. Hollin Hill is dated 1712 and EB stands for Edmund Bland, its first owner. Thursgill farms the land as far as Cautley.

In the summer, swifts are always to be seen over Sedbergh's roof tops, house martins and swallows search for insects around the farms, and along the hillside towards Cautley song birds take cover in the hawthorns and gorse: linnets, always more than one, yellowhammer, song thrush, pied flycatcher and willow warbler.

A From Sedbergh town centre go east along the main street (A684) and in 160yds (145m) go left through a gate set back in a wall onto a footpath, labelled 'Thorns Lane'. It leads below Castle Haw (the motte and Bailey) and to the rear of some houses. Cross the stream and turn left to follow a narrow lane on the track to Underbank. Go part way down the farm track and left through fields to cross Ashbeck Gill. Pass the fine farmhouse of Stone Hall, leaving the farmyard by a gate to the right of the barn and continuing to Hollin Hill where there is a step stile at the rear of the barn. Go across the next field to a ladder stile then, passing the upper end of a stone wall, go down the near side of the white house (Ellerthwaite) to join a wooded lane which leads to Thursgill.

From here, an ancient packhorse route leads on to Cautley along the lower slopes of the Howgills with views up the valley and across to Baugh Fell. Cross Hobdale Beck and several other streams and springs, keeping up on the hillside, almost always above the wall, to descend to a footbridge over Cautley Holme Beck, with a first view of Cautley Spout. On crossing the footbridge a single file track leads towards the

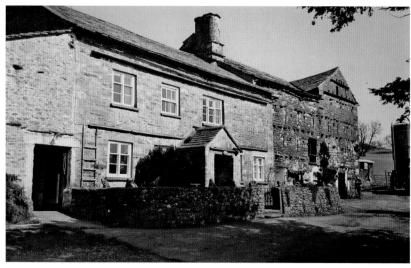

Hollin Hill farm was built in 1712

falls. Cross this and after 10m you will be on the wide main track. Further up there is a national park information plate on top of a boulder. Turn up the track to the base of the falls for a well-earned rest.

❷ Cautley Spout 682 975

The rugged scenery is magnificent where the precipitous Cautley Crags complement the falls of Cautley Spout. The great hollow beneath the crags was formed by the action of ice to form a typical corrie. The falls drop 650ft (200m) in a series of cataracts and after heavy rain are spectacular. Semi-wild horses roam the hillsides.

In the ravine below the falls, where rowan and ash trees have a footing, devilsbit scabious and golden rod cling to rock crevices. New Zealand willowherb and occasional specimens of Starry saxifrage are to be seen higher up on the banks of Red Gill Beck.

Well below the falls an enclosed area has been established – the Cautley Beck Habitat Enhancement – to exclude sheep and encourage plants, fish and wildlife.

B▸ Climb the staircase up the side of the falls, with close views of them all the way. The path crosses Swere Gill, hugs the side of Red Gill Beck and forks right along Force Gill Beck. Once at the saddle, turn right to visit the summit of The Calf. Take care crossing Swere Gill, which can be very dangerous if in spate. An alternative would be to use the old path which

goes up from near the top of the engineered stairway, following high above the left bank of the Swere and thence on to meet the improved bridleway and path to the Calf.

❸ The Calf 667 970

The highest point of the Howgills is 2,220ft (676m) above sea level and presents one of the most far-reaching views in England. This amazing panorama looks west to the length of the Lakeland mountains, north to the Eden valley, with Cross Fell and Mickle Fell, east to Wild Boar Fell and Baugh Fell. To the south are Penyghent, Ingleborough and Whernside with Morecambe Bay and the Lune valley.

The whole of the Howgills are made up of very compact, ancient sandstones of Silurian age, and since the rock is of an even hardness, it produces rounded outline to the hills, with few abrupt features.

Keep an eye open for the raven. It is larger than the carrion crow, with slower wingbeats and a deeper voice. One species it feeds on is the dor beetle, the rounded, shiny dung beetle that can be seen slowly walking over the footpath. Buzzards and the occasional peregrine falcon also inhabit these hills.

⏵ Return the same way from the summit of The Calf and continue in the same direction on a newly constructed track skirting the tops of Bram Rigg, Calders and Arant Haw. Curving round to the right, ahead is Winder with Crook to the left of it. The route lies between them, down the valley of Settlebeck. Turn left at the low point on the path to Winder atop the right bank of Settlebeck Gill. Follow the gill bank. Lower down above the gorge, the bank in front of you drops steeply away. Though the kissing gate can be seen from here, do not drop down by the beck, but move the short distance right onto the main path. Continue to the road which leads back into the main street of Sedbergh.

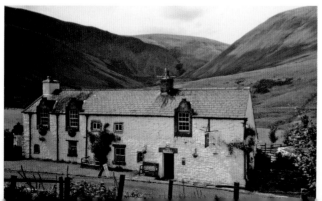

Cross Keys Inn and Cautley Crags

START/FINISH:
Carlingill Bridge, SD 624996; turn off the Tebay to Kendal road near Low Borrowbridge, signed 'Carlin Gill'; there is parking space off the road above the bridge.

DISTANCE:
7½ miles (12km)

APPROXIMATE TIME:
4 hours or so

HIGHEST POINT:
1,525ft (465m), reached near to the summit of Linghaw

MAP:
Harvey Superwalker, Howgill Fells; OS Explorer OL19 Howgill Fells & Upper Eden Valley

REFRESHMENTS:
There is not a café, pub or tea room for miles, so be self sufficient in food and drink

ADVICE:
For the sure-footed; there is a rough gill scramble. Good boots are recommended. Mist could be a problem on the tops; binoculars useful for birds and views

LANDSCAPE/WILDLIFE:
Glacial deposits, folded strata; golden-ringed dragonfly, small heath butterfly, dor beetle, fresh water sponge; parsley, ferns; New Zealand willowherb, devilsbit scabious, slender St John's-wort, raven, little owl

You can see the intriguing entrance to Carlin Gill from the motorway, and few people come for a closer inspection. This walk explores it in detail with an exciting bit of gill scrambling followed by a wonderful high level footpath on the western edge of the Howgills. There are outstanding views of the Lune valley and on a clear day a profile of the whole of the Lake District with Morecambe Bay not far below. The return is to Howgill Lane, through farms and along the Roman road of Fair Mile.

❶ Carlin Gill Bridge 624 996
Carlin Gill Bridge is a simple stone arch over a rocky gorge. Not far from the bridge is a mound topped by a cairn, which may have been a burial cairn. This is Gibbet Hill where human bones have been found. The clanking of chains may once have been heard as the body of a wrong-doer swung from the gibbet.

Carlin Gill – the name means 'old woman ravine' – marks the limit of the Yorkshire Dales National Park which followed the

Carlin Gill Bridge

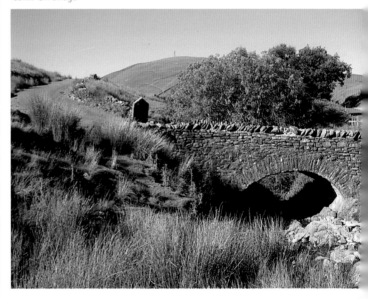

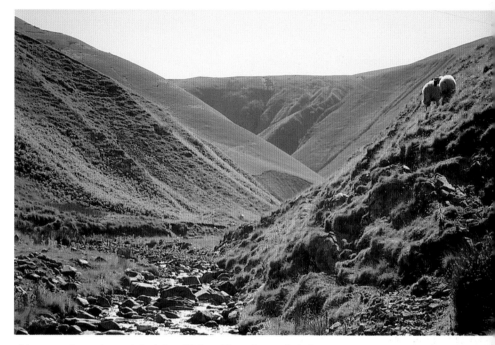

Valley of Carlin Gill

old county boundary of the West Riding. There is good shelter for a variety of mountain flowers. The rocky parts often have parsley fern, and New Zealand willowherb – tiny white flower heads each on a slender reddish stem, while foxgloves stand boldly on the screes. Clinging to damp rock ledges grow yellow mountain saxifrage which likes these cool places and is only found above 1,000ft (300m). At the foot of Black Force are fronds of hard fern, lady fern, brittle bladder fern and maidenhair spleenwort. In summer the cliffs are decked with devil's-bit scabious, slender St John's-wort, common valerian, golden rod and more than one type of hawkweed.

Sand martins are a feature since they nest in numbers in the sandy top of the glacial debris that plasters the lower part of the gill. Dippers, grey wagtails and wheatears inhabit the gill, and three insects you are likely to see are the golden-ringed dragonfly – large and green with yellow bands, the small heath butterfly and the slow moving glossy dor beetle. The stream is exceptional for the growth of a fresh-water sponge that is dotted over the wet stones.

A Start by walking up the side of the beck, crossing over occasionally to find the best route. Take extreme care as there are many slippery boulders in wet weather. Soon pass

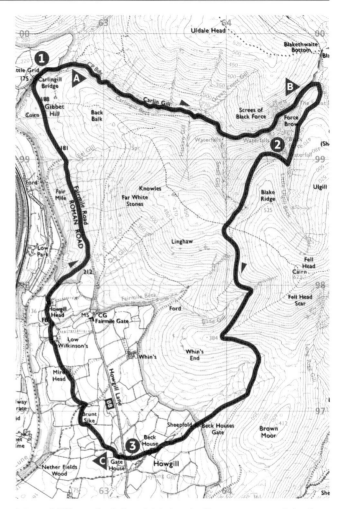

Weasel Gill on the left, which has built out a stony delta into the main valley. As the valley narrows, Green Knott Gill enters from the left and Small Gill from the right. In the gorge, the rock strata dip steeply as the sides close in. On the right, don't miss the narrow ravine of Black Force where Little Ulgill Beck tumbles down a staircase of rocks and falls.

❷ Black Force 644 911

If, while scrambling up the gill and rounding the top of it, you cast your eyes upward now and then, (with care, as you can easily slip!) you may see a buzzard, raven or peregrine. Their sound may give a clue to their presence. Buzzards are fairly frequent on the Howgills and give a mewing cry. The raven

has a deep-throated purrk, and the peregrine a harsh kee-errk, a 'mew' that is high and piercing.

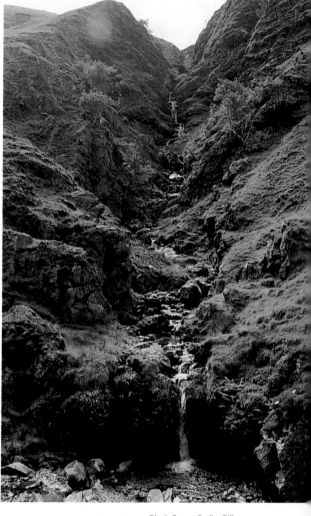

B After Black Force there is an exciting scramble – along the beck if the water is low. Continue up to the Spout, a waterfall shoot, 30ft (10m) high and almost hidden under a rock ledge that blocks the main gorge. From the foot of the waterfall scramble up the left side, and a brief zigzag brings you above it.

The valley divides and the route takes the right fork, that of Great Ulgill Beck, to where a worn track comes in from the left. Cross the beck to the right and climb up the steep grassy bank to find a good path high above Carlin Gill – along the top of the steepest slope.

In clear weather there are fine views of the Lake District from above Carlin Gill. Scafell Pike appears roughly behind an aerial mast with Great Gable further to the right. As you come over the col of Linghaw, a fresh panorama greets you with the lower Lune valley, Morecambe Bay and southern Lakeland.

Black Force, Carlin Gill

The route has taken a broad U-turn to a higher level and now heads for the upper end of Black Force where the rock layers form a downfold. Cross Little Ulgill Beck which disappears in to Black Force chasm, and go up the steep track opposite and round the hillside of Blake Ridge – still with precipitous views of Carlin Gill – and then away and to the col or saddle on Linghaw, now with a view to the south of the Lune valley and Morecambe Bay. Linghaw summit lies 250yd (230m) from the col, which is the highest point of the walk at 1,525ft (365m).

Carlin Gill Force

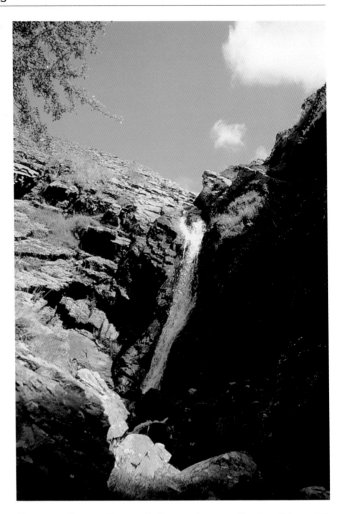

Golden-ringed Dragonfly
emerging, Carlin Gill

Carry on along a fine track that makes excellent walking with short green turf winding round the head of Blind Gill. The path rounds the next ridge of Whins End to descend to Ellergill Beck. Follow the path to Beck Houses Gate and pass through the farmyard (of Beck House) and along the concrete drive to reach Howgill Lane.

❸ Howgill Lane 631 966

Birds to be seen in the farmland along the Lune are the yellowhammer, swifts and swallows, and the little owl.

Howgill Lane and Fair Mile forms the old Roman road from Ribchester in Lancashire to Carlisle. Three miles (5km) north

of Carlingill Bridge are the remains of the Roman fort of Low Borrowbridge, which guarded the Lune gorge. Fair Mile takes its name from the sheep and horse fairs that once were held here.

▶ From Howgill Lane, the next 1 mile (1.6km) of the route passes through four or five farms and regains the road again further north. Cross the road to go through Gate House farmyard and, turning up-valley, proceed to Brunt Syke, passing round the farmhouse. Without losing height, go through the fields and over a ladder stile to pass below the farmhouse of Mire Head. Take care as the stile may be unstable. Don't miss the step stile to go left of the gate and the wall to Low Wilkinson's, where the route is through the farmyard and straight on, crossing a footbridge hidden among the trees where Fairmile Beck follows a cleft in the rock. Pass right of Midge Hole, more properly called Howgill Head, and on to a gate in the intake wall. Go forward up through the bracken to reach the road from where there are fine views of the Lune gorge.

Turn left for 1 mile (1.6km) along Fairmile Road to complete the walk. Gibbet Hill is a mound on the left about 250yds (230m) from Carlingill Bridge.

View down Carlin Gill to Lune Valley and Lake District

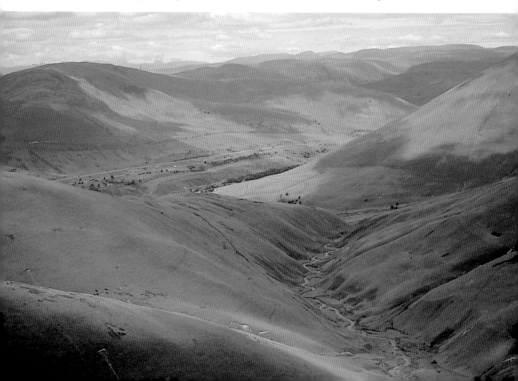

The two dales are divided by the Dent Fault. Uldale is in the Carboniferous 'stepped' scenery of the Yorkshire Dales, whilst Wandale lies in the more ancient rounded Silurian country of the Howgills. They are two little known valleys with isolated farming communities. There are half a dozen fine waterfalls in Uldale and tremendous views along the mid level tracks along both dales.

START/FINISH:
Rawthey Bridge. Parking south of bridge off the A683 the Sedbergh to Kirkby Stephen road (at 979711); the bridge is about a mile north of Cautley and Cross Keys Hotel, on the Kirby Stephen-Sedbergh bus route

DISTANCE:
9½ miles (15.3km)

APPROXIMATE TIME:
About 5 hours

HIGHEST POINT:
1,230ft (375m), reached at the head of Wandale

MAP:
Harvey Superwalker, Howgill Fells; OS Explorer OL19 Howgill Fells & Upper Eden Valley

REFRESHMENTS:
There are no tea rooms or pubs on the route but a good selection in Sedbergh and Kirkby Stephen

ADVICE:
Prepare for a full day. Moderate walking, mainly on bridleway tracks, though wet in places; the only rough bit is Uldale Force, where there is a possible danger of vertigo and the path can get overgrown

LANDSCAPE/WILDLIFE:
Limestones, shales and sandstones, waterfalls; skylark, meadow pipit, buzzard; a good collection of ferns and water loving plants, northern marsh and common spotted orchids, St John's-wort, meadow vetchling

① Rawthey Bridge 713 978

The bridge is a fine monument to those who built it in 1824, forming a high arch over the river. Stones from a nearby stone circle are incorporated in the foundations and the bridge is decorated with a carved face on one side and a gargoyle on the other. The bridge enabled the turnpike road to be extended to Kirkby Stephen. The Lancaster to Newcastle coach used to come this way and one day, when it reached the Cross Keys at Cautley, the driver got out and the horses set off without him, rattling over Rawthey Bridge and beyond. The landlord and the curate gave chase but failed to catch up with the runaway coach and, expecting it to have turned over in the ditch, they eventually found it standing outside the Kings Arms in Kirkby Stephen, the next scheduled stop, with the passengers unaware of what had happened.

Bluecaster, as the name suggests is on the line of a Roman road that continues north of Rawthey Bridge along the byroad known as the Street. Above the low moorland of Bluecaster, the skylark may be pouring out its musical song while the meadow pipit twitters on high before side-slipping through the air, wings outspread and tail up, in its own attractive song flight.

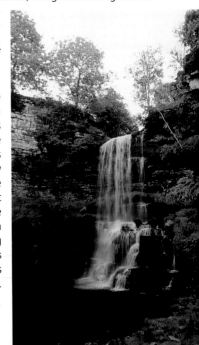

Uldale Force

The evocative call of the curlew may also carry across the moor.

The alternating limestones, shales and sandstones of the Carboniferous 'Yoredale' strata provide a series of splendid waterfalls along the valley. At the footbridge are the lower falls in six steps, and there are two single falls between there and the quarry. Rawthey Gill Quarry is in sandstone, a good building stone, where flagstones for roofing were worked. Plants growing in the quarry include a fine display of ferns: lady fern, male fern, brittle bladder fern, hard shield fern and maidenhair spleenwort, the dripping water off the man-made cliff providing a damp environment for them.

A From the gate below the bridge go forward for a few paces then right, up the hillside, along wheel tracks on the pre 1765 road from Sedbergh, and still an unclassified county highway. At the brow of the first rise turn left on a double track through rushes and grass, directly away from the view of Cautley Spout. The low moorland to the right is Bluecaster and ahead is Wild Boar Fell and Baugh Fell. A path descends to a footbridge (don't cross) from which is a view of the stepped lower falls. After two more small waterfalls the path leads through Rawthey Gill Quarry opposite the end of which are the high Whin Stone Gill Falls on a side stream.

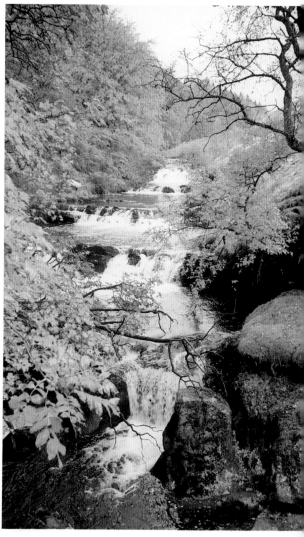

Lower Uldale Falls

From the end of the quarry fork up the valley side, first above a bed of rushes and then above some trees which enclose a deep chasm. The path is narrow and cannot always be seen on the ground. It visits an 8ft (2.4m) waterfall, then proceeds into the rock bowl and the high drop of Uldale Force.

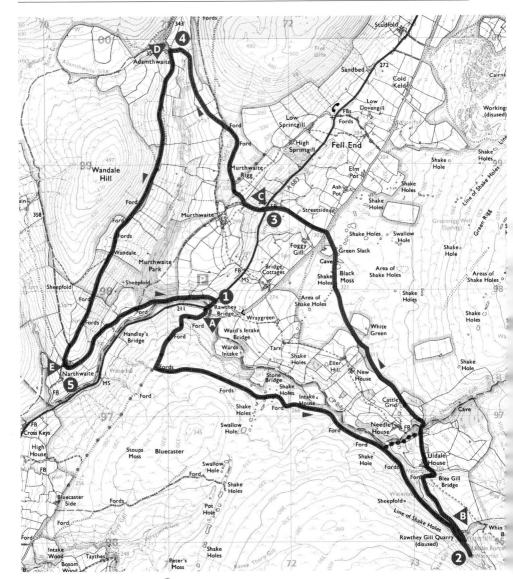

➋ Uldale Force 736 958

Uldale Force is a secretive waterfall, well hidden in a rocky bowl, yet it is big and forceful, emitting a thunderous sound as the water crashes onto shelves of rock below. Persistent feet have now cut a small path above its subsidiary fall and into the main chamber, a strange and wonderful place. Good views of the falls are obtained from a distance – very great care and attention is needed on the path to Uldale Force.

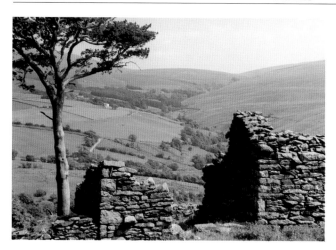

Ruin and view of Uldale

Uldale House is dated 1828. Other farmhouses in Uldale (the name means 'valley of the wolf') are Needle House, New House, Eller Hill and Wray Green. From the byroad into Uldale there are fine views over the farmhouses across to Cautley Spout and the Howgills.

B Retreat from Uldale Force by the same path and return to the quarry and, if the river is low, cross to the far bank for a closer view of Whin Stone Falls (a good picnic site), then down

Wild Boar fell from Murthwaite, Wandale

Northern marsh orchid

stream a little further and through the gate to pick up a bridle path to Blea Gill Bridge and Uldale House. If the river is not easy to cross, return on the south bank of the river to the foot bridge and walk up through the pinewoods to the road above Needle House with little or no extra distance or loss of time. The tarred road then leads across the moorland of Black Moss, past some sink holes, one containing a cave entrance, and to a quiet road known as The Street – the old road to Kirkby Stephen. Cross the Street to descend through narrow fields to the A683, the Kirkby Stephen road.

③ Kirkby Stephen road 718 986
Just before emerging onto the A683 there is an interesting boggy area containing several marsh plants: marsh marigold, marsh lousewort, marsh valerian, marsh bedstraw and northern marsh orchid, while monkey-flower grows in Sally Beck. On the far side of the road common spotted orchids grow among meadowsweet and foxgloves.

▶ Climb steeply up the zigzags and follow the field boundary to join a farm track (the rooftops of Murthwaite farm are just visible to the left). The route is to the right along the track, branching left at the wall corner, now with views into Wandale, and skirting the slopes of Harter Fell. After passing opposite Adamthwaite Farm curve down to cross the beck and join a road. Turn left to pass through Adamthwaite farmyard – left of the farmhouse.

④ Adamthwaite 710 999
The old galleried farmhouse of Adamthwaite is inscribed with '1684 TA' over the door. It lies in the parish of Ravenstonedale, only 2½ miles (4km) away, and at the top of the rise is Adamthwaite Cross. The story goes that when the Scots were in the area and likely to invade Ravenstonedale, the villagers took all their pewter to bury it at Adamthwaite Cross. The wily Scots caught them in the act and the poor people fled, losing all their treasured possessions.

Distant views along the bridleway to Narthwaite include the bare limestone of Stennerskeugh Clouds, Wild Boar Fell, Baugh Fell, Whernside and Middleton Fell. It is a good vantage point to see a buzzard either perching on a tree, rock or post, or soaring and then dropping to prey on the ground.

▶ From Adamthwaite farmyard join a narrow walled lane to begin a scenic 2 miles (3.2km) with great views, and several ruins, leading down to Narthwaite.

⑤ Narthwaite 702 974

The Narthwaite group of farm buildings and cottages once housed a Quaker Meeting room, where meetings were held from 1793 until 1907. The room was on the upper floor of a large barn, distinguished by alternating courses of sandstone and limestone.

The ancient meadow below Marthwaite Wood contains a wealth of wild flowers: hay rattle, betony, eyebright, common spotted orchid, St John's-wort and meadow vetchling. The wood has birch, hazel, rowan, and oak, many of which have been coppiced.

▶ Go through the farmyard, right of the farmhouse and down a pleasant lane, and straight on, where the lane turns down to the right, through a meadow. At a wood, take the right hand gate, then the right path to leave the wood and walk along its lower edge in a pasture. At the far end of this ancient meadow pass into an equally ancient wood with a steep bank to the river. Cross a field to a stile and steeply up to the road, turning right to Rawthey Bridge.

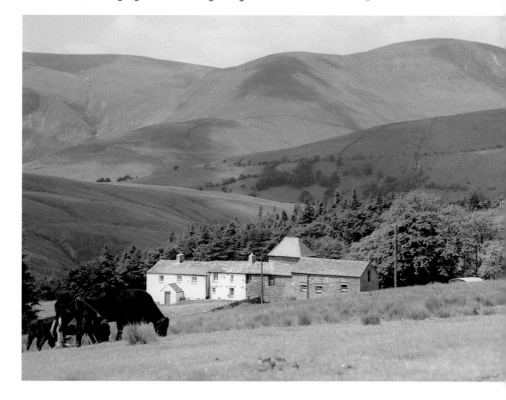

New House, Uldale and the Howgills

Barbondale & Leck Beck

Barbon is noted for its car and motorbike hill climbs in the summer months and here is a circuit of the high moorland of Barbon Low Fell. The walk visits the three quite different villages of Barbon, Cowan Bridge and Casterton, has fine views of the Lune valley and meanders down the quiet valley of Leck Beck. But there is Dales limestone country here too as the route crosses Ease Gill, one of the most important caving areas in Britain, and there are literary connections with the Brontë sisters in Cowan Bridge.

1 Barbon 627 825

Mentioned in Domesday Book in 1086 by the name 'Berebrune', Barbon means farm by the spring. Today four or five small roads lead into the village of stone buildings and white cottages. The fine church was built in 1892 under the care of the Rev James Harrison. Today, the village is the setting for three car and motor-bike hill climbs on Saturdays in May, June and July.

Barbon Manor stands high on the hillside among the trees. It was built by the Kay-Shuttleworths as a Victorian retreat. Sir James Kay-Shuttleworth, who introduced Charlotte Brontë to her biographer Mrs Gaskell, is considered to be the founder of English popular education.

Barbon church

Whelprigg Hall, Near Barbon

In the autumn, look out for fungi in the woods in Barbondale. There is stinkhorn, unmistakable by its smell of rotting flesh, the well-known and poisonous fly agaric, red with white spots, and false chanterelle, a bright orange toadstool. On leaving the woods for open moorland, look out for buzzard circling round and listen in spring for the call of the cuckoo.

> Start by passing the church on your left and left along the road that bridges Barbon Beck and leads to Barbon Manor. Leave the tarmac drive where it curves to the left. A guidepost directs walkers into the woodland of Barbondale along a good wide track. Emerge from the wood and continue to where you come alongside the beck then, a little further on, cross the footbridge and turn right along the road. About 100yds (100m) or so beyond Blindbeck Bridge turn left up the signed track to Bullpot Farm, now a caving centre.

2 Bullpot Farm 663 814

This is the highest part of the walk at just over 1,000ft (306m). The caving hut marks the start of a very extensive network of potholes and sinkholes. On the surface we can admire Bullpot of the witches, the first big pothole down from Bullpot Farm. It is a 50ft (15m) shaft. Over the stile and to the left are Cow Pot and Lancaster Hole. The entrances are not impressive but underground they lead to the caves of the Ease Gill system. They are for the well-equipped caver, and Tony Waltham describes them in his book 'Yorkshire Dales: Limestone Country' as

A competitor returns from the Barbon hill climb

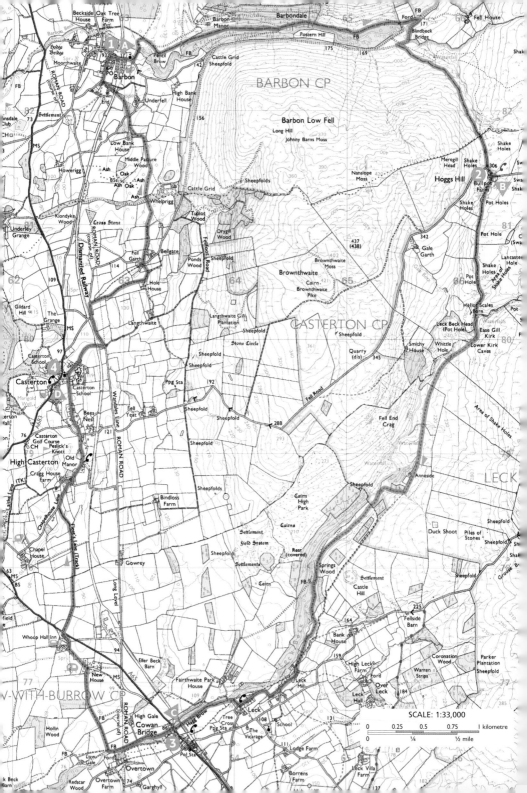

'really magnificent with every type of passage...and some of
the loveliest stalagmite and stalactite displays in the country.
The complexity almost defies description with more than
45km of interconnected passages.'

Bluebells in Barbondale

Hellot Scales Barn is a ruin and over to the right of it are the
springs of Leck Beck Head with the Dent Fault and ancient
Silurian slates to the west. Ease Gill Kirk is a rock basin with
vertical limestone walls which becomes a roaring torrent
when in spate, though most of the time it can be entered.

From the banks of Leck Beck look out for goosander and grey
wagtail. You may hear the laughing call of the green
woodpecker, but keep an eye above for the buzzard. In the
spring, Springs Wood is awash with wild garlic and bluebells,
and you will also find wood sanicle, forget-me-not, hairy
rock-cress and 11 species of fern.

B► Go through the small swing gate at Bullpot farm, signed
to Ease Gill. The large pothole on the right is Bullpot of the
Witches. The path turns sharp left near the ruins of Hellot
Scales Barn, descending to cross Ease Gill Beck. Ease Gill Kirk
is the rock basin just upstream. Beyond this, keep to the
higher edge of the valley, passing to the left of Lower Ease Gill
Kirk, a deep rock basin, and eventually to the ruins of
Anneside, dominated by a large sycamore. At the next 'dip'
take the stile over the wire fence to bring you down to the
beckside and a good track along the valley bottom. It leads to
Leck Mill and, the hamlet of Leck (fork right here). Beyond a

Ease Gill Kirk

line of houses in Leck, turn right to return to the riverside. The path passes under the arches of the disused railway and emerges in Cowan Bridge.

3 Cowan Bridge 636 764
A cottage just over the old bridge has a plaque which records that the four Brontë sisters, Mary, Elizabeth, Charlotte and Emily lived here as pupils of the Rev Carus-Wilson from 1824-25. It was portrayed as 'Lowood' in Jane Eyre. The school moved to Casterton in 1833.

Below Cowan Bridge, the riverside vegetation along Leck beck is a good place for butterflies such as peacock, small tortoiseshell, green-veined white and meadow brown, with orange-tip in May and June.

Take care crossing the A65, go over the old bridge and proceed down the right bank of Leck Beck. Go straight on and, after passing a footbridge and before a cattle grid, turn right through the fields. With a field boundary on the right go on to the far corner to cross a footbridge. Go through the campsite, directed Whoop Hall, to a metal gate, then diagonally across fields to come out at Whoop Hall Inn. From the front of the inn, cross the A65 and straight forward through fields again. The path takes a straight line and into the rather shady Fleets Lane which can be muddy. Join a country lane and turn right into High Casterton, pass the golf course and some fine houses and gardens to reach Casterton.

4 Casterton 624 796
A Roman camp was established here on the route to Carlisle. Casterton girls school which grew from the little school at

Cowan Bridge is now one of the foremost for girls' education in the country. The church was built by the Rev Carus-Wilson who had founded the school and he is said to be the model for Mr Brocklehurst in Charlotte Brontë's Jane Eyre. The Pheasant Inn is a traditional pub and there is a nine-hole golf course.

On a pond in the grounds of the newly restored Hole House are wigeon and mandarin duck, a good chance to see these wild birds close to. Among the trees near to Whelprigg Hall nuthatches and treecreepers, are resident and there are good views of the Lune valley.

▶ Keep right of the church, past the school to the Roman Road. Turn left and, soon after the next junction turn off right along the driveway to Hole House. Follow the path left to Fell Garth and cross the road. The footpath continues in the same northerly direction, passing near the front of Whelprigg Hall. After crossing the drive, aim for the far left corner of the parkland onto a stony track and, just before the farm buildings, go right (stile and gate) to cross a field diagonally to the corner. Cross the lane (near Under Fell) and follow the path to Town End and into Barbon village.

Wild garlic, Springs Wood, near Cowan Bridge

Penyghent from Helwith Bridge

An excellent walk combines a mountain of great character with a riverside ramble along the Ribble Way. There is an opportunity to see both moorland and river birds. For a week or two from about the first of April the beautiful purple saxifrage flowers on the limestone cliffs below the summit of Penyghent.

❶ Helwith Bridge 811 695
The bridge of five arches spans both the River Ribble and the Settle-Carlisle Railway, on the site of an ancient east-west crossing of the Ribble. The picnic area is well placed next to an attractive section of the river with a large rock in the middle of it. Formerly there was a quarry here that produced Horton Blue Slate and was closed in 1976. The slate (of Silurian age) is hard and strong and withstands weathering. It provided slabs for roofs, shelves, and headstones for graves. You will see good use of it in the fine gate posts along the route.

The first part of the ascent along Long Lane is across ancient Silurian rocks. Right away, you can see the sloping bedding surface of the flaggy sandstone on the left. The limestone is soon reached, and pavements and sink holes appear in the Great Scar Limestone. Churn Milk Hole is a large deep hole where the limestone meets the Yoredale series of strata. Look out for the ring ouzel, or mountain blackbird here. It has a white crescentic bib, a chaka chaka alarm call and a brief piping song. Skylarks and meadow pipits are common right up to the summit, with the curlew more on the lower slopes.

▲ From the car park make your way over Helwith Bridge and back to the main road (the B6479). Turn left and, straight forward at the corner, go up the inviting stony track, signed to Dale Head. Keep left at an early junction of lanes and head (NE) for the top of Penyghent which is visible most of the way up. After 2 miles (3.2km) at a T-junction of tracks is Churn Milk Hole on the right. Turn left (N) to continue on a well maintained path, the final ascent being on a restored stepped section, much in keeping with the surrounding. The summit is at the stone survey pillar close to the wall which might provide some shelter.

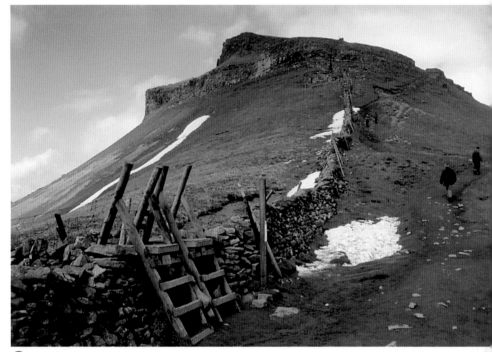

The nose of Penyghent

❷ Penyghent summit 838 733

The view (SE) from the summit looks, only 2 miles (3.2km), across to Fountains Fell with the little farmhouse of Rainscar below, while to the west lie Ingleborough and Whernside.

The top of Penyghent is made up of a layer of Millstone Grit and below this are alternating beds of limestone, shale and sandstone that characterise the Yoredale strata. The limestones and sandstones are easy to pick out, though the shale is mostly hidden since it weathers easily. Just down from the top, black shale appears in the path.

The name, now usually written as one word, is said to mean 'hill of the winds', and it is here you are likely to hear the deep croaking prrk of the raven, which glides gracefully but will also show off its aerobatic skills. On the limestone cliffs, at about the 1,900ft (580m) contour, the purple saxifrage produces cushions of purple flowers in April. It is a true mountain plant and only grows at this altitude, often surrounded by snow. It is less common than formerly and global warming could lead to its demise in this locality. At the same time of year, in the scree below the cliffs, grows a tiny plant called moschatel or town hall clock. The flower is

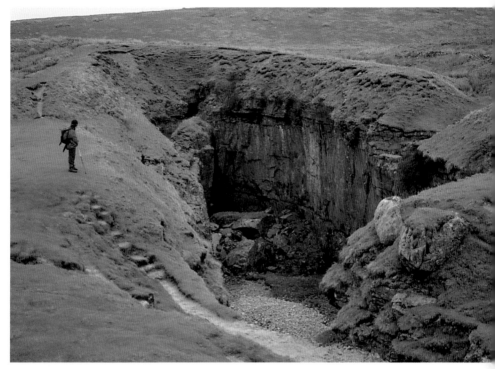

greenish-yellow with four faces, as of a clock tower, plus one on the top facing upwards.

Hull Pot

▶ From the summit, cross the wall and, walking away from it, proceed in a north-westerly direction to an abrupt edge with a wonderful view. Continue northwards, dropping down to the foot of some limestone cliffs. Take the grassy path, to the right of the main route to Horton, heading for the yawning hole of Hull Pot almost 1 mile (1.6km) distant. Continue for ¾ mile (1.2km) then, near the corner of a wall, take a sharp left (south) down a rough track which then swings slowly right to bring you directly opposite Hull Pot. This section can be very boggy when wet and the main track (Pennine Way) to Horton may be preferred (see dotted line on map).

❸ Hull Pot 824 745

Hull Pot forms a huge rectangular hole about 100yds (90m) long and about 22yds (20m) wide and deep. The floor is littered with rocks and boulders and on the far side is a lip where in wet weather some of the water in the beck reaches the pothole. In really wet weather it turns into a magnificent

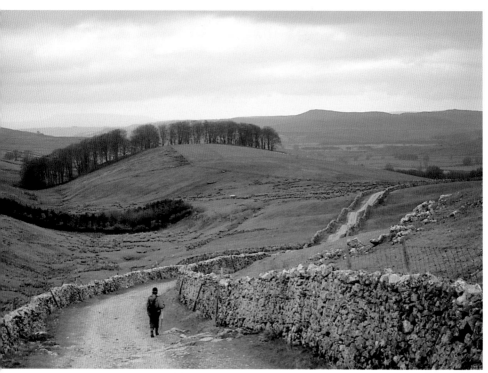

Horton Scar Lane with Pendle Hill in the far distance

50ft (15m) waterfall. In an exceptional flood, the whole pothole fills to the brim and overflows. Water from Hull Pot, and other potholes in the area, re-emerges at Brants Gill, 1½ miles (2.4km) away just above Horton village. Because of a restriction underground, Brants Gill releases a constant amount of water. After heavy rain, the overflow water, which comes out at Douk Ghyll Scar, can increase considerably and surges down Horton Beck and through the lower end of the village.

From Hull Pot turn (SW) down the dry valley, entering the walled Horton Scar Lane, now with the dry valley to the left; there is even a dry waterfall. It is a scenic stretch with Pendle Hill in the distance ahead. The lane winds down, keeping right at a junction, and enters Horton-in-Ribblesdale. Turn right to reach café, information centre and toilets.

④ Horton-in-Ribblesdale 804 726
The village straggles along the winding B6479 with Ingleborough on one side and Penyghent on the other, with many fine views of both. Mentioned in Domesday Book, Horton has survived the centuries as a small farming

community, though it now has added income from quarrying and tourism. The interesting church fits perfectly into the landscape, still has its original Norman walls, and exudes a solid beauty.

Along the riverside in spring and summer there are swallows and sand martins, the martins having brown upper parts and a blunter forked tail than the swallow. They nest in holes in the sandy parts of the riverbank. Dipper, grey wagtail, oyster catcher and kingfisher are also present through much of the year. Heron, too, like to fish here.

D Continue northward through the village, traverse the car park, to cross the river by a footbridge. Turn left (S) down the right bank along the Ribble Way. Follow the Ribble Way signs all the way back to Helwith Bridge without crossing the river again. After entering a walled section, the path turns away from the river and passes under the railway. In wet weather this stretch (from the river to the railway) can have 10cm (4 in) of water over the whole width of the track so you could cross the footbridge and go along the public right of way to the main road at Studfeld Farm and return via the main road or the footpath from the farm to Helwith Bridge. The last bit from the railway bridge is on a tarmac road which leads up to Arcow quarry, so keep a look out for loaded trucks as you return to the car park at Helwith Bridge.

Penyghent from the Ribble Way

START/FINISH:
Settle lies between Skipton and Ingleton on the A65, now bypassed; there are several pay and display car parks and street parking. Trains from Leeds; buses from Skipton Monday to Saturday and summer Sundays from Keighley, Skipton and Ilkley

DISTANCE:
5½ miles (9km)

APPROXIMATE TIME:
3½ hours

HIGHEST POINT:
1380ft (420m) at Jubilee Caves and Victoria Cave

MAP:
OS Explorer OL2, Yorkshire Dales, Southern & Western areas

REFRESHMENTS:
There are several good cafés and restaurants in Settle

ADVICE:
Take care over steep scree when visiting cave entrances such as Victoria Cave; if you are considering exploring beyond the entrance, then hard hats and a torch are advisable

LANDSCAPE/WILDLIFE:
Craven faults, transition from Askrigg block to Bowland basin, great scar limestone, reef limestone, Bowland shale; green woodpecker, lapwing, curlew

The most famous cave near Settle is Victoria Cave, the excavation of which tells a fascinating story, the long and high escarpment of Attermire Scar being studded with caves and holes. This scenic walk is rich in geological interest, the area being crossed by both the Mid-Craven and South-Craven faults, bringing abrupt changes to the landscape.

① Settle 819 636

Settle is a market town for the surrounding villages and farms, has good shops and services, and an open market on Tuesdays. Above the market place the limestone knoll of Castleberg sets the scene, complete with flagpole. Of particular interest are the Shambles (old shops facing the

market place) the fine town hall, the impressive 17th Century building known as the Folly and Ye Olde Naked Man Café, a former inn. The town gives its name to the Settle-Carlisle Railway which begins its picturesque route from here north through the high dales and down the Eden valley.

Birds to look out for on the wooded hillside include the green woodpecker, recognised by its laughing call, or yaffle. Lapwing, or green plover, prefer open, damp pastureland and, on the higher parts, the curlew adds its ringing call.

A From the market square start up the steep Constitution Hill, left of the Shambles, the large building with archways at the rear of the market square. At the brow of the hill turn still steeply up to the right on a rough stony lane to a gate. Pass through the gate and follow the wall across steadily rising ground. There are good views back of Settle and ahead along Ribblesdale, and to Penyghent on the skyline. Beyond the wall, keep climbing to pass below a beech wood and along to

Penyghent from above Langcliffe

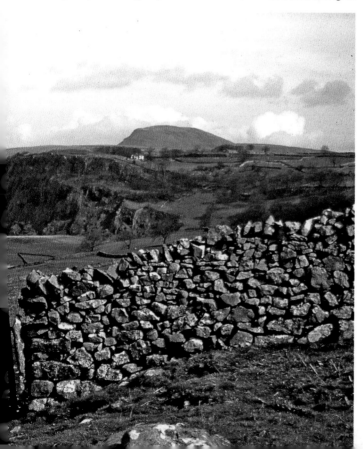

more beech woods. All Three Peaks are now in view, and the path comes out onto the Malham road.

Leave the road immediately, to turn right along a cart track, over a cattle grid, with a wall on the right. Proceed up the track and go through a metal gate where it is worth going up left to Jubilee Caves and the brow of the hill for the view to Penyghent and Fountains Fell. Return to the metal gate and go through the kissing gate on the left to continue, left of the wall, along to Victoria Cave. Hard hats must be worn to enter the cave.

② Victoria Cave 838 651

The cave was discovered in 1837, the year of Queen Victoria's coronation, and is an important archaeological site. The oldest deposit of clay contained bones of spotted hyena, rhinoceros, hippopotamus and straight-tusked elephant. It was dated, using uranium in the tufa deposits, at 120,000

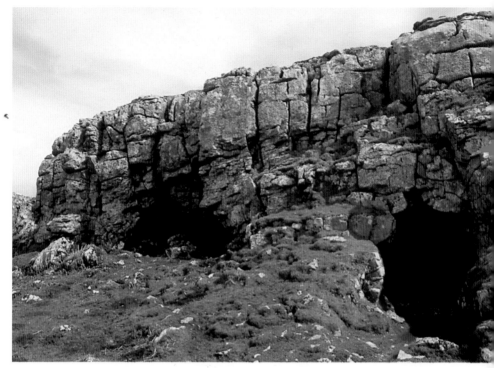

years ago, a period with a warmer climate than today. On top of this clay was found a bone harpoon, 12,000 years old. Brown bears hibernated in the cave after this. The most striking finds were on the surface and included pottery, coins and jewellery decorated with coloured enamels, as well as gold and silver textile tools. They were left by Romano-British people who used the cave as a workshop in the 2nd to 4th Centuries AD.

Jubilee Cave has two entrances that don't go in very far. High up before Victoria Cave is Albert Cave, closed by a new iron gate, on which crawls a wrought iron snail. Lower down is Wet Cave which you pass as you go up to Victoria Cave. Then comes the large entrance of Victoria Cave. Beyond this and high up again is Blackpot Cave. All of them can be easily entered.

The south end of Attermire Scar contains more caves. The small vertical hole above a grassy ledge is Attermire Cave and can be explored for 55yds (50m) with the aid of a torch. There are two other cave entrances, one further round the cliff is Horseshoe Cave.

The view south from near Attermire Scar looks south across the Mid-Craven and the South-Craven faults, bringing an end to the great scar limestone. The top of Rye Loaf Hill is capped by millstone grit, the Grassington grit. The mire of Attermire is the badly drained area covered with reeds at the foot of Attermire Scar, beneath which are Bowland shales. Sugar Loaf Hill and High Hill lie between the two faults.

B From Victoria Cave, continue along the wall, through a gate and across open moor until you reach a ladder stile on your right. Cross the wall here, then descend and curve round

to the right to the ruined target of a shooting range. Pass the ruin and after 50 yds or so cross the wall on your left by the stone step stile and take a half-right direction between two widely-spaced walls and up the hillside to a gate. The route goes through the gate and passes Sugar Loaf Hill on the left.

3 Sugar Loaf Hill 838 634

On the way up the slope towards Sugar Loaf Hill look back to admire the landscape. The magnificent series of south-facing scars and gullies are a result of the Mid-Craven fault. The fault which runs west-east displaced the limestone here 560ft (170m) to the south. Sugar Loaf Hill capped by limestone actually contains shale of the Bowland Shale group. On the other side of the path, further on near the limekiln, the steep knobbly surface of High Hill is in reef limestone. The change is from the great scar limestone of the Askrigg block to the north, to over 1000m (over 3,000ft) of Bowland shales to the south. When it was formed over 300 million years ago, the reef limestones grew in tropical seas on the edge of this 'Bowland basin' looking out over it, just as High Hill looks south over the lowland today.

Warrendale Knotts

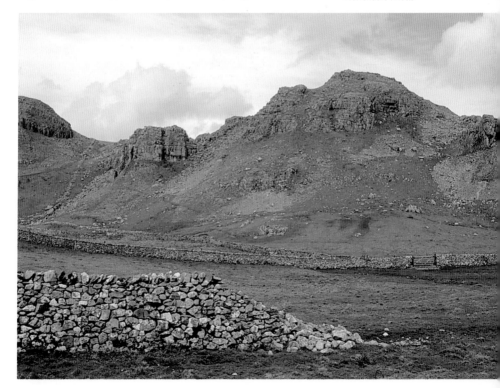

▶ From Sugar Loaf Hill continue over the brow to new views to the south. A rubbly limestone track brings you out onto Stockdale Lane.

④ Stockdale Lane 835 630

This was an important packhorse route between Settle and Malham. John Housman, a traveller in 1800, described it as follows: 'The road leads us over a wild, hilly country and extensive tracks of moors... is by no means to be recommended to strangers except in clear weather.' Stockdale Lane must be an easier road today but it still climbs to 1700ft (520m) above sea level. Fortunately our route does not lie in that direction.

The view of the south side of High Hill is along the line of the South Craven fault with Bowland shales to the south.

▶ Keep in a south direction down the last bit of Stockdale Lane. At the road junction turn right, then after 90m/100yds left on to Lambert Lane. Keep bearing right. At the beginning of tarmac is Mitchell Lane which brings you down towards Settle with Ingleborough rising up behind it. At the foot of the lane is an attractive memorial picnic site, sheltered by a circular wall, a former sheepfold. The final part of the route is through Upper Settle and along Victoria Street, past the Folly and back to the market place.

Descending into Settle with Ingleborough

Crummackdale

Some classic geology here. Crummackdale is a rectangular valley, about 2 miles (3.2km) long and ½ mile (800m) wide with high limestone scars on three sides. The dale forms a window in the Carboniferous limestone through to the ancient 'basement' rocks beneath. The surface between them – the unconformity – is well seen and one of the best examples in the country. The perched blocks of Norber, known as erratics, are huge boulders of the older Silurian sandstone sitting on the younger limestone, having been transported there by a powerful glacier. At the north end of the dale, a rock known as Moughton whetstone is striped green and red.

1 Austwick 767 684

The name is mentioned in Domesday Book and the village has endured to the fair sized residential and farming community of today. Austwick Hall is the oldest building and was inhabited by the Inglebys and then the Clapham family. It is said that gamecocks were used in cockfighting at the hall even in the 19th Century. Among the attractive stone built cottages there are a few 17th and 18th Century buildings with dated lintels above the door. Harry Speight, in his 'Craven and North-west Yorkshire Highlands', mentions a bygone tradition in Austwick of 'the failings and lack of ordinary intelligence of its inhabitants' Among the tales is one of a

Norber erratic

START/FINISH:
Austwick village lies off the A65 between Settle and Ingleton. Bus 581 from Settle connects with trains arriving in Settle from Leeds

DISTANCE:
7 miles (11.3km)

APPROXIMATE TIME:
3½ to 4 hours, which gives time to wander among the Norber boulders

HIGHEST POINT:
1000ft (305m) on Norber, rising again to about the same altitude of nearly 985ft (300m) at Moughton Whetstone Hole

MAP:
OS Explorer OL2, Yorkshire Dales, Southern & Western areas; Harvey Superwalker, Three Peaks

REFRESHMENTS:
Game Cock pub in Austwick (GR 767684)

ADVICE:
Mostly easy walking on green lanes and good tracks

LANDSCAPE/WILDLIFE:
Unconformity between basement rocks and Carboniferous limestone, perched erratic blocks, folded strata; wheatear, meadow pipit, curlew

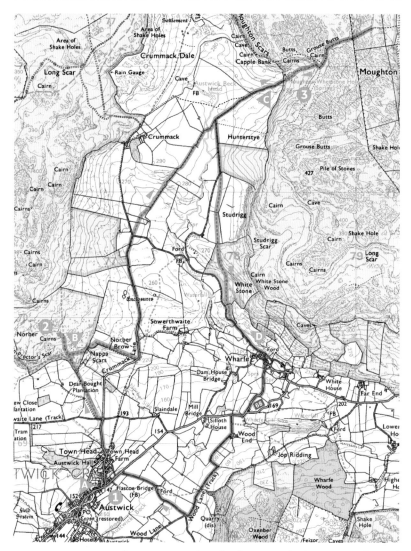

man who was seen to wheel an empty barrow again and again into a hay barn. It turned out he was wheeling sunshine into the barn to dry the hay!

▶ Beginning in the centre of the village, pass the Game Cock Inn and School (on the left) and then turn up Town Head Lane. Austwick Hall can be seen over to the left among the trees. Keep on up the road turning left at the crossroads of lanes. About 50yds (45m) along, take the ladder stile on the right to follow a cart track across a field. Leave this track to

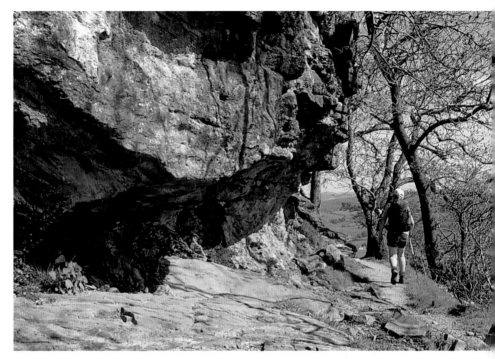

The path traverses the unconformity on Nappa Scars

pass round the wall corner and go over the stile by the huge boulder in the wall and up past angular erratic blocks of Austwick sandstone lying about on the limestone slope. Wind up the bank to the right to the guide post, and take the Norber direction. From the path you see a large cairn up to the left and you soon find yourself on a green shelf of land littered with blocks of the ancient rock, many of them perched on a plinth of limestone.

② Norber 765 699

The huge boulders of Silurian basement rock (Austwick sandstone) have been swept uphill by the powerful movement of an Ice Age glacier as it moved along Crummackdale, marooning them on this shelf of limestone. They are 'erratic' because they are not in their correct geological position. The blocks were plucked from outcrops ½ mile (800m) further north. You can see, from Crummack Lane, that they came from an area of hillside with some blocks in position and others scattered about. To distinguish the erratics from the limestone, note that a dull, pale green lichen grows only on the sandstone whereas a white lichen grows on the limestone. The pillars of limestone beneath the erratics have been used to measure the rate of erosion of the

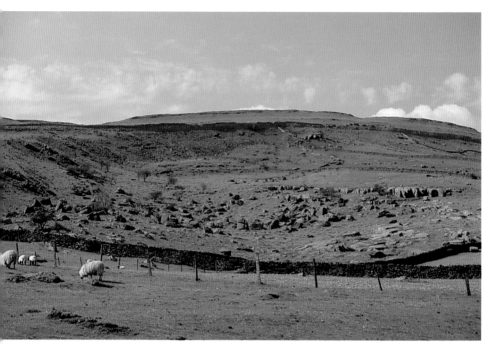

The source of the Norber erratics

limestone as it is dissolved by rain and surface water – something like 12ins (30cm) in 12,000 years, or one inch in 1,000 years. In spring and early summer there are wheatears, meadow pipits and curlews on Norber. The wheatear appears in April, having flown in from north Africa. It is a small and lively bird displaying a white rump – the 'white arse' becoming a polite 'wheatear'.

The path along the ledge of rock at Nappa Scars is right along the unconformity, a fascinating sequence of strata. The underlying basement rocks are steeply dipping and the lower part of the limestone is full of pebbles and even large boulders of the older rock – a conglomerate. This indicates that the basement rocks were being eroded on an ancient beach as the Carboniferous sea invaded the land. The Ordovician age (about 440 million years) of the older rocks has been determined by rare fossil trilobites found in them.

Crossing Crummackdale, it is evident that the older rock strata are tilted, the sloping layers being part of two or three large folds. At Austwick Beck Head there is a strong spring, the source of the beck. All round the dale there is a line of springs where the limestone comes into contact with the impervious rocks beneath, and the water gushes out.

B From Norber retreat to the signpost and go east (or left) to the wall and a step stile higher up, aiming for a group of larches and another step stile. Take care where the path goes along a ledge of rock with a limestone scar above – Nappa Scars. The path here is actually on the unconformity. Follow the wall and continue up Crummack Lane. At a three way junction of lanes, go over the ladder stile, signed Horton, for a pleasant way through fields for the next ½ mile (800m) or so. The view ahead is of Moughton Scar and, after crossing Austwick Beck, join Moughton Lane coming up from the village of Wharfe. Follow this truly green lane to a gate at its end and Moughton Whetstone Hole.

③ Moughton Whetstone Hole 791 722

Springs of clear water emerge at the base of the limestone. Moughton (locally 'Mootn') whetstone is a sharpening stone and, if you look in and around the stream, many of the little chips of stone are beautifully banded green and dark red. The bands are a result of ancient weathering of iron in the rock, which occurred during desert conditions before the Carboniferous limestone was laid down. They are known as liesegang rings and are independent of the bedding.

If you have a spare half hour it is worth going up the track and onto the shelf of limestone pavements for an exhilarating view towards Penyghent. There is so much limestone, with juniper bushes dotted here and there, that it stands in stark contrast to the green vale below.

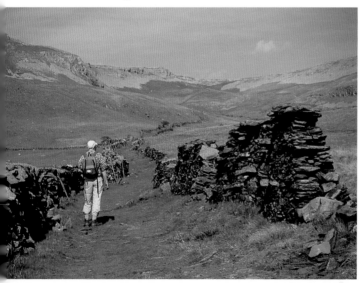

Green lane near the head of Crummackdale

The hamlet of Wharfe

C ▷ Return down Moughton Lane and views of the unconformity high up on Studrigg Scar. You can follow the lane all the way to Wharfe but it is used by mountain bikers and narrow in places. It is preferable to go through the fields. The turn off comes at the second angle in the lane (or where the access area notice is and the lane turns sharp right) and the route goes left of the lane. As this is an access area, it is possible to use this diversion all the way to the hamlet of Wharfe.

D ▷ In Wharfe, go down between the houses and on to the road, turning right for nearly 200yds (180m) then left on Wood Lane. At a crossroads of lanes turn right, over Flascoe clapper bridge which crosses Austwick Beck and onto the road again which leads into Austwick.

Near Wharfe, Crummackdale

Ingleborough from Clapham

This is an excellent walk, especially in clear weather, when there are fine distant views. Ingleborough is the most popular hill in Yorkshire and on the route are Clapham Woods, Ingleborough Lake, the limestone gorge of Trow Gill, the famous Gaping Gill pothole, and an unrivalled spread of limestone pavements at Sulber Nick and at the head of Crummackdale.

1 Clapham 744 691

The presence in the 19th Century of the Farrar family at Ingleborough Hall did much to develop the village into the attractive layout seen today. Three bridges cross the beck that runs down the centre of the village, with waterfalls and church at the top. Clapham was where Dalesman publishing began, and there is still an office here, also the headquarters of the Mountain Rescue Service, Yorkshire Dales Millennium Trust and Ingleborough Estate which, among other things, takes schoolchildren for short stays.

Botanist Reginald Farrar (1880-1920) was a great plant collector and it was he who popularised the alpine rock garden. In acid soils he was able to plant rhododendrons and azaleas that he had collected from China, Tibet and Upper Burma. Many can be seen in Clapham Woods where they are a blaze of colour in April and June.

The four-way finger post at Sulber Nick with Penyghent

START/FINISH:
Clapham, reached just off the A65 between Settle and Ingleton. There is a large car park. Bus 581 from Settle connects with trains arriving in Settle from Leeds. Clapham station (1¼ miles from village) is on the Leeds/Skipton/Morecambe line

DISTANCE:
11 miles (17.5km)

APPROXIMATE TIME:
5 to 6 hours

HIGHEST POINT:
2373ft (723m), the summit of Ingleborough

MAP:
Harveys Superwalker, Yorkshire Dales Three Peaks; OS Explorer OL2, Yorkshire Dales, Southern & Western areas.

REFRESHMENTS:
Two cafés and the New Inn pub in Clapham; refreshment kiosk at Ingleborough Cave, 1½ miles (2.4km) from start

ADVICE:
Be prepared for exposed conditions, which often include hill fog; paths are good but take extreme care at Gaping Gill, especially with children and pets.

LANDSCAPE/WILDLIFE:
Tremendous limestone scenery: Ingleborough Cave, Gaping Gill, limestone pavements, perched blocks; ferns in the grikes, rue-leaved saxifrage

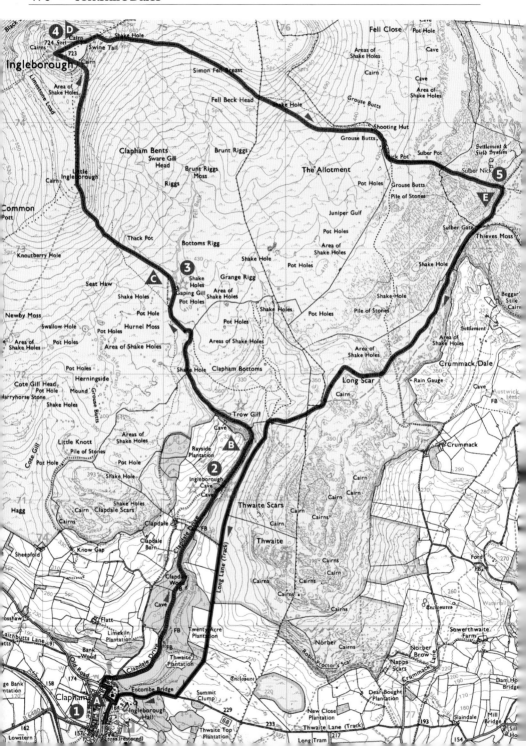

Clapham

Clapham Lake has resulted from the damming of the little valley of Clapdale. Besides providing fresh water it also powered a turbine to generate electricity to drive circular saws, and for street lighting in Clapham – some of the earliest in Yorkshire.

A Go to the top end of the village on the left side of Clapham Beck and, at Sawmill House pay a small sum for admission to the woods and a copy of the Ingleborough Estate nature trail. The track winds along this delightful wooded glen, past the lake to Ingleborough Cave.

❷ Ingleborough Cave 754 711

Ingleborough Cave is at the upper end of Clapham Woods. The show cave is open to the public and a tour lasts 50 minutes. The cave is connected underground from Gaping Gill. For years, potholers tried to make a connection through the complex underground passages. It wasn't until 1983 that, with the use of breathing apparatus, they managed to find a way through.

Clapdale

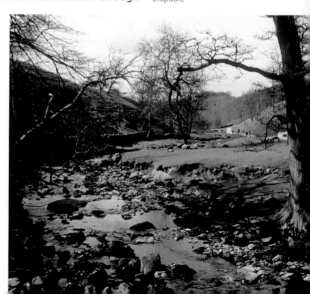

Trow Gill is a deep cleft in the limestone, carved out by rushing meltwater at the end of the last Ice Age. The narrowing gorge has cliffs that are over 80ft (25m) high.

B Proceed further up Clapdale and round to the left to the narrow gorge of Trow Gill. Look out for slippery stones when walking in wet weather. As you rise up to

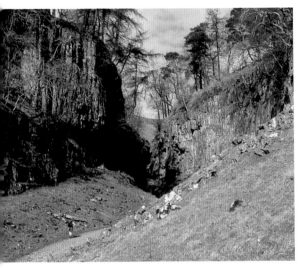

Trow Gill

a more open view, still with the wall on the left, turn left over the double ladder stile and finally, fork right to reach Gaping Gill. Extreme care should be taken here, especially with children and pets.

③ Gaping Gill 751 727

Fell Beck forms a shallow valley above Gaping Gill hole, where it ends in a funnel-shaped depression, at the bottom of which the water in the beck disappears over the lip of a circular hole, descending in an unbroken fall for 330ft (100m). The shaft opens out into a lofty chamber 100ft (30m) high, 100ft (30m) wide and 460ft (140m) long; big enough, it has been said, to fit a cathedral. Gaping Gill is situated where Fell Beck first reaches the Great Scar Limestone, and there is a string of potholes and swallow holes at this level around the mountain. The public can enter Gaping Gill on certain bank holiday weekends for a charge. See www.bpc-cave.org.uk for details.

The track up to Little Ingleborough and beyond, to the summit of Ingleborough, has been built by the National Park to take the heavy pounding by hikers. Many trials in footpath restoration were made but the present one seems to have solved the problem of footpath erosion. There are some well-engineered steps up the steepest part, but for the most part the path is built up well above the peaty ground and surfaced with a gritty gravel which knits together and makes for easy walking.

▶ Continue from Gaping Gill in a north-westerly direction up to Little Ingleborough. For the first time the stepped outline of Ingleborough is seen where limestones alternate with sandstones. On reaching the flat top of the mountain cut across to the left to the true summit; nearby is a fine shelter which makes a good place for a rest or picnic.

④ Ingleborough 741 746

In clear conditions, a wander around the summit plateau will repay with ample views of Pendle, Morecambe Bay, The Lake District and the Howgills. There is a cairn, survey pillar and a cross shaped shelter on the top, and around the margins

remnants of a large Iron Age hill fort, probably of the 1st Century AD built by the Brigantes as a final defence against the Romans.

Rare winter visitors are the dotterel and snow bunting which are seen occasionally high on Ingleborough. Nesting birds are sparse though a pair of golden plover may be present, otherwise the carrion crow and meadow pipit may be all there is.

▶ To find the way off the summit, from the shelter proceed to the north east corner where a well-built conical cairn marks the path down. It is fairly steep with good footholds. Part way down, just after some large stone sets that pave the path at a cairn on the right, fork to the right, to the right side of this spur. The route follows the south side of Simon Fell with fine views to the south. The track has been built up and brings you down to a wall with a double ladder stile. After the second wall, keep to the left to pass among limestone pavements and to the four-way finger post at Sulber Nick.

⑤ Sulber Nick 780 734

The extensive limestone pavements are a result of the horizontal nature of the great scar limestone, stripped of its soil during the Ice Age, and the fact that the limestone is so pure that new soil takes a long time to develop. The great thickness of the limestone has led to pavements at different levels within it, each developed along a different bedding plane. The regular jointing produces upstanding blocks of limestone, and the action of rain has superimposed on them small channels and runnels giving them a fretted surface. Here and there on the pavements there are perched limestone blocks that have been deposited in odd positions by the ice.

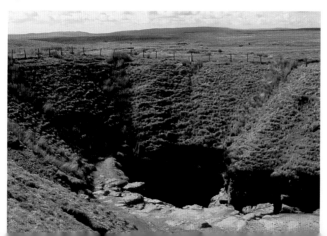

Gaping Gill

View from the top of
Ingleborough north to
Whernside and Ribble Head

The pavements are home to a number of rare plants. In the fissures (grikes) they are protected not only from the wind but also from grazing sheep. You are likely to see the long shiny leaves of hart's tongue fern and the delicate leaves of maidenhair spleenwort. There are other ferns such as the larger broad buckler fern, lady fern, and polypody. Herb robert and dog's mercury are usually present and, near the top of the grikes look for a small plant with tiny white flowers and three-lobed leaves – rue-leaved saxifrage. Sometimes trees manage to survive the nibbling of sheep and an isolated ash, rowan or hawthorn may lend a strange appearance to an otherwise seemingly deserted landscape.

E At the finger post follow the bridleway to Clapham, 3¾ miles. Near the brow of the hill at a gate by the corner of the wall, there is a wonderful view of pavements above Crummackdale. This point is Sulber Gate. Keep straight on, with fine walking on short turf, keeping to the right at the first fork. There are other tracks to right and left, so the best thing is to aim for the cairn on the highest ground ahead. The path winds round the cairn, dropping down to a gate, where the woods of Trow Gill are visible across the valley.

From the gate the route leads along the hillside with Clapdale to the right and views of Thwaite scars on the left. The last part is on Long Lane with a right turn as the track steepens and passes through a tunnel (below Ingleborough Hall grounds), before arriving back in Clapham.

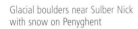

Glacial boulders near Sulber Nick
with snow on Penyghent

Ingleton Glens & Scars

The twin gorges of the River Twiss and River Doe at Ingleton are famous for spectacular waterfalls and wooded glens that form the basis of this walk. The scenic waterfalls trail has been open to the public since 1885 and continues to be very popular. After a look at the geology between Ingleton and Thornton Force, the walk continues high on Scales Moor to obtain a real flavour of the area with fine views of Whernside and Ingleborough. Chapel-le-Dale has two impressive potholes, a metal sculpture and an interesting little church. The return is along an old Roman road under Twisleton Scars before dropping down into the other half of the 'falls walk'.

① Ingleton 694 732

Ingleton is a small market town just outside the National Park and which attracted large numbers of tourists even in Victorian times. The narrow winding streets and terraces of cottages look across to the arches of the railway viaduct, now disused. By a twist of geology, Ingleton has a small coalfield which produced coal from the middle of the 19th Century to 1937. It is cut off by the South Craven Fault near the town. The Ingleton glens form an important geological area and as you walk along Swilla Glen, on the first section of the walk, gently dipping Carboniferous limestone adorns the sides of the gorge. About 110yds (100m) after crossing the first footbridge look out on the left for a small cave on the far bank – a trial adit for lead. This marks the position of the North Craven Fault. To the left of the cave is the downfaulted Great

START/FINISH:
Ingleton, where there is a National Park Visitor Centre and car park, or Waterfall car park. Daily bus 581 runs between Settle and Ingleton

DISTANCE:
10½ miles (17km)

APPROXIMATE TIME:
5 to 6 hours

HIGHEST POINT:
1,295ft (395m) along Scales Moor

MAP:
OS Explorer OL2, Yorkshire Dales, Southern & Western areas; Harvey Yorkshire Dales, Three Peaks

REFRESHMENTS:
Ingleton is well served by cafés, pubs and restaurants. There is a refreshment kiosk above Pecca Falls soon after the start of the walk

ADVICE:
There is an entrance charge for Ingleton Falls. The middle section of this walk is over high ground and fairly exposed as it approaches Chapel-le-Dale, so be well equipped

LANDSCAPE/WILDLIFE:
Exposure of North Craven fault, igneous dyke, unconformity, perched boulders, potholes, Ordovician shales, green slates and gritstones; ladies slipper orchid

Thornton Force

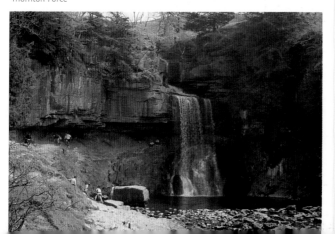

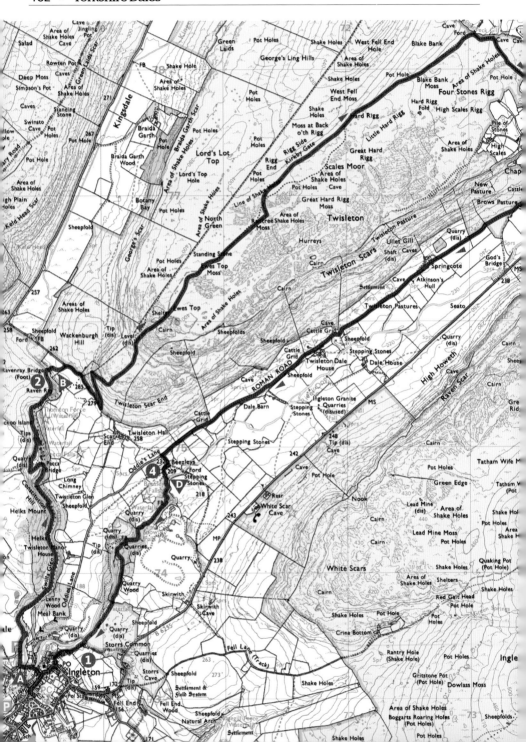

Scar Limestone (about 330 million years old) and on the right are shales of Upper Ordovician age (about 440 million years old). Look in the near bank to see an igneous dyke, which has been intruded into the shales. The dyke is of Devonian age (about 395 million years old) and is related to the Shap granite on Shap Fell to the north-west. It weathers to a brown colour in the blue-black shale.

Further up the gorge, the greenish Ordovician slates and gritstones (these are dated at about 480 million years) outcrop alternately, producing a staircase of pools and falls in Pecca Falls. Thornton Force shows an important geological feature, the 'unconformity' between the almost vertical slates beneath and the first layer of horizontal Carboniferous limestone with a conglomerate at its base. To the left of Thornton Force the path traverses the edge of a large terminal moraine which impounded a lake in Kingsdale at the end of the last Ice Age. Growth of rushes and bracken indicate the more acid soils of the glacial deposit.

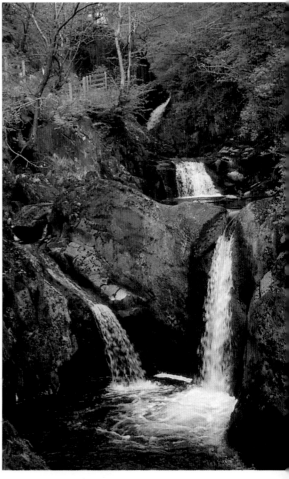

Pecca Falls

In the wooded gorge, flowers abound in the spring with sweet woodruff, wood sanicle, bugle, wild arum, wild garlic, bluebells, primroses and yellow pimpernel. In an experiment, the most beautiful and rarest British orchid, the lady's slipper, has been planted to re-establish it in the Yorkshire Dales. Look out for it next to the path in Swilla Glen; it takes several years to produce a flower.

A From the town, make your way down, near the viaduct, to the river bridges of the Doe and the Twiss and the entrance to the Falls Walk. Swilla Glen, Pecca Falls and Thornton Force form a succession of delightful scenery. Climb the path to the left of Thornton Force to the river crossing at Ravenray footbridge.

Sink hole on Scales Moor

② Ravenray 695 756

Ravenray is the terminal moraine through which Kingsdale Beck has cut a valley before dropping over Thornton Force, and becoming the River Twiss. Our route over Scales Moor is along a former packhorse track from Ingleton to Dent, known as Craven Old Way. The packhorse 'train' was made up of 20 or 30 packhorses or ponies together with driver (or jagger) and assistants. A pair of wooden panniers or baskets carried the loads of wool, cloth, charcoal, peat, coal, salt or metal. Each horse carried up to 250lb (110kg) and the leading animal wore bells to warn travellers and help keep the train together.

The upland of Scales Moor has sink holes, perched boulders and limestone pavements. One very large boulder has Ingleborough behind it and ahead is the bulk of Whernside, the highest of the Three Peaks with the Ribblehead Viaduct coming into view. Birds include the ground-nesting curlew, skylark, lapwing and meadow pipit.

B From Ravenray Bridge, the sign is to Beezley Falls but as soon as the rooftops of the farm of Twisleton Hall come into

view, turn left, backwards up the grassy track, then again to the right making a zigzag up the hillside. Follow the blue topped posts, with a cairn to the left. The path to Chapel-le-Dale is a high level route for the next 3 miles (5km) along the Craven Old Way. Towards Ellerbeck, make for the lower end of a group of conifers and turn right onto a tarmac road, eventually passing a metal sculpture, Gillhead cottage and Hurtle Pot before arriving in Chapel-le-Dale. Here, take a short cut through the churchyard.

❸ Chapel-le-Dale 737 771

About 100yds (90m) or so before reaching the church, look out on the right, shaded under trees, for a rusty metal sculpture of a figure. It was made by Charles l'Anson, and in 1983 thrown from here into Hurtle Pot where for years it lay at the bottom of a deep lake. Recently, potholers rescued and re-erected it, to be admired again by passers by. Hurtle pot is next to the track and surrounded by a wall. Gillhead is the fine, 17th Century farmhouse, beautifully restored.

The grounds of St Leonards church are designated as an SSSI on account of its exceptional cave systems and wildflower interest. Inside the church is a memorial to those who died during the construction of the Settle-Carlisle railway.

The unclassified road from Chapel-le-Dale is very close to the base of the Carboniferous limestone (the unconformity) shown by the number of springs that gush out. There is one just beyond a cattle grid with limestone around it and basement slates in the bed below. Over to the left is a large quarry in the same Ingleton slates.

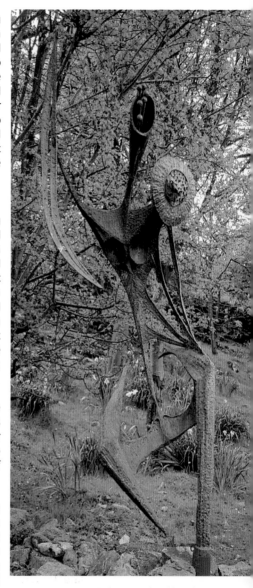

Sculpture at Chapel-le-Dale

▶ From Chapel-le-Dale follow the quiet, unfenced road that looks up to dramatic Twisleton Scars on the right and Raven Scar on the left. After 2½ miles (4km) turn left to Beezley Falls and the final part of the Waterfalls Walk.

Cottage at Chapel-le-Dale

④ Beezley 705 748

This is the name of the farm at the head of the second leg of the waterfalls walk. The River Doe tumbles through a narrow gorge forming a splendid series of waterfalls, white rushing water alternating with dark pools. Baxenghyll is where the gorge is particularly narrow and a metal bridge provides spectacular views in both directions. Where the valley opens out, in spring you may see hundreds of early purple orchids on the grassy slopes. Mealbank Quarry opposite has a thin coal seam in the limestone cliff.

▶ Follow the waterfalls walk past Beezley Falls, Rival Falls and Snow Falls. After passing Mealbank Quarry on the right, exit into the village and shops.

Parish church, Chapel-le-Dale

Smardale

Situated on the northern edge of the dales country, Smardale is a hidden valley full of surprises along which runs a former railway line, with an elegant viaduct. It is now a nature reserve and a haven for wildlife. At certain times of the year and when the sun shines, hundreds of butterflies dance along with you. The Coast to Coast long-distance footpath crosses the reserve.

1 Ravenstonedale 722 037

Ravenstonedale lies 800ft (245m) above sea level, yet is cosily set in a hollow, sheltered by tall trees and surrounded by wonderful scenery. It lies on Scandal Beck, the stream that flows through Smardale Gill and goes on to join the River Eden. In 1131, a small monastic house was established near Ravenstonedale church by the Gilbertine Order, the ruins of which were excavated in 1988. The church of St Oswald was completely rebuilt in 1744 and is noted for its three-decker pulpit. It once offered sanctuary to wrong doers if they managed to ring the bell before being arrested. The village school, still very active, was founded in 1688 by Thomas Fothergill of Ravenstonedale, later Master of St John's College, Cambridge.

A From the school, walk up the main street past the Black Swan to the triangular green at the south-west end of the village taking the path labelled 'Greenside' through a

The Howgills with Green Bell from Greenside

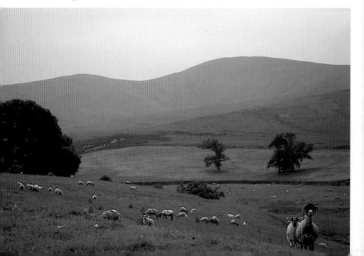

START/FINISH:
The village of Ravenstonedale is just off the A685 midway between Tebay and Kirkby Stephen. The walk starts at the school next to the church. Buses between Sedbergh and Kirkby Stephen call here from Monday to Saturday

DISTANCE:
9½ miles (15.3km)

APPROXIMATE TIME:
About 4½ hours

HIGHEST POINT:
1,080ft (330m) reached on the shoulder of Smardale Fell

MAP:
OS Explorer OL19, Howgill Fells & Upper Eden Valley

REFRESHMENTS:
In Ravenstonedale, bar meals the Black Swan and The Kings Head; in Newbiggin-on-Lune, tea room at the Lune Spring Garden Centre

ADVICE:
Take extra care in icy weather in the waterfall area as the steps can be slippery

LANDSCAPE/WILDLIFE:
Skylark, redstart, wheatear, wood warbler; melancholy thistle, rockrose, bloody cranesbill, common spotted and fragrant orchids, common wintergreen; roe deer, red squirrel; butterflies: scotch argus, common blue, northern brown argus

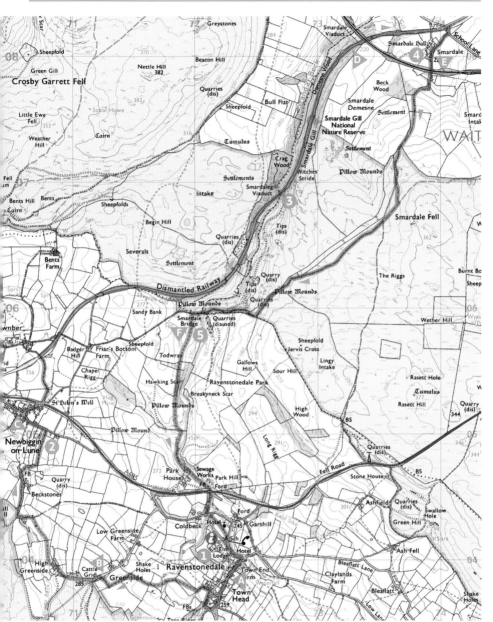

farmyard. Go left on a short, walled section to a diagonal across a field that leads to a stone bridge and up to a squeezer stile. The yellow arrows take you up to some sycamores, left of an old farmhouse and onto a lane in the small community of Greenside.

Turn left along the road. There are good views south to Green Bell and the northern slopes of the Howgills. To go round the next farm, turn right on a step stile after the cattle grid. The markers lead you round to a field overlooking Greenside Beck in the hollow to the left. Retain height and make for a barn among the trees. Turn down to cross the beck then right, along the road. There is a fine circular lime kiln with a double entrance by the roadside. Cross to the right bank at the farm and take the beckside path, followed by a meadow and lane that lead into Newbiggin-on-Lune.

② Newbiggin-on-Lune 705 051

Part of Ravenstonedale parish, Newbiggin village has developed round a village green. One house is fortified, another has a spinning gallery and the small Victorian church of St Aidan's is now a private house. The old railway station for Ravenstonedale was here and can still be made out at the west end of the village. The new road now follows the course of the old railway to Tebay and, in the other direction, the railway has become a nature reserve. Across the bypass is the ever-flowing St Helen's Well and a mound which is the site of a chapel. The well, together with Greenside Beck and a spring in the village make three sources of the River Lune.

At Brownber, just across the old railway line from Newbiggin, lived a branch of the Fothergill family where their most famous member was Elizabeth Gaunt. She was daughter of Anthony Fothergill and known locally for her kindness to all who came by. On one occasion she sheltered a rebel who betrayed her and bore evidence against her. Under the notorious Judge Jeffreys, the man received a pardon for his treachery and she was burnt alive, the last woman to be

Barn on the Smardale track with wild roses and yellow biting stonecrop

Scotch argus butterfly,
Smardale Gill

burnt at Tyburn. On that day of 4th October 1685, the Quaker, William Penn, witnessed her death and wrote of the way she calmly arranged the straw about her to shorten her sufferings while the crowd burst into tears. A stained glass window in the church commemorates the death of Elizabeth Gaunt.

C Turn right through Newbiggin (tea room on the right) to cross the main road at the crossing. Go forward and take the left track as far as the bridge under the old railway. (St Helen's Well can be seen a few yards along the track to the right.) Go up the steps of the embankment for a pleasant walk along the line of the railway. The next 3 miles (5km) is on the level and just over half way along is the restored viaduct high above Scandal Beck. Just before reaching the viaduct stands an abandoned cottage, a disused quarry and two huge kilns, which provided stone and mortar for the building of the viaduct.

3 Smardale Viaduct 727 068

The NNR (National Nature Reserve) of Smardale Gill is outstanding for flowering plants. The groups of melancholy thistle and carline thistle, golden carpets of rockrose, spread of bloody cranesbill and herb paris are rarely seen in such profusion. Common spotted orchid and fragrant orchid grow on the embankments. The less obvious blue moor grass is the food plant of the Scotch argus butterfly, which makes this reserve rather special. Towards the end of August these medium-sized dark brown butterflies are on the wing. Other butterflies include common blue, northern brown argus (the food plant is rockrose), dark green fritillary, and migrants, such as painted lady, red admiral, small tortoiseshell and peacock.

Beyond the impressive viaduct, the line is more enclosed by woodland but there are still many interesting plants including common wintergreen, stone bramble, guelder rose, sweet woodruff and St John's-wort growing alongside the track. Birds to look out for are redstart, wood warbler, pied flycatcher and treecreeper. Roe deer and red squirrel inhabit the woods.

D Towards the far end of the former railway track, the Settle-Carlisle railway crosses overhead on an even higher viaduct. On leaving the reserve, go to the road, then make three right turns to pass the front entrance of Smardale Hall.

4 Smardale Hall 738 079

This working farm has an ancient and impressive farmhouse. It was rebuilt in the 17th Century and the four mock towers

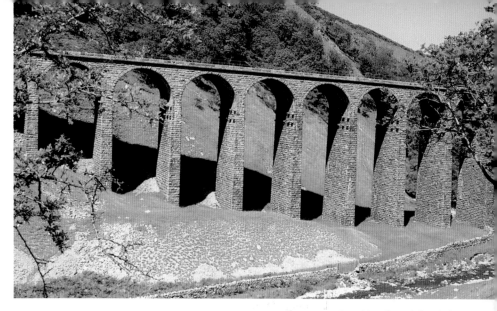

are of later addition. The oldest part is now the barn which was the banqueting hall of the original building and has a huge old fireplace, big enough to roast an ox. You are quite likely to see a heron or two in this area as in nearby Oxenbrow Wood there is a heronry.

Smardale railway viaduct, built in 1860 and restored in 1990

From Smardale Fell there are views back to the Eden and on to the Howgills and Wild Boar Fell, with the sound of skylarks above. Of particular interest are the pillow mounds (or giant's graves) that may be seen on the descent to the beck. These grassy mounds are oblong in shape, rising to 2 or 3ft (up to 1m). They may have been rabbit warrens cared for by the monks. On the far side of the valley below the bridge are some good lynchets, terraces of medieval farming.

▶ From Smardale Hall pass under the Settle-Carlisle railway and along a path signed 'Brownber, A685'. Follow the tractor track by a wood and round and up to a wooden gate. From here, there is a steady climb to the highest point on the shoulder of Smardale Fell with outstanding views, with a wall not far to the right all the way along this section. At the finger post keep straight on with a sign to Smardale Bridge.

5 Smardale Bridge 720 059

The fine stone bridge is on an ancient route from the Lune valley to the Eden and now sees regular traffic again as a steady flow of 'coast to coasters' pass this way. In June, by the track down to the bridge, grow the lovely pink flowers of bird's-eye primrose, and in Scandal Beck, masses of water crowfoot spread across the water and clumps of yellow

Berries of stone bramble, Smardale Gill

monkey flower border the stream. In the wall by the bridge are brittle bladder fern, rue-leaved saxifrage, maidenhair spleenwort and wall rue.

There are some raised embankments on both sides of the valley of Scandal Beck, one of which is followed by the footpath. These are the remains of walls built in the 1560s by Lord Wharton who purchased the land at the dissolution of the monasteries, evicting many tenants in the process. The walls were built to 9ft (2.75m) high around the 600 acres (243ha) of Ravenstonedale Park.

On returning to Ravenstonedale the route passes the Gilbertine ruins at the rear of the church. The Gilbertines were the only monastic order founded in England, mainly based in Lincolnshire and the small monastery here dates from 1131. There are few records though nearby place names include Friar's Bottom and Chapel Rigg.

▶ About 100yds (100m) beyond the bridge turn left, and climb to pass below a conifer wood and above deciduous trees. Descend to a gated stile and plank bridge to follow the beck for a short distance. Steps lead up to a cart track for a few paces before the route descends again, keeping close to the river. Go under the new road bridge, left of The King's Head pub, across a field to Ravenstonedale churchyard and back to the school.

Smardale Bridge

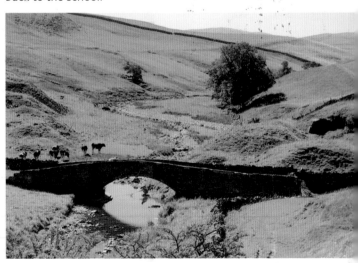